WHAT IS JAPANESE CINEMA?

WHAT IS JAPANESE CINEMA?

A HISTORY

YOMOTA INUHIKO

TRANSLATED
BY PHILIP KAFFEN

Columbia University Press
New York

Columbia University Press
Publishers Since 1893
New York Chichester, West Sussex
cup.columbia.edu

Originally published in the Japanese as *Nihon eigashi 110 nen*
 (Tokyo: Shueisha, 2014).
English translation rights arranged with Yomota Inuhiko through
 the Japan Publishing Industry Foundation for Culture.

Library of Congress Cataloging-in-Publication Data
Names: Yomota, Inuhiko, 1953– author. | Kaffen, Philip, translator.
Title: What is Japanese cinema? : a history / Yomota Inuhiko;
 translated by Philip Kaffen.
Other titles: Nihon eigashi 100-nen. English
Description: New York : Columbia University Press, [2019] |
 "Originally published in the Japanese as Nihon eigashi 110 nen
 (Tokyo: Shueisha, 2014)." | Includes bibliographical references
 and index.
Identifiers: LCCN 2018054005| ISBN 9780231191623 (cloth)
 | ISBN 9780231191630 (paperback) |
 ISBN 9780231549486 (e-book)
Subjects: LCSH: Motion pictures—Japan—History. Classification:
LCC PN1993.5.J3 N542513 2019 |
 DDC 791.430952—dc23
LC record available at https://lccn.loc.gov/2018054005

Cover design: Chang Jae Lee
Cover image: Teshigahara Hiroshi, *Woman in the Dunes*, 1964.
 © Sogetsu Foundation

In memory of Kuzui Kinshirō (1925–2014)

CONTENTS

NOTE ON NAMES AND
FILM TITLES

Names are in the Japanese order with family name first. Film titles are a bit problematic, but to the extent possible, the English translation of the title has been provided with the original Japanese title in parenthesis. In cases in which a standard translated title has remained fixed or an official release title exists, that is the title that will be used (e.g., *The Life of Oharu* for *Saikaku ichidai onna*). When no official release title and no standard translation exist, an approximation of the Japanese has been used. On occasion, if a film has become famous outside Japan under its original title (e.g., *Ikiru*), that will be the sole title, although generally an indication of what the title means is provided. In recent years, many Japanese titles have been given in English either written with the alphabet or transliterated phonetically into Japanese. In cases in which an English title but no Japanese title is given, this probably is the case.

PREFACE TO THE ENGLISH TRANSLATION

Samurai. Godzilla. The life of a traditional Japanese family unfolding in tatami-mat rooms. The brute violence of yakuza films and the pure *shōjo* girls of anime. For most film lovers in English-speaking areas this is the image of Japanese cinema.

This view isn't wrong. These are certainly essential elements of Japanese cinema. This book, however, was written for people who want to know the ways in which these elements are related to one another or who have an intellectual interest in the deeper world hidden in the background. It is the tale of how the Japanese people took an optical machine originally invented in the West—the cinematograph—and made it their own, absorbing it and utilizing it to create a distinctive culture. In other words, it is none other than the story of modernity in Japan.

When encountering a work of art, you must always be wary of a certain trap. That is the temptation to praise a work before really understanding it. I hope that readers will come to see that behind any film they have watched and enjoyed there is a huge

accumulation of culture and that no single work is complete in itself but always emerges as part of a chain of relationships to history.

"Japanese cinema" is made up of two words: "Japanese" and "cinema." For those who are interested in Japanese cinema, the choice of which of those words to emphasize makes a big difference in the direction of their explorations.

Those who prioritize "cinema" will put all filmmakers—whether Kurosawa Akira, D. W. Griffiths, Jean-Luc Godard, Charlie Chaplin, or Steven Spielberg—on one horizontal plane. The history of Japanese cinema is but a portion of the history of world cinema. That Kurosawa is Japanese is merely incidental and what is significant is the extent to which his works contribute to the expansion of the global language of technical images. A person who loves cinema transcends ethnic or national boundaries. A film lover is a resident of something we might call the "World Republic of Cinema." Cinema has its own specific language and by becoming conversant in it, one should be able to understand the cinematic works of any filmmaker in the world. For someone who believes in the international nature of film, more than being Japanese, it is fundamentally important that Japanese cinema is cinema. From this perspective, lovers of Japanese cinema also love the films of John Ford, Godard, and Im Kwon-Taek.

Conversely, another viewpoint insists that Japanese cinema must be seen as part of the culture of Japan. After all, the camera movements of Mizoguchi Kenji are strongly influenced by the methods of traditional Japanese painting. Kurosawa Akira borrows many of the themes for his works from Kabuki—the popular theater of Edo period Japan. Youth melodramas of the 1960s are sharply inscribed with the class divisions of postwar Japanese society, and to understand the anime of Miyazaki Hayao, one must know about the distinctive imaginative world of Japanese folklore. From this perspective, it is impossible to ignore cinema's intimate connections with Japanese culture, from literature to painting and theater. Or rather, you need to know not just culture but also the realities of Japanese history and society. Only when one can understand both the images in the hearts of the people who

made Japanese films and those in the hearts of those who laughed or cried along when they watched those films is it possible to grasp the depth of Japanese cinema.

Which of these two perspectives is correct?

In fact, both are correct and both are necessary. Although Japanese cinema cannot be separated from the cultural particularities of Japan, we must also see it as a part of the universal history of humanity's desire for images and movement. The situation is the same in the United States. The depth of someone's grasp of American cinema can vary considerably based on whether he or she is knowledgeable about the ethnic diversity of American society, or the New and Old Testament, or Jewish comedic traditions, or the trauma exerted by the Vietnam War. Yet, at the same time, it is precisely because film fans around the world have discovered something universal that transcends history in Japanese and American cinema that they love and respect them.

As a film historian, I would be delighted if Japanese cinema becomes a launching pad for the readers of this book to develop a general interest in Japanese people and Japanese culture. At the same time, I believe it would be equally wonderful if an encounter with Japanese films stimulates readers' interest in seeing more films from around the world.

Ah yes, I would like to add one additional thing.

In terms of world history, just as the nineteenth century did not end in 1900, but rather in 1914 with the outbreak of the First World War, the first decade of Japanese cinema of the 2000s did not end in 2010. That is because in 2011, Japan experienced a decisive rupture. The great disaster of East Japan—a massive earthquake and tsunami, followed by the meltdown of nuclear reactors at Fukushima—created an irreversible discontinuity in the hundred-plus year history of Japanese cinema.

What will Japanese cinema become in the wake of this disaster? As I am writing this preface, already six years have gone by. In that time, hundreds of documentary films have been produced. In addition, there is no shortage of fiction films making reference to these

terrible events, appealing to the melodramatic imaginations of their viewers. It is extremely difficult to get a picture of the overall shape of the cinematic works after this disaster. Film historians will have to take the utmost care, and will undoubtedly need time to develop any kind of comprehensive reflection on this work. That is the reason this book ends just before 2011.

I would like to express my thanks to Phil Kaffen for translating this book whose content ranges across so many topics, as well as to editor Mark Oshima for his careful and thorough chapter notes. I am grateful for the short comments offered by Professor Paul Anderer, an extraordinary scholar of Japanese literature, and those of the generous film scholar, Dudley Andrew. Finally, I would also like to dedicate this book to my first girlfriend, who rebuffed my invitation to go see *Citizen Kane* together when we were thirteen years old.

WHAT IS JAPANESE CINEMA?

INTRODUCTION

The history of cinema can never be told just through the history of masterpieces. To be sure, it is not hard to place *Tokyo Story* (*Tokyo monogatari*, 1953) alongside *Seven Samurai* (*Shichinin no samurai*, 1954) or *Nausicaä of the Valley of the Wind* (*Kaze no tani no naushika*, 1984) and call such an ensemble "Japanese cinema." Just as one cannot describe the great peaks of the Himalayas one after another and reach a true picture of this place called the "roof of the world," it is impossible to get an accurate picture of the films of a particular society if we merely assemble a series of works considered to be artistically superior, or those from the top-ten lists of film journals or that garner top box office receipts. In between such famous film works, and linking them together, are innumerable nameless films. Without taking those films into account as well, we cannot understand the ways that Japanese cinema developed or chart the changes it has undergone.

The first film to be shot in Japan by a Japanese person was in the year 1897. Since that time, there have been two golden ages of film in Japan, as it became the great film nation of East Asia.

The first golden age was from the late 1920s through the early 1930s, and the second was from the 1950s through the 1960s. Could there be another—third—wave in the twenty-first century? In the 2000s, Japan has been in a film production bubble, producing more than seven hundred films each year. If the rise of a truly new Japanese cinema is indeed possible, however, what form might it take, whether in terms of quality or in terms of quantity? To find out, we must look back and retrace the steps of Japanese cinema to this point. With this goal in mind, this book has been written for the general reader, rather than the expert.

When we begin to write out this history, the question of where to draw a dividing line between one era and another becomes crucial. Film history certainly overlaps with the surrounding social, political, and cultural histories, but it does not necessarily reflect these histories directly. At the same time, we must keep in mind the technological histories at play—from silent film to talkies, from black and white to color, from film to video, and digital. This book, with a few exceptions, proceeds in decades to accentuate the changes each era produced, so that it is accessible to the general reader. The drawback to this approach is that many excellent and important directors and works must be left on the cutting-room floor.

Today, watching past films from around the world is not difficult nor is it the exclusive preserve of a chosen elite. If the reader can use this book as an initial guide for a stroll through the vast forest of a century of Japanese cinema, I would have no greater joy.

THE CHARACTERISTICS OF JAPANESE CINEMA

What is "Japanese cinema" and what makes it "Japanese"? One of the first difficulties we encounter when we attempt to think about Japanese cinema is that it is impossible to find one definition of "Japanese cinema" that is applicable to all films at all times in this

history. This problem was already evident before the Second World War, when Japan was still an imperial power with many territories and cultures under its jurisdiction that are now independent nations. This problem has grown even stronger in the present, even as the shape and meaning of this problem have changed.

For example, if we look to the prewar period, to what extent can we call those films "Japanese" that were directed and produced by Japanese in Taiwan, or Korea, or Manchuria? In the present, can and should we use the word "Japanese" for those films directed by *zainichi* (resident) Koreans in Japan, like the works of Sai Yōichi or Yi Hagin? If we were to decide that these do not count as Japanese films, and furthermore, if even those films that star *zainichi* Koreans do not fit into the category of Japanese cinema, postwar Japanese film history—in which *zainichi* Korean artists and performers played such an enormous role—would virtually cease to exist. Or, what about someone like Takamine Gō, who, while Japanese, produced films in the Okinawan language with Japanese subtitles? What about the films of Kurosawa Akira or Ōshima Nagisa after the 1970s that were produced with French capital?

From this chain of questions, we can see that in recent years, the term "Japanese cinema" no longer refers to a unified entity. I feel a certain ambivalence in using the term at all at this point. Of course, these trends are hardly limited to Japanese cinema. It has already become commonplace in Europe for capital, staff, and cast to be multinational. Even in Chinese-speaking film zones, beginning in the 1990s, we can find films like *Farewell My Concubine* (1993), which was shot in China by a Chinese filmmaker living in New York, with a Taiwanese producer working through a Hong Kong studio. Films with Japanese directors, employing only Japanese actors, using Japanese language, and shot in Japan will become increasingly rare in the twenty-first century.

Next, we must confront a second difficulty that looms before us: the question of whether or not we can declare the existence of some kind of commonality or consistency to Japanese films across time.

A frighteningly vast gulf separates the Onoe Matsunosuke vehicle *Jiraiya the Hero* (*Gōketsu jiraiya*, 1921) from Kurosawa Akira's *Ikiru* (*Ikiru*, 1952), one that goes beyond techniques or themes and goes to the level of the very idea of what cinema is. Although they are somewhat closer in time, an even deeper gulf exists between Kurosawa's film and Tsukamoto Shinya's *Tetsuo* (*Tetsuo*, 1989). Comparing films made internationally at about the same time as these films, *Jiraiya*'s contemporaries in the 1910s and 1920s include such works as *Vie et Passion du Christ* (*Life and Passion of the Christ*, 1903) in France, and D. G. Phalke's *Birth of Shree Krishna* (1918) in India. Kurosawa's work in the 1950s has much in common with the neorealist films contemporary to him like De Sica's *Umberto D* (1952). Meanwhile, Tsukamoto's work in the 1980s reminds us of splatter movies, or the paintings of H. R. Giger, rather than anything that we typically think of as "traditionally Japanese."

I have consciously chosen three films from the 1910s and 1920s, 1950s, and 1980s. Although they usually are all classified as "Japanese cinema," for the most part, they were shot with cinematic sensibilities that do not overlap. This suggests that it is not particularly useful to describe them as "Japanese cinema" as though this was a constant throughout history. More than having something in common because they are Japanese, what is striking is that these three films brilliantly embody the contemporaneity of world film history; to ignore this and force the rubric of "nationality" upon them risks missing essential features of these films as individual works. Likewise, over this past century, Japanese cinema has undergone such dramatic changes that the very meaning of Japanese cinema can differ completely depending on the historical moment in focus.

With these questions in mind, in the rest of this book, we explore the relationship of cinema in Japan to the world and whether we can identify any kind of commonality to "Japanese cinema" despite all the exceptions and meanderings through the ages, while also refraining from trying to pass final judgments. To that end, we must first consider how to position Japanese cinema within 110 years of Japanese culture and society.

CINEMA AS A LIMINAL ART

Emerging at the end of the nineteenth century, Japanese cinema occupied a position as the representative mass art of Japan in the century that followed. But is this statement perhaps a bit too simple? Rather, we should say that it did so until the 1960s. When we look at Japanese cinema as an art, however, it has never held a high position within society. To the contrary, up to a certain period, it sat on the border between what the philosopher Tsurumi Shunsuke called "mass art" and "liminal art."[1]

Liminal art itself, in the boundary between the categories of art and nonart, frequently gave a new impetus to Japanese films in a period of decline. The films of Makino Masahiro in the prewar period remained the product in many ways of a cottage industry, and in the 1960s, Hara Masato appeared like a comet from the just-emerging world of eight-millimeter home movie cameras. Even up to the 1990s, it was possible for new directors to emerge out of the intersection of Pink Film and adult video. Because cinema long occupied the lowest place among mass arts, it could be strongly inspired by liminal art.

From the middle of the nineteenth century, when Japan began aiming at Western-style modernization, literature and fine art were seen as the highest forms of culture and the most worthy of emulation. The artists associated with them gave off an air of being spiritual seekers, enveloped by a cloud of passionate, nearly religious myths. Cinema was able to achieve a similar kind of myth-like status only in the postwar period, when directors such as Mizoguchi Kenji and Kurosawa Akira gained status by being admired internationally.

Until a relatively late date, most viewers of Japanese cinema were either children or poor urban laborers with minimal education. For regular intellectuals to go to a movie theater was seen as highly eccentric. Theater[2] and music were the closest arts to cinema, and it is a fact that cinema inherited richly from both. Even so, with the

exception of the early days when cinema was still quite rare, proud Kabuki actors referred to the new art of cinema as "gutter theater" and would not deign to grace it with their presence. Noh actors made no effort to interact with cinema. The only forms of theater that were receptive to cinema were *tabi shibai*, which occupied the lowest class position in the world of theater, and the newly emergent *shinpa*. In Japan, from the earliest screenings, *benshi*[3] or "vocal explainers" were on hand as part of the performance, but in the beginning, rather than respected artists, they had more the dubious air of a carnival barker. But this arrangement suited these early displays of this optical apparatus imported to Japan from the West not as a high art but as the cheapest kind of spectacle.

The first real film studio appeared in Japan in 1912, roughly the same time as the establishment of film studios in Hollywood, many that continue to exist today. Even at this point, studios in the two countries were completely different things—in Japan, filmmaking was a small-scale cottage industry, but in Hollywood, films were made in what had already become a modern factory. What was formalized in Hollywood during the 1910s—narration, camera techniques, and the star system for actresses—was not fully incorporated into Japanese cinema until the 1920s. Japanese cinema has always been beset with a sense that it was lagging behind America while at the same time was inspired by America. Even Ozu Yasujirō, who would later be praised for an individual film style seemingly so "Japanese" and rigorously opposed to Hollywood conventions, was so deeply influenced by American cinema that his early works in the 1920s were said to "reek of butter."[4]

But Japanese film is also different from Hollywood in another way. Hollywood film is the quintessential art form embodying American culture, but at the same time it has also promoted itself ideologically as "universal." Japanese cinema has never done so. By contrast, no matter how much Japanese films were praised internationally for their artistic merit, Japanese cinema remained resolutely local. It also did not serve as a medium for political conspiracy and power struggles as would Chinese cinema in its later

development. It was not under linguistic pressure from American films, the ways that English cinema was; rather, it was produced, distributed, and consumed within the enclosed world that used the Japanese language. For a long time in the postwar period, viewers in Japan believed in the strange stereotype that Hollywood film was entertainment, European film was art, and film produced by other Asian countries was for the serious study of history. This breakdown became meaningless by the 1990s, but regardless, Japanese cinema was perceived as belonging to none of these categories. In contrast with Western films that were adored by Japanese youth, who saw them as embodying positive values, Japanese cinema has always been seen as inferior. On that point, Japanese cinema could not attain the heights of popularity and domestic cultural centrality reached by Hong Kong films in Hong Kong.

MASUMURA YASUZŌ'S CRITIQUE OF JAPANESE FILM

I would like to introduce a theory of Japanese cinema penned by a Japanese man in a foreign language over a half a century ago, and this will help to guide our investigation of Japanese tradition and film. "History of Japanese Cinema" was written in Italian by film director Masumura Yasuzō, who studied at the Centro sperimentale di cinematografia in Rome in the 1950s and published it there in 1954.[5] In the essay, Masumura directly attacked the melodramatic elements that he saw as the core of Japanese cinema. According to Masumura, Japan's directors, "by harmonizing lyrical elements like landscapes and scenes of nature, with sentimental love stories, or poetic depictions of motherly love, developed fragile passive sensibilities." By actively avoiding actual life in society, they fell into an antirealist attitude. Masumura declared that, "In the end, the kind of beauty in Japanese cinema is not a masculine beauty, bravely facing outward, but rather, is entirely composed of feminine, emotional qualities."

For Masumura, who had studied in Italy, art should be "a direct expression of people's passion," and at the same time, must be "extremely masculine." However, he believed that in Japan, art was a "product of a warped society" and forged over a long period of political totalitarianism. The constant themes of Japanese cinema—"destiny, natural love, cruelty, a delicate, pretty sensibility, mysticism, and the leisurely temporal sensibility to express them"—were an effect of such a contemplative, aestheticized antirealism. Consequently, Japanese cinema never confronted the problems of society or produced any comedies in the true sense.

Masumura's critique does not mince words. It is overflowing with the sense of urgency and impatience of one who had just personally witnessed Italian neorealism firsthand. What was probably in his mind were prewar Shōchiku melodramas and the "mother films" produced at Daiei in the postwar, as well as films by directors such as Naruse Mikio and Kinoshita Keisuke. The sense of frustration he felt with these films rises up from his very language.

Of course, looking back on this argument now, it is extremely easy to debunk the claims that Masumura made in 1954 by finding exceptions to his assertions. Kurosawa Akira's *Seven Samurai*, which had been showered with praise that same year at Venice, was a thoroughly masculine film, the genealogy of Japanese documentary film, from Kamei Fumio through Ogawa Shinsuke never strayed from the path of reality while in pursuit of the politics immanent in film images. Suzuki Seijun may be highly aestheticized, but he refused every last trace of sentimentalism, creating films of masculine appeal. Contemporary Japanese animation, in comparison with that of the West, is replete with emotional expression that at times borders on excess. Moreover, didn't such comedy directors as Maeda Yōichi and Morisaki Azuma emerge in the 1960s? What these counterexamples demonstrate is that against the mainly prewar films that Masumura had in mind, postwar Japan cinema developed in an extremely varied fashion.

Be that as it may, if there is a reason to still listen attentively to Masumura's critique, it is because he so skillfully and succinctly

sheds light on the particular qualities of Japanese melodramas. He masterfully plumbed the *shinpa*-esque elements that flowed through the undercurrents of Japanese cinema, grasping the essence of the cinematic environment in which he had grown up. Upon his return to Japan, Masumura, who worked as an assistant director for Mizoguchi on the film *Street of Shame* (*Akasen chitai*, 1956), would witness the love and hate the great master felt throughout his whole life for this *shinpa*-esque aesthetic. The entire itinerary of Masumura as a director can be traced back to this point, putting his critique of Japanese cinema into practice in the form of his movies.

MIXING WITH NEIGHBORING GENRES

To explore Masumura's critique of Japanese cinema more rigorously, we have to consider how it was influenced by the broader Japanese culture that preceded it as well as the cultural context within which it was established.

Needless to say, because cinema was the newest system within the extant arts, broadly speaking, it has borrowed a great deal from its predecessors. Although as a new medium it eliminated many aspects from existing genres, it also slipped into the tracks of existing cultural contexts, where it found its audience and used this to grow. We could say that the cinematograph, which came to be seen as a conception of the Lumière Brothers in Lyon, was at the same time both an optical apparatus devised by *fin de siècle* Europe and a quintessential product of the *episteme* of Western modernity. In East Asia, which had advanced by actively mirroring the West from the middle of the nineteenth century, the system of representation and projection that constitutes the basis of the apparatus known as cinema was, naturally enough, a symbol of modernization and an embodiment of Western principles. Over the course of a century, however, cinema developed in singular ways not only in Japan but also in other parts of the world. In other words, the technology had many tendencies built into it, but the actual manifestation of film

depended very much on the existing culture and the way it changed over time in relationship to other things. This fact demonstrates that each of these countries had an active and different interaction with this quintessential example of Western modernity and the traditional cultures in these countries.

So, the cultural context really matters. Just as Italian cinema has always taken much from opera from its earliest days to the present, and Chinese cinema grows out of all kinds of aspects of Chinese culture—from philosophy like Daoist thought and, of course, from the performing arts like Peking and Cantonese opera—Japanese cinema is likewise an art that blossomed in the soil of Japanese culture. To put it the other way around, just as knowledge of opera or Daoism, as well as history, is necessary to truly understand Italian or Chinese cinema, knowledge of Japanese history and the arts neighboring cinema is necessary to understand Japanese cinema at a profound level. Let's look at this more concretely.

Of course, literature is among the most important of these neighboring arts. Even in the Edo period, by the middle of the eighteenth century, Japan had seen the rise of a mass reading culture rare in the world. This included all kinds of illustrated fiction with pictures by famous *ukiyo-e* artists and a large literate public that could read them. After the Meiji Restoration, literature famously began with a transcript of a *rakugo* story and then grew to books of stories from *kōdan*, then to newspaper novels and children's literature.[6] Soon Japan was overflowing with all manner of reading materials. High literacy rates have continued to ensure a strong readership over a long period of time. In that sense, Japanese literary culture is incomparably stronger than that of Italy, which was compelled to deal with a dearth of native content by publishing adaptations of French novels in newspapers, or that of India, where linguistic plurality combined with British colonial rule proved a major cultural obstacle throughout the twentieth century. The flourishing of contemporary manga is an extension of the historical trend of the centrality of print culture.

Not only did such literary materials provide source material for films but also aroused in viewers the latent desire for a narrative

visual culture and shaped the form of the films that were made. Cin-
ema in turn influenced the techniques of mass literature[7], bringing
to it the flavor of modernism. In the early days of cinema in Japan,
stories from *kōdan* dominated film as a source for *jidaigeki* enter-
tainment with all the fantastic and contradictory elements of that
genre. But when mass literature, fiction that began as print, in par-
ticular serialized in newspapers and magazines, overtook *kōdan* as
the basis of cinema around the mid-1920s, the more absurd elements
remaining from *kōdan* gradually disappeared from *jidaigeki*.[8] In the
mid-1930s, when the talkie revolution had died down somewhat,
adaptations of pure literature began in earnest. Kawabata Yasunari's
Dancing Girl of Izu is one of the iconic works of "pure literature," and
if you compare the six adaptations of it that have been filmed since
then, you can trace the changing relationship between cinema and
pure literature over time. The beginning of Kawabata's *Snow Coun-*
try, published in 1935, gives us a vivid sense of the new relationship
between cinema and pure literature when the protagonist speaks
explicitly about the technique of "cinematic double exposure."

Manji (dir. Masumura Yasuzō, 1964).

Of course, the visual arts have a long history in Japan and many Japanese film directors have been quite conscious of its influence, consciously incorporating it into their methodologies. For example, when Mizoguchi Kenji was going to shoot *Genroku Chūshingura* (1942), he argued that where Western painting emphasized a single point by concentrating the gaze through close-ups, Japanese painting, taking the long shot as its basis, aimed for "composition of the entire scene," allowing for any given image to have multiple points of perspective. He insisted that Japanese cinema "must learn by standing quietly and studying carefully even the most ordinary traditional Japanese painting."[9] Seeing the perfect model of composition in the painting *Scenes of Kyoto and Its Environs* by the early Edo-period artist Sumiyoshi Gukei, Mizoguchi liked to gaze upon things from a distance, with a wide-angle perspective. He also held a strong interest in the spatial composition of the *ukiyo-e* woodblock print artist Andō Hiroshige's series of famous views, adapting the way these prints use composition to create a sense of gentle and fluid shifts in time through continuous changes in space. Mizoguchi incorporated this into his own style. We can see one of the most beautiful examples of this in *Ugetsu* (*Ugetsu monogatari*, 1953), when the camera glides from the open-air bath over the rocky area, dissolving into the scene on the shore.

CONNECTIONS WITH TRADITIONAL THEATER

In the end, however, we have no room for doubt: theater and music have contributed the most to the establishment of Japanese cinema. The place where we go to watch movies is still called a "theater," after all.[10]

I've already mentioned how Kabuki was initially contemptuous of cinema. Even so, in fact, cinema borrowed heavily from the mass arts of the Edo period. *Jidaigeki*[11] in the prewar period were influenced by Kabuki in numerous ways, from film actors using Kabuki stage names, their dress and makeup, to their movements

and enunciation. Kabuki and puppet theater[12] also provided a rich source of narrative themes. The narrative of *Chūshingura*, a huge hit in the eighteenth century, has been adapted more than 80 times by cinema as far as I can confirm, constituting its own grand genre, comparable to the adaptations of epic poetry in India. The reason that there were virtually no true actresses in Japanese cinema until the early 1920s is a direct result of the influence of *onnagata*—men who played women's roles—in Kabuki. Furthermore, from Mizoguchi's *Tale of Last Chrysanthemums* (*Zangiku monogatari*, 1939) to Imamura Shōhei's *Stolen Desire* (*Nusumareta yokujō*, 1958), narratives of the travails of Kabuki actors or other kinds of traveling performers have served as convenient fodder for cinema.

Kabuki is, of course, crucial to the history of film in Japan, but the more modern genre of *shinpa*, which is less familiar to Western readers, has a perhaps more important and problematic position. *Shinpa* emerged as a result of a reform movement in Kabuki at the end of the nineteenth century. Then there is *shingeki*,[13] or "modern theater," which includes plays from Western theater and Japanese-written plays using similar techniques, and most important, for the history of film, the relatively short-lived genre of theater called *shin kokugeki* (New Japanese National Drama). For the first Japanese actress to be born, the operations of *shinpa* were indispensible[14], and the fruits of *shin kokugeki* played no small role in rendering more sophisticated the techniques of *jidaigeki*. Needless to say, however, the most important force in the formation of Japanese cinema, its real basenote, was *shinpa*. *Shinpa* began as an underground theater, and before long, it took up the friction between the demimonde and the bourgeoisie, as depicted by novelists like Ozaki Kōyō and Izumi Kyōka. An emergent Japanese cinema leaped on *shinpa*, appropriating as its own the worldview and the sense of morality it represented. *Shinpa* treated themes like love between different classes, men who strive for worldly success and self-sacrificing women, and the reunion of broken families. When these themes, that proved so irresistible to *shinpa*, linked up with Western melodrama, which was transmitted globally through Hollywood, the result was the

formation of a unique brand of Japanese melodrama. The critique of Japanese cinema provided by Masumura Yasuzō is largely aimed at this point.

Among these various theatrical genres that were intertwined with the formation and development of Japanese cinema, the classical Noh theater, created in the fifteenth century, alone remained aloof. Perhaps because Noh was perfected as an art form at such a high level of purity so very long ago, it was unable to find an entry point to the new art of film. Of course, although its influence may have been marginal at the level of film as a whole, Noh left its mark unforgettably on individual works of various directors. In Ozu Yasujirō's *Late Spring* (*Banshun*, 1949) or Naruse Mikio's *Sound of the Mountain* (*Yama no oto*, 1954), Noh takes on a highly metaphorical character; Kurosawa's *Ran* (*Ran*, 1989) cites multiple Noh plays in a kind of mosaic. Noh's influence is felt even in the way the characters walk.

The women's theatrical revue Takarazuka remained close to the world of cinema through its founder Kobayashi Ichizō who presided over the entry of his company into film with the production company Tōhō. The troupe was an especially significant source of trained actresses; however, the world of the Takarazuka troupe never appeared directly as the subject matter for film. When compared with the way traditional theater became an important theme in the cinema of the Chinese-speaking spheres of Taiwan or Hong Kong, this can appear only as a dramatic loss. It is a shame that in Japan it doesn't seem to have been possible to establish and support a genre of action films that featured actresses in male garb.

THE ORIGINS OF THE *BENSHI*

In Japan, music did not develop as a purely instrumental performance. In most cases, it developed as a form to accompany the voice—that is, the linguistic message—or the theatrical representation. In puppet theater (*ningyō jōruri*), the visual elements performed on the stage and the musical narration performed to the side of the stage

were separate, but viewers enjoyed them together as a composite performance.

When the cinematograph was first brought into Japan, as I've noted, there were already vocal explainers. These explainers ultimately came to be called motion picture *benshi* and were indispensable to the screenings of silent films. In large cities with several theaters, viewers would even decide what theater to go to based not on the content of films but rather on which *benshi* was performing. Famous *benshi* could even make requests to producers about how a film would be directed. The total time of a film screening could be freely lengthened or shortened by the length of the narrative of the *benshi*. There are numerous theories for why the system of *benshi* developed in this way in Japan alone. The most convincing of these theories attributes their prominence to the fact that they were rooted in the tradition of mass arts. A rich variety of performing arts has existed in Japan since the Edo period and before featuring recitation—*rakugo*, *kōdan*, *saimon*, sermon ballads, and workers' songs—using narrative in many sophisticated ways. *Benshi* did not lack for models in establishing their narrative techniques. Puppet theater, as I mentioned earlier, had already given the Japanese a system for enjoying distinct visual and vocal elements simultaneously. Therefore, when the Japanese first came into contact with cinema at the end of the nineteenth century, the combination of explanation and silent films did not seem at all strange. Efforts after the 1910s to abolish the system of *benshi* by screening films in the Western style with inter-titles alone were invariably led by intellectuals. Each of these efforts collapsed, however. Apart from the fact that many small theaters did not have the financial resources to invest in the necessary equipment, the existence of the *benshi* is one of the reasons that the talkie revolution was so late in Japan. As the director Itō Daisuke, the great master of *jidaigeki* film, would put it many years later, "in Japan, the cinema was never truly silent."

Benshi had mostly vanished by the late 1930s, but their traces remained in surprising ways, shaping notable characteristics of

Japanese cinema. For example, when there are endless speeches by an unseen narrator at the beginning or end of a film, what we are seeing is a remnant of the pre- and postfilm speeches of the *benshi* embedded into the film itself. This style of narrating also continued in animation and documentary. The prominence of the long take from prewar to postwar Japanese cinema, and the fact that Japanese cinema turned neither toward the rigorous construction of montage à la Eisenstein, nor simply toward copying the narrative techniques of classical Hollywood cinema, also can be seen partly as a result of the long shadow cast by *benshi*. Film historians from the intellectual classes in fact consistently disparaged *benshi*. *Benshi*, however, were not the cause for the belatedness of Japanese cinema, nor did they contribute to the warping of Hollywood norms of narration. They were simply a unique characteristic of Japanese cinema, and we must investigate the sources and influence of the *benshi*.

CULTURAL HYBRIDITY

In all of its many manifestations, Japanese cinema was not just an extension of traditional Japanese culture or solely under its influence. Looking at actual films, the first thing that draws our attention is an overwhelming cultural hybridity—the will to build an entirely new composite form by layering heterogeneous cultural sources.

To see how numerous cultural sources are hidden within a given film, it will be sufficient to take up the work *Humanity and Paper Balloons* (*Ninjō kami fūsen*, 1937) directed by Yamanaka Sadao for PCL. The immediate source material for this work comes from the late nineteenth-century four-act Kabuki play *Shinza the Barber* (*Tsuyu kosode mukashi hachijō*, 1873) by Kawatake Mokuami. It takes from the play only its characters, and in fact, the story itself is an adaptation of Jacques Feyder's *Pension Mimosas* (1935). The overall atmosphere of the play consciously emulates Gorky's *Lower Depths*, whereas in terms of genre, the film borrows the form of *Grand Hotel* (1932). Although the play is ostensibly set in Edo, the director

Humanity and Paper Balloons (dir. Yamanaka Sadao, 1937).

quietly infuses it with nostalgia for his own youth in Kyoto through his depiction of alleys like those where he grew up. The work attains a certain harmony by weaving together its various utterly heterogeneous elements—Japanese traditional theater with the latest French film, a Russian novel and Hollywood form. In Japan, cinema alone allowed for this thorough mixing of genres. It is true that modern novels emphasized a variety of materials, but there is probably no novel that was composed completely by incorporating the fruits of premodern elements with those of the latest Western works.

Critics have noted how Japanese cinema quite ambitiously sought out elements of Western—especially Hollywood—films, and developed itself by remaking them into Japanese versions. Henry King's *Stella Dallas* (1925) has been adapted repeatedly. Beginning with Naruse Mikio's *No Blood Relations* (*Nasanu naka*, 1932) and Yamamoto Satsuo's *Mother's Song* (*Haha no kyoku*, 1937), in the postwar period, it would go so far as to shape an entire genre: The maternal

melodramas, or "*haha mono*" starring Mimasu Aiko. Not only did Nikkatsu action films borrow the framework of Hollywood films, from *Casablanca* (1942) to *Shane* (1953), at the same time, Japanese filmmakers persistently remade contemporary new wave and neorealist films. If I may draw on personal experience, the first time I saw Godard's *Breathless* (1960) and Fellini's *La Strada* (1954) in arthouse theaters, I was seized by a curious feeling of déjà vu. This is because the narratives were exactly the same as Nikkatsu films I had seen, including *Like a Shooting Star* (*Kurenai no nagareboshi*, 1967), starring Watari Tetsuya, and *Glass Johnny: Looks Like a Beast* (*Garasu no Jonnii yajū no yō ni miete*, 1962), starring Shishido Jō. Such citation, or piracy, has never been seen as ethically problematic within the Japanese film industry; to the contrary, it has been praised as timely, a fresh approach. Even in the 1990s, this orientation toward hybridity was evident. The director Iwai Shunji borrowed ideas from Krzysztof Kieślowski's *The Double Life of Véronique* (1991) and Percy Adlon's *Baghdad Cafe* (1987), while Oshii Mamoru was citing Chris Marker and Jean Luc Godard.

Two divergent impulses have existed throughout Japanese film history: the impetus to advance cinema by trying to make it something purely Japanese and the impetus to advance cinema by constructing a cosmopolitan, global mosaic via cultural mixing. These two approaches are the two poles of the axis of nationalism. In the late 1910s, Kaeriyama Norimasa launched the "Pure Film Movement" (*jun eigageki undō*) as a way of elevating Japanese cinema to the levels of Western film. The movement began as a reaction to the stereotyped representations of Japan and Japanese in Western films and led to a kind of nationalism in wanting to provide positive images of Japan. Several innovative trends emerged in the wake of this movement. Such films as *Amateur Club* (*Amachua kurabu*, 1920) and *Souls on the Road* (*Rojō no reikon*, 1921) were colored by an extremely cosmopolitan tone and set in places like Hayama and Karuizawa, which were made to resemble Western summer resort towns. They incorporated subtitles in foreign languages and consistently copied Hollywood slapstick comedy.

Conversely, during the Second World War, when American films could no longer be imported, Japanese cinema threw off the yoke of modernism that had suffused its output hitherto and returned to the standpoint of traditional values. In contrast to its previous mode of expression, the orientation of nationalism shifted so it was now avoiding the West. One after another, Japan produced films that affirmed the worldview of ascetic arts and discipline, or the samurai code. Incidentally, Noël Burch especially praised the Japanese cinema of this period in which it was liberated from Hollywood codes, arguing that it was here that it attained a peak in terms of formalism.[15]

Let me give one final example. Kurosawa Akira's late film Ran was an extremely eclectically produced work. Relying on French producers, Kurosawa based the narrative on Shakespeare's King Lear, while also changing the setting of the film to Japan during the Warring States period (circa fifteenth or sixteenth century). Nonetheless, as the last master who evoked the "good old days of Japanese cinema," Kurosawa became an object of mass nationalist sentiment. At the same time, many in the film industry did not identify with Kurosawa very much and treated him as an entity now removed from the world of Japanese cinema to which they belonged.

Each of the examples I've cited, from three different eras, makes visible a different face of nationalism that Japanese cinema confronted. Yet, these examples attest to the fact that the concept of Japanese cinema is not something a priori; to maintain its self-identity, it was necessary at every opportunity to affirm its relationship to nationalism before the other (a synonym for Hollywood by and large) of foreign film.

MORE THAN ONE WAVE

In looking back over the history of Japanese cinema, it is clear that there have been peaks of accomplishment at two periods in the past. The first was from the late 1920s through the 1930s; the second was from the 1950s through the first half of the 1960s.

Japanese cinema reached its first peak in the shift from silent cinema to talkies. *Jidaigeki* stars formed independent, competing production companies and brought in young, experimentally minded directors and screenwriters, giving them new opportunities. Independent production companies did not survive the talkie revolution, but once they vanished, those individuals moved to major studios and became active there. The newly formed Tōhō studio, which established itself through the development of sound technologies, joined Shōchiku and Nikkatsu, as the third major studio. Auteurs like Mizoguchi Kenji and Ozu Yasujirō developed their own individual styles. Before the outbreak of the Pacific War in 1941, Japan produced nearly five hundred films annually, second only to Hollywood. Of course, once the importation of Eastman Film from America was cut off, wartime restrictions limited the distribution of raw film stock and the number of films produced dropped sharply. Awash in national policy (*kokusaku eiga*) films, Japanese cinema entered a difficult period.

The second peak began in the 1950s, following the end of the American Occupation, when Nikkatsu started producing films once more. Six major studios mass-produced films to be distributed as full programs, while independent production companies also fought valiantly. The film industry showed astonishing development as the core of mass entertainment. In 1958, viewership exceeded 1 billion, reaching its highest point. The peak of production in terms of numbers of films was only slightly behind, reaching its high point in 1960, and making Japan, along with America, Hong Kong, and India, one of the major film-producing countries. Masters like Kurosawa Akira, Mizoguchi Kenji, and Kinugasa Teinosuke were spotlighted internationally and, as if chronologically synchronized with France, New Wave filmmakers from Shōchiku, Nikkatsu, and Daiei debuted one after another. This feverish period, however, would cool quickly from the mid-1960s. With the influence of television, the number of viewers fell precipitously, and the studio system ceased to function smoothly. Low-budget, fast-production Pink cinema advanced in the cracks, supplementing the drop in major studio output.

Stuck in a fallow period in the 1970s, Japanese cinema would not see any signs of another new wave until the mid-1980s. By that point, the studio system had collapsed and most of the major studios of the past ceased producing, barely surviving by making films with minimal distribution. The studio system was replaced by the rise of independent production. Unique directors with their own idiosyncratic takes on cinema like Kitano Takeshi, Tsukamoto Shinya, and Zeze Takahisa, started making movies without passing through an apprentice stage in the studios as assistant directors. Film planning came to be premised on ancillary markets like video and television following theatrical release. When such directors were showered with praise at international film festivals in the 1990s, it generated the momentum for another rise of Japanese cinema. Of course, the conditions surrounding cinema were entirely different from its earlier peaks. In the 2000s, instead of "films," there was "data" and "content" and production companies yielded to "production committees" for individual projects. We are now in a period in which the question of what form cinema will take in its development is one that does not allow for either optimism or pessimism.

In looking back at 110 years of Japanese cinema, something else becomes clear: the development of film was decisively shaped by the fact that it grew up in the two cities of Tokyo and Kyoto with their contrasting histories and cultures.

The first film shot in Japan had been shot in Tokyo, the more modern city. Kyoto, which had been the capital until thirty years prior, had well preserved Japanese traditional culture in the older parts of town. This made Kyoto perfect for location shooting, especially of *jidaigeki*. So film production came to be divided between two cities. Kyoto specialized mostly in *jidaigeki*, whereas Tokyo focused on *gendaigeki*. In the wake of the Great Kanto Earthquake of 1923, much of Tokyo was leveled. For a few years after the earthquake, Kyoto was the sole center of production, but soon, both cities, while competing with one another, made up the two faces of Japanese cinema, and the characteristics of these two cities was far more important in determining what kinds of films were made there

than studios or directors. In the 1930s, as Shōchiku in Tokyo became popular through its modern-flavored films about ordinary city people (*shōshimin eiga*), putting out star actresses one after another, in Kyoto, Nikkatsu was building up a golden age of *jidaigeki*, with a full roster of charismatic male actors. In the 1950s, in Tokyo, Nikkatsu "stories without national borders (*mukokuseki*)" action films flourished, whereas in Kyoto, Tōei caused a stir with its cheerful *jidaigeki*, and would later shift to making yakuza films (*ninkyō eiga*) with an extremely stylized and formalized aesthetic.

This situation, in which a single national cinema develops through the competition between contrasting styles associated with two cities, is fairly rare in world cinema history. In America, New York film production was not on a scale that could compete with that in Hollywood. Even in prewar China, movies were not made in Beijing, which was the bureaucratic capital, leaving Shanghai as the center of the film industry. Then Hong Kong was little more than a subsidiary site for the production of Cantonese versions of Shanghai films. Rome in Italy and Paris in France were the sole centers of film production in these countries. Japan provides a rare example, and this speaks to its divergent development along two distinct paths—one of cinema as mass entertainment, with nostalgic affirmation of traditional values, and another with a modern, Western-style sense of values.

THE REAPPEARANCE OF FORGOTTEN MEMORIES

We return to the two questions with which this chapter began.

Now in the twenty-first century, it is increasingly difficult and meaningless to try to define strictly what is or is not Japanese cinema. The hybridity that is one of the essential qualities Japanese cinema displays at every opportunity means that any strict category of "Japanese cinema" is likely to be full of exceptions from the start. But even with new developments that spill over any of these

definitions, the particularities of Japanese cinema don't evaporate. And yet, what kinds of changes will Japanese cinema undergo?

One of the most beautiful Japanese films I know, Takamine Gō's *Tsuru Henry* (*Mugen ryūkyū—Tsuru Henrii*, 1998) is a mysterious film in a colorful stew of languages: Japanese, Okinawan, Taiwanese, and English. The youthful protagonist is born as a mixed-race child in Okinawa, and after studying abroad at the University of California, Los Angeles, loses his memory and returns to the island. At this point, the setting shifts to a provisional, small outdoor theater, where the live actions of the protagonist and the projection of the film come to reflect each other. It is a reconstruction of the chain dramas[16] that the director, Takamine, saw when he was a child in Okinawa. These chain dramas have the feeling of something that has completely vanished since they disappeared from the mainland after their boom faded in the 1910s. It is a rare and wonderful thing to see such chain dramas serendipitously resurrected in the form of a film experiment in Okinawa.

The same could be said for the unexpected resurrection of *benshi* performance at the screening of independent films, or the appearance of puppet theater elements in animation. Whether or not these uses of the past are conscious, they can be illuminated by the work of a film historian. In the future, new situations in which locked away cultural memories are suddenly called up and given unexpected meanings within completely new contexts will undoubtedly emerge. At that point, if the latest film can be totally understood by mobilizing the entire history of Japanese cinema, then film historians will have done their job completely.

1

MOTION PICTURES: 1896–1918

THE ARRIVAL OF CINEMA

In 1893, Edison invented the kinetoscope—a machine into which one person at a time can peek to watch moving photomechanical images. Three years later, in November 1896, the kinetoscope first came to Japan and was set up at an inn in Kobe. To give these "dancing photographs" some dignity, the armaments magnate Takahashi Nobuharu even sought out viewers from the imperial family, beginning with Prince Komatsu Akihito. On November 25, it opened to the general public in Kobe. Soon after, it became possible for many viewers to see images at the same time. In February 1897, the first public screening of the Lumière brothers' cinematograph, which had been imported by the industrialist Inabata Katsutarō, took place in Osaka. The form of this screening was the same as that for contemporary cinema. Images were projected from behind viewers in the back of a room against a wall in the front. The screening was accompanied by a cameraman from Paris, who also filmed Kabuki actors in Kyoto and took the footage back with him to France. The first screening of the vitascope—a kinetoscope retooled to project—took place in March

of that year in Tokyo, and the vitascope soon won out. Such new-fangled imported devices quickly became such a hot topic among a Japanese population obsessed with new technologies that by April 1897 an introductory text, *The Technology of Automated Photography* (*Jidō shashinjutsu*), was published in Osaka.

The writer Tanizaki Jun'ichirō, though only a boy of twelve when the first screening took place in Tokyo, would later recall an early film screening at the Kinkikan Theater in Kanda: "It was a whole variety of different things—simple photographs of real things and trick movies, all played in a loop in which the ends of a single roll of film were connected together so that the same footage was projected repeatedly."[1]

That Tanizaki, who was so fascinated by cinema as a boy, would eventually come to be involved with the film industry in the early 1920s when the world of Japanese cinema needed a breath of new life.

What was Japan like in the 1890s, when cinema first appeared? Thirty years had passed since the Meiji Restoration of 1868, and Japan was already showing astonishing strides as a modern state, trying to modernize and Westernize with a policy of trying to separate from the supposed backwardness of Asia. It was an age in which the growth of nationalism following Japan's victory in the Russo-Japanese War occasioned high praise for "things Japanese." It was an age that awoke to the possibilities of culture as a support for the nation-state. There were re-evaluations of Japan's traditions, like Shiga Shigeta-ka's *On Japanese Landscape* (*Nihon fūkeiron*), which was published in 1894. It was also at this time when the concept of "Japanese painting" or *nihonga*,[2] creating new paintings using "traditional" methods and themes, was established out of the shock provoked by the arrival of Western painting. In the world of literature, Ozaki Kōyō dominated, while his pupil, Izumi Kyōka, had just debuted.[3] Kyōka's novels provided the source for many *shinpa* plays, and these works would create the foundations for Japanese film melodrama.

Cinema was imported as the latest technology from the West during this period. Along with the modern novel, it was symbolic of the

most contemporary Western culture. In 1898, footage shot by the Lumière cameraman of Japanese street scenes was publicly screened in Japan. For the first time, Japanese people could see themselves from an outside perspective, objectified in the images of their own country by the gaze of the French cameraman. Cinema would go on to become fully entwined with nationalism in the 1900s. This connection with nationalism, however, was not just a matter of defense and celebration of land and borders—it went to the nature of the gaze itself. This screening marked the moment when Japanese people unconsciously started to learn to regard themselves through the colonialist and imperialist gaze of modernity, a gaze that grasps something different as an object that is labeled "foreign."

It was no coincidence that the birth of Japanese cinema coincided with the colonization of Taiwan. Just as the cameraman from the Lumière Company visited Japan, Japanese people in the first decade of the twentieth century traveled from Taiwan and Thailand to Singapore with camera and projector in hand and made the people of those countries aware of the existence of cinema. The Chinese shot their first movie in Beijing in 1905, Koreans shot their first movie in 1919, and the Taiwanese shot their first movie in 1925. As I will detail in chapter 5, these countries started much later than Japan. This temporal lag in film loosely corresponds to the lag of these countries in modernization based on the Western model.

THE FIRST FOOTAGE SHOT
BY A JAPANESE PERSON

In 1897, Asano Shirō, who was employed at the Konishi camera shop in Tokyo, became the first Japanese to shoot footage. In the following year, 1898, Asano shot two shorts: *Bodhisattva in Disguise* (*Bake jizō*) and *Resurrecting the Dead* (*Shinin no sōsei*). In the latter, as two people are carrying a coffin, the bottom falls out and the corpse drops from it, shocking the dead person back to life. Although crude, the seeds of trick photography were already evident.[4] In 1899, Asano

shot three geisha dancing at a restaurant in Shinbashi. But why geisha? Of course, we can guess that ordinary women might not be eager to be filmed, and at the time, star geisha were popular enough that this could attract viewers and make the film economically viable. Here, however, we must not forget that there was also an internalized Orientalism. At the time, around the world, *Japonisme* was in full flower, and *ukiyo-e* pictures were lionized in Paris. There was international demand for footage of geisha, and when Asano's camera captured the geisha on film, he was appropriating and mimicking the Western gaze. Although Asano was probably unconscious of this problem, many years later, this question of the power relationships inevitably connected with the gaze of the camera would seriously trouble Japanese directors standing on the international stage. How can one represent "things Japanese" using Western technology while avoiding an Orientalist gaze?

At the time, many people were needed to project the footage, and the screening itself invariably took on the feeling of a spectacle. Cinema was often one event within a chain of other kinds of sideshow entertainments (*misemono*) and political performances related to the quest for voting rights and other political movements of the time (*sōshi shibai*).[5] At the beginning of Mizoguchi Kenji's *Water Magician* (*Taki no shiraito*, 1933),[6] a sideshow performance of an attractive woman with a water spectacle is depicted with profound feeling. Even many decades after this stage in cinema history, the unconscious memory of cinema's origins make the scene pulse with powerful emotion.

CONNECTIONS WITH MASS THEATER

The theatrical genre that first actively tried to cultivate a relationship with cinema was *shinpa* ("new wave"). As the name suggests, *shinpa* began as a reform movement within theater in the 1880s in contrast to Kabuki (*kyūha* or "old wave") and rose to the top of modern Meiji society as vernacular melodrama for the masses. It is

difficult to speculate about what *shinpa* was actually like on stage during the Meiji period, especially because *shinpa* today is only a pale shadow of what it once was. But it is probable that in contrast to the sedate melodrama that *shinpa* has become today, it must have been full of energy. It was a new theater, even avant-garde, and for the people in it, it must have been close in spirit to the underground theater of the late 1960s.

One of the film screenings held in Tokyo in March 1897 was at the Kawakami Theater, which had been built in Kanda the previous year. In April, the Seibikan (founded by Ii Yōhō) staged an experiment to incorporate a movie screening among new *shinpa* works, and this was a tremendous success. As part of this trend, the first feature film in Japan, *Shimizu Sadakichi: Pistol Thief* (*Pisutoru gōtō Shimizu Sadakichi*, 1899) was filmed by Komada Kōyō, making use of *shinpa* actors. In it, a detective and a police officer discover a thief hiding behind a tree in the garden of the house and arrest him. The entire film is only one shot, and no more than a single, seventy-foot reel, but when we consider the interwoven relationship between theatrical genres and cinema that followed, its significance is considerable.

When it emerged during the seventeenth century, Kabuki was the ideal theatrical form for representing the worldview of towns-people during the Edo period. But in the modern era, by the end of the nineteenth century, Kabuki had come to take on the feeling of classical texts for the elite. Thus, unlike *shinpa*, Kabuki took a dis-dainful view of cinema and tended to resist cooperation. Because films were shot outside on the ground rather than on the cypress wood stages of Kabuki, Kabuki actors contemptuously referred to films as "mud plays."

The oldest extant Japanese film, *Viewing Scarlet Maple Leaves* (*Momijigari*, 1899), filmed by Shibata Tsunekichi of the Mitsukoshi photography group, emerged from these conditions of Kabuki's contempt for film and ignorance of it. Two hundred feet of film doc-ument two of the most famous Kabuki actors of the time: Ichikawa Danjūrō IX, as a beautiful princess who is actually a demon, and Onoe Kikugorō V as the man who fights the demon. Of course,

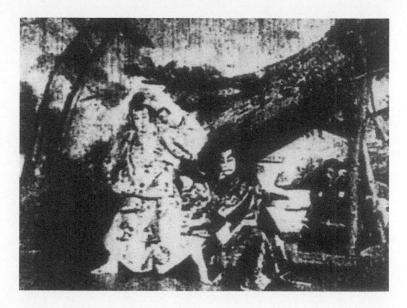

Momijigari (dir. Shibata Tsunekichi, 1899).

neither of the two Kabuki actors understood the meaning of cinema in the slightest. As a result, when Danjūrō accidentally dropped his fan, it apparently never occurred to anyone to reshoot the scene, something unthinkable today.[7] Incidentally, at this point, Noh theater, which represented the worldview of the samurai class, had no exchange with cinema at all.

ISSUES OF NATIONALISM

In 1903, Yoshizawa Shōten, a company in Asakusa, built the first theater dedicated exclusively to cinema. Asakusa is a *shitamachi* neighborhood of Tokyo that was home to the theater district in the late Edo period. In the modern period, the area was filled with movie theaters and other entertainment places that have continued to operate until quite recently. Asakusa is a place of continuity with

Promotional flyer for Asakusa Entertainment Hall (1910s).

the entertainment world of the Edo period and was also central to the creation of Japan's modern popular culture.

Throughout the twentieth century, many of Japan's representative comedians have come out of Asakusa, from Enomoto Ken'ichi, "Enoken," the superstar musical comedian of the early twentieth century to Hagimoto Kin'ichi, who presented sketch comedy on television in the 1970s and 1980s. The last of these is Kitano Takeshi, who was a comic performer under his stage name of "Beat Takeshi" before he was a film director.

In 1904, with the rise of the Russo-Japanese War, the Yoshizawa Shōten studio went to the battlefields on the Asian continent, shooting war footage and then bringing it back to Japan where such screenings were enormously popular. Although the techniques were crude, the films used trick photography, tracking shots, and even restaging events on site and presenting them as documentary footage. What is fascinating about these wartime documentaries is that,

along with the footage shot of Lieutenant Shirase's Antarctic expedition, cinema ceased to be merely the latest sideshow entertainment and instead took on a more serious role as a medium for representing society in a way that promoted the ideology of nationalism. Incidentally, at this time the Chinese novelist Lu Xun was going to medical school in Sendai and would later recall his profound shock when he saw news films showing Japanese soldiers beheading his compatriots.[8] Furthermore, it is no coincidence that it was in the same year that the cultural polemicist Okakura Kakuzō (Tenshin) published *The Awakening of Japan* (*Nihon no kakusei*), using Japan as a basis for his theory of civilization. Cinema had finally shown its true colors as a cultural apparatus in service to the nation-state.

MAKINO SHŌZŌ: THE FIRST DIRECTOR

To this point, what I have written has centered on Tokyo, but let's look at what was happening in Kyoto, which, along with Shanghai and Manila, later became an anchor of East Asian film in the interwar period.

Unlike Tokyo, Kyoto did not undergo rapid urban changes of modernization. Blessed with an abundance of shrines and temples, Kyoto was like Rome and possessed ideal conditions for filming *jidaigeki* outdoors. It was there in 1908 that Makino Shōzō (1878–1929) shot his first major work, *Battle at the Honnōji Temple* (*Honnōji kassen*), about the final battle of the warlord Oda Nobunaga for the Yokota Shōkai Company. Setting the narrative in Kyoto was to have a decisive influence on the subsequent direction of Japanese cinema.

Makino is the first person in Japan who could be called a real film director. Coming from a family that owned a small *ningyō jōruri* puppet theater and as the stage manager of that theater, Makino was backed by a long, continuous tradition throughout the Edo period of popular theater in Kansai that was heavily based on the *jōruri* repertory. The legend is that Makino never used a script while shooting. Because the director and the actors knew the stories of the *jōruri*

Chūshingura (dir. Makino Shōzō, 1910).

tales that were the source material of his works so thoroughly, Makino was able to direct the scenes just by giving his actors their lines verbally. When Makino discovered Onoe Matsunosuke and put him on screen, Japan's first star was born. Known as "Eyeballs Matsu" (*Medama no Matchan*) because of his strikingly large eyes, Matsunosuke starred in more than one thousand films in a seventeen-year period.

In 1910, Makino shot *Chūshingura*, an eighty-minute feature-length film with Matsunosuke. Based on an actual historical event, *Chūshingura* is a tale of revenge among the samurai class at the beginning of the eighteenth century. Originally written for the puppet theater and soon adapted to Kabuki and inspiring all kinds of related tales, it is an epic poem that has retained its popular appeal even into the twenty-first century.[9] Even among the more than eighty versions of *Chūshingura* (130 if we include spinoffs), Makino's film could be called the most monumental version in the early days of cinema. We can still get a good sense of what the film must have

been like, although in the print we have today missing scenes have been supplemented with later footage from a different version of *Chūshingura* made by Makino. Filmed entirely in medium shot, each shot lasts one or two minutes on average, giving the impression that the film is an extension of the Kabuki stage. At the time, no clear boundary existed between the actors and the roles they played, and it did not seem to bother Matsunosuke that he was playing three major roles, including that of the main protagonist and the enemy. When Ōishi Kuranosuke is leaving Akō Castle, he never breaks his frozen posture. As I will explain, this use of an empty screen would allow room for the *benshi*, so he could fully exploit his rhetorical skills. In his later years, Makino gave himself the name Griffiths Makino, from the director of *Intolerance* (1916), D. W. Griffith, taking the name as a badge of honor.

Nonetheless, cinema continued to occupy a low position within society. In his autobiography, Makino Shōzō's son, Makino Masahiro, writes about his frustration in being treated with contempt by his elementary school peers as a "riverside beggar."[10] It was also not unusual to have local yakuza mixed in with the film industry. Japanese cinema and gangster morality have lived together inseparably.[11] Cinema has been protected (or exploited) by yakuza and profited by it, and in turn, real yakuza modeled their lives on the image of yakuza in the movies. Yakuza were part of everyday life for Makino from his childhood days. Furthermore, Nagata Masaichi, the producer who gave the world Mizoguchi Kenji, was a young member of the Senbon yakuza clan with an interest in socialism. It is true that cinema was initially brought to Japan with the imperial family in attendance; however, it never became a pastime of the elite classes and has long maintained its position as entertainment for the masses, centered on children and laborers.

It was primarily the affluent who watched imported films from the West, but those who watched Japanese films were the lower classes. This relationship of class identity and film in Japan would be ripe for analysis by the sociologist of culture, Pierre Bourdieu.

THE ESTABLISHMENT OF NIKKATSU

The Emperor Meiji, nicknamed "The Great," died in 1912. Unlike European royalty and heads of state, he held a unique philosophy about the reproducibility of photographic imagery and refused to allow his photographic likeness to appear on films, currency, or stamps. But at the end of the 1950s, this man, who did not want unauthorized use of his name, was the subject of a film by the Shin Tōhō studio, where he was played by *jidaigeki* star Arashi Kanjūrō. The film was a phenomenal success.[12]

Also in 1912, four small film companies combined to form a trust and launched the Japanese Motion Picture Corporation (*Nihon katsudō shashin kabushiki gaisha* or Nikkatsu for short). No longer based on the conventional cottage industry mode of production, it was the first authentic film studio in Japan. This was the same period in which the companies that became Twentieth Century Fox and Warner Brothers were established. Nikkatsu constructed its studios in the Mukōjima area of Tokyo and in Kyoto under the western turret of Nijō Castle. In Tokyo, they produced what they called *shinpa*, and in Kyoto, they produced what they called *kyūgeki*. The cinematic opposition between Tokyo and Kyoto that would continue for the next fifty years begins here. *Shinpa* came to be called *gendaigeki* ("contemporary pieces"), and *kyūgeki* came to be called *jidaigeki* ("period pieces").

Of course, until the mid-1910s, both types of films were still derivative of theater; neither had yet created a distinctly cinematic space.

Nikkatsu's *shinpa* films were tearjerkers: melodramas about the separation of mother and child, or love between different classes, or the fall of a young woman who loses her virginity. Some films among them seemed to anticipate Henry King's 1925 *Stella Dallas*. Hosoyama Kiyomatsu's *Kachūsha* (1914) was an adaptation of Tolstoy's *Resurrection* (1899), but it was turned into an absurd narrative by adding a sequel in which the protagonist, a young aristocrat,

visits the Sengaku Temple in Edo and becomes friendly with Ōishi Kuranosuke, the leader of the forty-seven *rōnin* in the famous *Chūshingura* story.[13]

Needless to say, no one was conscious of the distinction between shot and scene in such films, except when trying to hide the immaturity of a performance. In film, actresses simply did not exist yet. They were replaced by female impersonators—*onnagata*—a tradition carried over from Kabuki and *shinpa*. Hybrids of theater and film called "chain dramas" (*rensageki*) featured *shinpa* troupes that performed the indoor scenes live on stage, while the outdoor scenes were shown on film. This trend was wildly popular. Thus, at this point, film could be thought of only as a supplement to theater.

THE SIGNIFICANCE OF *BENSHI*

In bringing this chapter to a close, I must discuss the characteristic that most distinguishes Japanese cinema from other cinemas (at least for its first thirty-five years): the existence of *benshi*, or professional explainers.

Records indicating the existence of explainers appear as early as 1886, when magic lanterns showing slides were popular in Japan. Therefore, at the point when cinema first appeared, audiences were already accustomed to the existence of *benshi* and did not see them as anything unusual or strange. *Benshi* would, for example, dress in frock coats and silk hats, like consummate Westerners, and explain the moral significance of the film before the screening with solemn authority. During the middle of these screenings, their voices rose up in the darkness, filling blank spaces with the art of *kowairo* (imitating the voices of famous actors) guiding the audience with rhetorical flourish.

In the West, the so-called period of early cinema ended by the middle of the 1900s, and when cinema began offering real narratives, lecturers were provisionally placed in theaters to assist viewers confused by movies with more complicated stories than

they had been accustomed. That arrangement, however, disappeared after a few years. Live music had always been performed together with *benshi*, but when the Western *benshi* disappeared, musical accompaniment continued, even in the absence of a performers specializing in vocal and narrative arts who belonged exclusively to certain theaters.

But in Japan, not only did *benshi* relay the narrative of a given film, they were performers in their own right, shaping and even changing the story to suit their talents. The length of a film showing might differ greatly depending on the *benshi's* narration, and standing at a meta-level, *benshi* were able to provide critical commentary on the narratives of the films for viewers. Especially in the most extreme cases, depending on the skill and the conception of the film held by the *benshi*, the viewer's film experience might be completely different. Audiences often went to movies not because they wanted to see a specific director or actor, but rather to see the performance of a particular *benshi*. As a result, especially popular *benshi* could even influence the shape of a film at the stage of production, making requests so that the movie could be best suited to their narrative. For such *benshi*, films were but raw materials for their own performances.

For a *benshi*, the stronger and more effective his performance, the better. This often meant getting a reaction with highly provocative rhetoric. In Korea, which was then a colony, there were cases in which *benshi* suddenly began to speak in Korean, inciting audiences by evoking nationalist sentiment. To prevent such "deviance," the rhetoric of *benshi* came to be regulated by the state, which imposed a licensing system.

Among Japanese film critics, some have given the mistaken explanation that *benshi* developed in Japan alone because audiences were ignorant of Western customs. The real reason is that Japanese people received cinema as a Western import and unconsciously regarded it within the context of Japanese theater. In Japanese theater, there is no necessity for a character to appear as a unified subject of visible body and audible voice. When we look at the chanting by the *jiutai* chorus in Noh, or *gidayū* chanting in Kabuki, or *jōruri* chanting in puppet theater, it was completely common for the body of a character to

appear in one place, while the voice was handled by someone else in another place. To understand this process, we undoubtedly need to consider such sophisticated monolog vocal performances as *rakugo* or *kōdan* or the oratorio tradition of multiple voices in the folk song tradition of *Kawachi ondo*. [14] It was within such a cultural context that *benshi* were brought to cinema as "voices from the outside." Consequently, viewers were able to enjoy cinema as an extension of popular theater. Other viewers the world over believed in cinema as a largely visual medium, but the Japanese alone experienced it as the completely natural mixing of sight and sound.

Film journalism was established in the 1910s, and it is easy to imagine the reasons that those critics who argued for a pure essence of film would criticize the *benshi*. One major reason for this criticism is that it would be impossible to determine a unified meaning for a film if any improvised explanation could be added to it, and the experience of the film would change depending on the *benshi* and other circumstances of each showing. Although critics took exception to *benshi*, the *benshi* were overwhelmingly supported by the masses. In the 1930s, when talkies began to spread, the figure of the *benshi* disappeared, quickly relegated to the status of anachronism.

Even after the passing of the *benshi*, we can discover their traces all over contemporary Japanese cinema. The long shot frequently taken as a particular characteristic of Japanese cinema or the preference for long takes were prepared specifically to provide extended breaks for *benshi*'s narration, and the distinct conclusions provided by a sentimental narrator also could be a trace of the *benshi*'s art. It is undeniable that some complex cinematic techniques were delayed on account of the *benshi*. However, to state this only as a criticism is fundamentally based on the premise that Hollywood is the only standard. What we should also say is that precisely because of the existence of the *benshi*, it was possible for Japan to develop its own narrative techniques without surrendering unconditionally to American cultural imperialism. No matter which of these views we take, it is impossible to grasp the foundations of Japanese cinema without addressing the place of the *benshi*.

2

THE RISE OF SILENT FILM: 1917–1930

THE PURE FILM MOVEMENT

From 1900 through the 1910s, most films reproduced only theatrical space on screen. Nonetheless, there were efforts to increase the vocabulary of filmmaking.

In the late 1900s, intertitles already were incorporated to explain the contents of each scene, and in *A New Version of the Cuckoo* (*Shin hototogisu*, 1909), a film version of a literary and *shinpa* classic, flashbacks, although crude, were used when the heroine recounts her life story after she is rescued from leaping to her death. As far as we can determine based on current research, the earliest efforts to divide scenes into multiple shots took place in 1909 at Yokota Shōkai. Techniques such as close-ups, tracking shots, and crosscutting were introduced by director Inoue Masao around 1917, with *The Captain's Daughter* (*Taii no musume*). But despite these innovations, the idea that the only reason to divide a scene was to compensate for inexperienced actors remained deeply rooted, and making a scene out of several different shots, which we usually think of as a basic and fundamental technique of classical Hollywood filmmaking, had yet to

become universal. The consciousness of enlivening narrative action through montage had yet to take root.

The Pure Film Movement (*jun eiga geki undō*) began in 1918 and the changes it brought were much more profound than these minor technical innovations. The movement was literally a reorganization of the epistemological paradigm of cinema. For this movement, cinema was a text exposed before the gazes of an anonymous audience, a text that did not change with a particular performance or audience. Intellectuals had already abandoned the term *katsudō shashin* (moving pictures) and had come to select *eiga* (cinema), which had higher cultural connotations. *Eiga* had been used to indicate magic lanterns before the cinematograph was imported. Consequently, in 1896, to distinguish movies from this earlier definition, such terms as "automatic lantern," "dancing photographs," and "moving pictures" were used; however, eventually such distinctions came to be unnecessary. The shift from "moving pictures" and similar terms to "cinema" announced the fact that film had come to be recognized as a medium completely distinct from all other electric spectacles, panoramas, and so forth. Of course, for this word to filter into mass consciousness, it would have to wait until the furor over the Pure Film Movement subsided, around 1922.

THE BIRTH OF FILM JOURNALISM

Before taking up this movement itself, I will discuss briefly the birth of film journalism and criticism where the movement originated.

The first film journal, *Motion Picture World* (*Katsudō shashinkai*), was published by the Yoshizawa Shōten Company in 1909. The journal initially focused on novelizations of films produced by Yoshizawa Shōten itself, to make them easier to understand. Beginning the following year, however, there appeared guides by critics on methods of classifying films and ways to write about film. In the 1910s, a flood of coterie journals was born, springing largely from college students. In 1919, *Kinema Junpō* was launched as a coterie

journal started by a small circle of friends. It would go on to be *the* representative film journal of Japan, with its top-ten lists, in particular, considered authoritative for many years. The majority of these coterie journals praised Western films while mercilessly castigating Japanese films for lacking the essence of cinema. It was out of these debates in coterie journals that the leader of the Pure Film Movement, Kaeriyama Norimasa (1893–1964), would emerge.

Kaeriyama wrote a theoretical treatise in 1917 called "The Production and Photography of Motion Picture Drama" (*Katsudō shashin geki no sōsaku to satsueihō*), in which he insisted that cinema must not imitate vulgar theater, but rather, find its own cinematic essence, purify it, and make it visible. He called for replacing scripts from stage plays with scripts written especially for film, using actresses instead of *onnagata* and getting rid of the *benshi* in favor of intertitles. He considered speed and realism—as well as illusion—indispensable to true cinema.

Based on his theories, he directed two films in 1918 at Tenkatsu Studios (*Tennenshoku katsudō shashin*): *The Glow of Life* (*Sei no kagayaki*) and *Maiden of the Mountains* (*Miyama no otome*). The former concerns a virginal girl at a coastal resort who is seduced by an aristocratic boy and then abandoned; after this, however, the girl gets happily married and refuses the aristocratic boy's effort to seduce her once more. In the latter, the young woman of the mountains, beset by misfortune, meets up with an explorer and presses upon him the significance of the sacred mountain, defusing his passion for the acquisition of gold. The director, by inserting intertitles in both Japanese and French, obviously had international distribution in mind. Rather than using *shinpa* players, as would be conventional, Kaeriyama made use of *shingeki* players. Diametrically opposed to *shinpa*, *shingeki* was a genre of theater that arose from the influence of modern Western theater, focused largely on the works of Chekhov, Gorky, and Ibsen, and for a predominantly intellectual audience.[1] Through the participation of *shingeki* actors, cinema began to be liberated from its *shinpa* roots, and one of the aims of this production was to elevate the standing of cinema by presenting it before a

higher social class. In addition, Kaeriyama supposedly shot the first female nude scene in Japan in his film, *The Phantom Woman* (*Gen'ei no onna*). However, this film is lost, so unfortunately, this story cannot be confirmed.

THE ARRIVAL OF ACTRESSES

Kaeriyama's plans caused quite a stir in the film industry. Around the end of the First World War, Hollywood studios began to establish branches little by little in Tokyo, and screenings of American films started to proliferate. In particular, Griffith's *Intolerance* (1916) came as an enormous shock to young Japanese cineastes. In the 1920s, German expressionist film out of *Universum Film-Aktien Gesellschaft* (UFA) appeared, followed by French avant-garde films. Within this

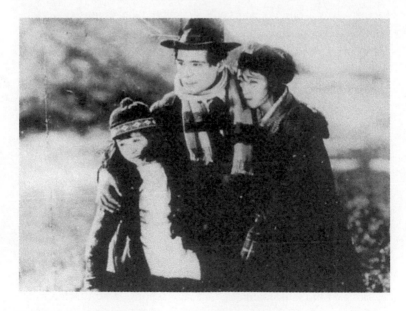

Souls on the Road (dir. Murata Minoru, 1921).

environment, new studios emerged, including Kokkatsu (an abbreviation of *Kokusai katsuei*) in 1919; in 1920, Taikatsu (an abbreviation of *Taisho katsuei*) appeared, and Shōchiku, which previously had been involved only in the production of Kabuki plays, established a studio at Kamata, in Tokyo, and began producing films.

Shōchiku built an actor's training school, entrusting it to Osanai Kaoru,[2] a strong advocate of the *shingeki* movement. Actresses emerged from Shōchiku one after another. But in fact, women were on screen before this. In the 1900s, for example, women appeared in film adaptations of women's theater, and in the 1910s, female *shinpa* roles were played by women in *rensageki*. But the actresses for Shōchiku were decidedly different from both. At Shōchiku, a star system was established modeled on Hollywood, and actresses were produced based on modern Western theatrical training. *Souls on the Road* (*Rojō no reikon*, 1921), directed by Murata Minoru under the guidance of Osanai Kaoru, is a morality play about Christian philanthropy that begins with a quote from Gorky in Russian. Set in Karuizawa, which was a resort town developed by Westerners at the time, the narrative revolves around a bourgeois daughter who invites two vagabonds into her home to celebrate Christmas. This primary narrative incorporates a subplot about conflict and reconciliation between a father and his artist son who live next door to each other. This theme resonated strongly with contemporary literature, particularly that of the *Shirakaba* school, a literary movement heavily influenced by Western ideas of idealism and humanism. Murata freely made use of all manner of cinematic techniques, including crosscutting. Overall the impression the work gives is highly confusing, but the main actress Hanabusa Yuriko became famous. The cheerful cuteness of Kurishima Sumiko, who was featured in the contemporary film *Poppies* (*Gubijinsō*, 1921), based on Natsume Sōseki's novel, endeared her to audiences of the new generation, who were fed up with the stylized femininity of *shinpa onnagata*. Kurishima would go on to become the first female star of Japanese cinema.

Tanizaki Jun'ichirō, who had already secured a reputation as an up-and-coming modernist writer, was profoundly curious about film

production. As a literary consultant for Taikatsu, he had Thomas Kurihara, recently returned from Hollywood, direct *Amateur Club* (1920), from his own script. The film was a slapstick comedy, featuring young boys and set in the South Seas, but one can detect its parodic intent when they do a mock-Kabuki scene, playing up the idea of Japan as the object of the Hollywood gaze. The film was the first to be shot with rigorous use of découpage,[3] while as a beauty in a swimsuit, its star actress Hayama Michiko was a sensation.

Hayama Michiko in Thomas Kurihara's *Amateur Club* (1920s).

The experiments of the new generation of Kaeriyama, Osanai, and Tanizaki were all disappointing failures at the box office. The majority of Japanese viewers continued to prefer to cry at *shinpa* melodramas, moved by the vocal gymnastics of the *benshi*. Kaeriyama retired from filmmaking in 1924. At Shōchiku, the actor's training school folded, and the studio quickly returned to making *shinpa* films, with Nomura Hōtei making maternal melodramas into box office smashes. Tanizaki and Kurihara turned away from Hollywood imitations and were drawn to reviving the world of Japanese pathos, drawing on the works of Izumi Kyōka and the Edo-period writer Ueda Akinari.[4] It would be a mistake, however, to see this turn as simply an imitation of Hollywood form that collapsed on account of an intense Japanese tendency toward cultural exclusivity. Western culture, for Japanese intellectuals, was something like what Freud identified as a superego, and the complaints of film critics stopped in pointing out how these films were not American enough. Meanwhile, the public flocked to a flood of Hollywood films, becoming intimate with its cinematic techniques for a time. The Pure Film Movement ended in 1923, in part, because of the Great Kantō Earthquake (関東大地震) of that year that leveled Tokyo. Film studios had no choice but to relocate to Kyoto temporarily, which is to say, to move to the center of *kyūgeki*. There, in Kyoto, it was not possible for the winds of the avant-garde and modernism to blow as they did in Tokyo.

Even while acknowledging this string of defeats, it is impossible to dismiss the significance of this movement within Japanese cinema. First, the position of the director was established. In addition, it became impossible to rely on *onnagata* any longer, and their disappearance allowed for the birth of actresses and the star system. With more realism demanded, instead of *shinpa* and *kyūgeki*, cinema shifted toward *gendaigeki* and *jidaigeki*. Second, film censorship also became strictly regulated. Among other things, this regulation attests to the fact that state authorities no longer saw cinema as merely spectacle or on the same level as theater; instead, they recognized it as a larger medium, with the possibility of influencing large groups of people.

THE SELF-CONSCIOUSNESS
OF JAPANESE CINEMA

As noted at the beginning of this chapter, during the Pure Film Movement, motion pictures (*katsudō shashin*) became cinema (*eiga*). That Kaeriyama gave the name "film play" (*eiga geki*) to the movement marks this transitional moment. At this time, discourses about cinema produced major changes. The film historian Aaron Gerow argues that it was during this movement that a discourse of "Japanese cinema," rather than simply cinema, first became possible.[5] Film critics at the time earnestly debated the differences between true Japanese cinema and a cinema made in Japan that lacked value, consigning *kyūgeki, shinpa, rensageki*, and *benshi* to the latter, and announcing a sharp break with them. True Japanese cinema not only must be pure as cinema but also must represent, in transparent form, the true Japan. To be understood by foreigners (i.e., Westerners) and be exported abroad were the barometers of this orientation.

It is said that Kaeriyama made *A Story of White Chrysanthemums* (*Shiragiku monogatari*, 1920) at Italy's request, but this is unclear. The Pure Film Movement, needless to say, contained contradictions. In this film, we see this contradiction as the members of the movement initially evaded a Japanese setting, placing the story in a summer resort and then tried to depend on Western cultural trends, such as *shingeki* and Christianity. Unresolved, these questions of what constitutes "Japanese-ness" and "cinema" continued to be pressing issues for Kurosawa Akira and Mizoguchi Kenji in the 1950s and extend up to the present moment.

The desire for the export of Japanese cinema abroad led to an oddly warped consciousness surrounding those Japanese people who had traveled to Hollywood during the 1910s. For example, in Cecil B. DeMille's *The Cheat* (1915), Hayakawa Sessue performed with an expressionless style peculiar to Kabuki, one that appeared eccentric in the context of the actors around him. Within the world

of silent cinema, which was full of frantic and meaningless move-
ment, Hayakawa's expressionless performance seemed to epitomize
the figure of the mysterious and inscrutable Asian. At a time when
a firestorm against Japanese immigrants was raging in America, the
existence of Hayakawa, with his dangerous black hair, his good looks,
and forceful seduction of a white woman, was unique. In Japan, how-
ever, *The Cheat* was judged as an insult to Japan, and to this day, it
never has been released officially in Japan. Sessue was forced into a
strange, double position in his native land. On one hand, he was crit-
icized for presenting a warped view of the real Japan; on the other
hand, he was praised for achieving success in a revered place like
America. Kamiyama Sōjin, who went to Hollywood just after, never
played a Japanese person there because of Hayakawa's precedent.
Instead, Kamiyama specialized in playing bizarre Arabs or Chinese
people, whereas ironically, the roles of Japanese people would come
to be played largely by Chinese actors.

SHŌCHIKU'S *SHŌSHIMIN* FILMS

After the commotion from the Pure Film Movement died down, all
of the film studios seemed to return to the older conventions of
shinpa and *onnagata*. Gradually, however, as the seeds of the move-
ment came to bear fruit, steady changes in style became apparent.
Under the direction of the young producer Kido Shirō, Shōchiku
started to move in the direction of making bright, cheerful cosmo-
politan films. What they sought was the depiction of the everyday
lives and human emotions of college students or businessmen as
something utterly relatable, rather than the lives of the beautiful
elite, as with *shinpa*. These Shōchiku *gendaigeki* truly emerged in
1926. Ushihara Kiyohiko shot healthy youth films like *He and Tokyo*
(*Kare to Tokyo*, 1928) and sport films like *King of the Land* (*Riku no ōja*,
1928), both featuring actress Yagumo Emiko. Gosho Heinosuke shot
Bride of the Village (*Mura no hanayome*, 1928) and *Dancing Girl of Izu*
(*Izu no odoriko*, 1933) starring Tanaka Kinuyo based on the Kawabata

novel, but these films were set in the countryside and had a lyrical style. Saitō Torajirō specialized in slapstick: *Kid Commotion* (*Koda-kara sōdō*, 1935) was laced with gags that approached black humor. Of course, these *gendaigeki* assembled actors with their distinct performance styles, such as Ryū Chishū, Sakamoto Takeshi, Saitō Tat-suo, and Iida Chōko, but these actors were not marquee stars like those who appeared in *jidaigeki*.

The light, cheerful mood evident in Shōchiku's *gendaigeki* was changing gradually, coming to depict the modest joys of humble city dwellers of *shōshimin*. The person who most represents this trend was Ozu Yasujirō (1903–1963). Ozu began by making nonsense comedies, strongly influenced by Lubitsch and Vidor, and he initially was derided as "reeking of butter" (overly Westernized). He slowly changed his themes and style, preferring to focus on the sense of resignation and worldviews of life among college students and businessmen as well as common people in ordinary neighborhoods. Typical examples include *I Flunked, But* (*Rakudai wa shita keredo*, 1930) and *I Was Born, But* (*Umarete wa mita keredo*, 1932). From the low-angle shots and the fixed camera setup, to the uncanny repetition of the characters' actions, the impulse toward formalism in Ozu's films is strongly visible. By the 1950s, the rigor of his style had been perfected, and he was hailed as a master.

REFORMS AT NIKKATSU

At Nikkatsu, modernization lagged a step behind that of Shōchiku. Around 1923, at its Mukōjima studio, *onnagata* still existed, but eventually they were abolished and actresses were accepted. The actresses who gathered at Nikkatsu included the glamorous Sakai Yoneko; the loud, passionate Okada Yoshiko; the pure, sweet Natsu-kawa Shizue; and the elegant, but strongly spirited Irie Takako. The Nikkatsu contemporary-film division at Mukōjima collapsed in the Great Kantō Earthquake, and they were forced to move the studio to Kyoto. Murata Minoru, who had been at Shōchiku previously,

transferred to Nikkatsu, where he made films such as *Seisaku's Wife* (*Seisaku no tsuma*, 1924) and *Ashes* (*Kaijin*, 1929). Such films depict the ways that lingering customs and community consciousness in rural families oppress individuals to an inhuman degree. Jack Abe Yutaka, who had returned from Hollywood, successfully combined speedy direction with sophisticated themes in *The Woman Who Touched the Leg* (*Ashi ni sawatta onna*, 1926).

The most important director of contemporary films at Nikkatsu was Mizoguchi Kenji (1898–1956). Mizoguchi mastered Hollywood techniques, directing *Foggy Harbor* (*Kiri no minato*, 1923) without intertitles, as if carrying on the legacy of the Pure Film Movement. Set in a harbor town and taking the absurdity of fate as its theme, it is the story of a young, well-intentioned sailor who believes he has accidentally committed a murder. Just before that, Mizoguchi had adapted an E. T. A. Hoffman mystery novel and set it in Shanghai with a film called *Blood and Spirit* (*Chi to rei*, 1923). The set decoration was based largely on German expressionism, but the film, while full of good ideas, was poorly executed. Mizoguchi had a strong passion for learning and worked across multiple genres with varied techniques; in the 1920s, however, the long-take technique for which he would later be internationally recognized was not yet established, and in this period, each shot was in fact quite short. Scoring a hit with his depiction of working-class emotions in *Passions of a Woman Teacher* (*Kyōren no onna shishō*, 1926), he gradually came to turn toward Izumi Kyōka's world of *shinpa*, bringing to it a *gendaigeki* aesthetic.

KINUGASA TEINOSUKE THRIVES

Kinugasa Teinosuke (1896–1982) was originally an actor as an *onnagata* at Nikkatsu's Mukōjima studio, but he freelanced as a result of systemic changes in the industry and came to flourish as a director. In *Nichirin* (1925), he told the story of Himiko, a queen during the time of Japan's ancient regime, making use of the Kabuki actor Ichikawa Ennosuke II. By featuring Himiko, a figure not in the official

imperial chronicles, this was a challenge to the then-dominant emperor system. The film opened temporarily, but then screenings were canceled. When it finally opened, large parts of the film were cut, and it ended up a box office failure.

After this, Kinugasa started up an independent production company, teaming up with Kawabata Yasunari to direct *A Page of Madness* (*Kurutta ippeiji*, 1926). The film tells the story of an aged sailor who has abused his wife to the point of madness. He comes to work as a custodian in the mental hospital where she is held, as a way of atoning for his crimes. Their only daughter is distressed that her lover might find out that her mother is insane. The confused mental state of the mentally ill is repeatedly depicted from their point of view. Kinugasa directed this narrative, which at first glance appears like *shinpa*, by making striking use of techniques like chiaroscuro, successions of quick cuts, overlap, and bizarre clothes and settings. Although Mizoguchi's attempts with modernism had mixed results,

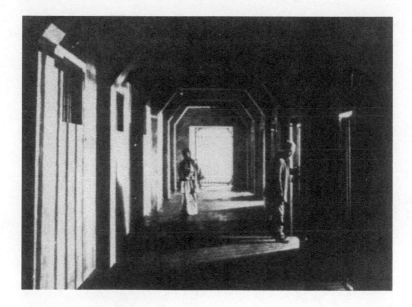

A Page of Madness (dir. Kinugasa Teinosuke, 1926).

the approach taken by Kinugasa and Kawabata to German expressionism's glorification of madness and the grotesque proved quite accomplished. That said, common viewers were unable to follow the narrative, and so ironically, they were compelled to rely on the explanations of the benshi that the Pure Film Movement had worked so hard to banish. Once they did so, however, the film could be understood.

We could call A Page of Madness the first authentically avant-garde film made in Japan. Kinugasa followed up this work with Crossways (Jūjiro, 1928), which successfully made use once more of a chain of optical images and warped stage settings through a spinning spherical object. With this experiment, he once more placed vertigo and mental confusion on film. He took the film with him for the next two years through the Soviet Union and Germany. Crossways opened in theaters throughout Europe to high praise. Upon returning, Kinugasa was active as a director of bewitching jidaigeki in the 1930s. Hasegawa Kazuo (whose original acting name was Hayashi Chōjirō) became extremely popular, starring in such Kinugasa jidaigeki as The Revenge of Yukinojō (Yukinojō henge, 1935) and Snake Princess (Hebi hime-sama, 1940), deftly playing both an onnagata star and a handsome male character. As is well known, in the postwar period, Kinugasa's Gate of Hell (Jigokumon, 1953) would take the Grand Prix at the Cannes Film Festival. After that, Kinugasa devoted himself to adapting Izumi Kyōka's melodramatic novels for film. International distribution was one of the goals of the Pure Film Movement and directors like Mizoguchi and Kinugasa who were members of the next generation achieved the goals of the movement. The personal goals of these directors, however, were set much higher.

CONSTRUCTING JIDAIGEKI

At this point, let us take up the trends of jidaigeki in the 1920s.

By the time he appeared in his landmark one thousandth film, Araki Mataemon, for Nikkatsu studios in 1925, Onoe Matsunosuke

had maintained his popularity over many years. Throughout that time, however, little by little, changes were rippling beneath the smooth surface of the mega-genre. If the source for *jidaigeki* had switched at one point from Kabuki to *kōdan*, in turn, in the mid-1920s, *kōdan* also yielded to mass literature. This occasioned a switch in *jidaigeki*, from films as frivolous forms of entertainment for children to films as complex, realistic works worthy of appreciation by adults. The popularity of the conventional sword-fighting style of Matsunosuke, in which he would leisurely cut down his enemies while striking impressive poses, was waning, and viewers came to seek out speedier, more realistic, and more intense sword-fighting styles. Makino Films, which had split from Nikkatsu under the direction of Makino Shōzō, gathered together many directors, writers, and actors to meet this demand. Sandwiched between the big studios, Makino Films was able to produce and distribute films freely as an independent production company between 1923 and 1932. It would be difficult to overstate the significance of this company. It was there that a quite literally radical renovation in *jidaigeki* took place, giving birth to many stars. These stars followed in the footsteps of Makino, establishing independent production companies in the 1920s and producing films according to their tastes and preferences. Fully half of Kyoto's shining achievements as one of the crown film cities of Asia could ultimately be attributed to Makino.

Among the actors who gathered at Makino Films, the first to gain popularity for displaying a new type of sword-fighting style was Bandō Tsumasaburō, popularly known as "Bantsuma." His expression was brutish while at the same time, vibrant, and without a trace of modern melancholy; in particular, he brought a matchless intensity to his portrayal of outlaws, full of despair and expelled to the margins of society. In Futagawa Buntarō's *Orochi* (1925),[6] he conveyed with extraordinary power the almost masochistic nihilism of a *rōnin* who sinks to the bottom of society, betrayed by everyone around him. The last swordfight of the film, stretching over ten minutes, remains astonishing even today.

Even Bantsuma was not unique, however, and many other powerful actors are famous for the characters they played in series. Ōkōchi Denjirō, his visage animated by a mixture of rage and dignity, achieved popularity with his portrayal of *Tange Sazen*, in which his gestures at times verged on the grotesque. Ichikawa Utaemon played *The Idle Vassal* (*Hatamoto taikutsu otoko*) in a large-hearted, joyful manner; Arashi Kanjūrō (known as "Arakan") played the Robin Hood-like figure of *Kurama Tengu* and the Edo-period detective of Umon in *Umon Torimonochō* with affection and a blank, Keatonesque expression. Tsukigata Ryūnosuke had a sharp gaze, while Kataoka Chiezō's performances were laced with his humorous and cheerful demeanor. All these actors lent their trademark characters originality and opened up numerous narrative and staging possibilities in *jidaigeki*.[7] Although characters gave voice to anarchism or nihilism, these films were never subject to the kinds of oppressive censorship *gendaigeki* suffered; as a result, various social critiques could be expressed even as they were hidden away in its shadows. Of course, *bakumatsu mono*—films set during the final decades of the Edo period, often extolling devotion to the emperor—were also produced in abundance. One new genre that emerged at the end of the 1920s was *mata tabi mono*, that is, films based on Hasegawa Shin's[8] stories of wandering gamblers. Tsuji Kichirō's *Kutsukake Tokijirō* (1929) and Inagaki Hiroshi's *In Search of Mother* (*Mabuta no haha*, 1932) are two representative films of these Hasegawa Shin stories. The protagonists of the films were lonely yakuza, exhausted by their struggles against authority in cities, who chose a path of wandering. By adhering to nihilism as darkness was spreading in the political sphere, *matatabi mono* deftly loosened itself from the spellbinding thrall of national community.

Two noteworthy directors of *jidaigeki* during this period, Itō Daisuke (1898–1981) and Makino Masahiro (1908–1993), deserve particular attention. Itō was so fond of dynamic camera movements that he earned the sobriquet *Idō Daisuki* ("I love movement!"). Although previously it had been sufficient for actors to simply perform their sword-fighting scenes in front of an immobile camera, Itō

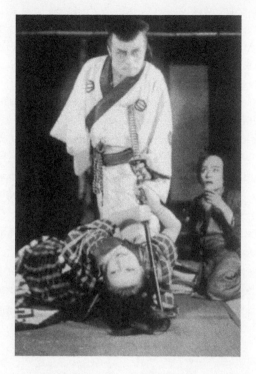

Shinpan Ōka Seidan: Kaiketsuhen (dir. Itō Daisuke, 1928).

instead chose to fill the entire screen with fierce fighting. He then sent his cameraman, with a camera strapped to his body, hurling into the fight, having him shoot film as he whirled around within the chaos. The protagonists of his three-part series, *Diary of Chūji's Travels* (*Chūji tabi nikki*, 1927) and his *Tange Sazen* series (1928–1934) played by Ōkochi Denjirō, were men ostracized by the authorities, struggling for survival, while assailed by feelings of despair and nihilism. In the latter in particular, the protagonist Tange Sazen wields his sword deftly in spite of having only one eye and one arm. Itō's versions of these stories gained him so much popularity that two different directors would make competing works at the same time based on the same material. Reflecting on this period when the

benshi were at their peak, Itō famously declared that, "cinema was never truly silent in Japan."

Makino Masahiro, the son of Makino Shōzō, resembled a monkey, and so when he was a child, he would play monkey roles in his father's films. He first sat in the director's chair himself, just before his father died, making the three-part *Samurai Town* (*Rōningai*, 1928–1929). Makino's detailed portrayal of the passion and anti-authority morals of gloomy *rōnin*—masterless samurai—earned considerable critical praise, although half of the honor may belong to the scenarist, Yamagami Itarō. In the wake of *Orochi*, nihilism in *jidaigeki* was not uncommon, but Makino added a more grounded critical spirit and realism to his depiction of social contradictions. To be sure, many of his works took up the world of samurai, but what informed the basis of his worldview was the existence of ordinary folk, those who reveled at festivals at every opportunity. As a result, whether he was depicting the powerful ruler Oda Nobunaga or Ōishi Kuranosuke, he endowed his samurai with easy-going, amiable personalities, making them largely indistinguishable from common townsfolk.

TENDENCY FILMS AND THEIR AFTERMATH

In bringing to a close this chapter on the mature period of silent film, I must touch on the relationship between left-wing political factions and cinema. In the late 1920s, Japanese intellectuals developed an obsession with communism. The complete works of Marx and Engels were published in Japan even before the Soviet Union or Germany, and Tokyo's livelier districts were overflowing with youth outfitted in Russian folk costumes. In 1928, the All Japan Proletariat Arts Federation (Nippona Artista Proleta Federacio, NAPF) was formed and the Japanese Proletariat Film Federation (NCPF) was organized along with it. With Sasa Genjū and Iwasaki Akira as its core, the federation shot footage of May Day Parades and labor struggles on nine-and-a-half- and sixteen-millimeter film. The completed films circulated throughout the country in the form of independent

screenings. By 1932, state pressure forced the organization called Prokino to become covert, but they continued their activities underground for several more years. As the forerunner for independent film in Japan, Prokino proved a highly valuable endeavor.

Whipped up by the Marx boom and stimulated by Prokino, major film studios during this period produced a number of films that were called "tendency films" (keikō eiga). The term refers to the fact that the films were generally left leaning. In jidaigeki, Itō Daisuke's Man-Slashing, Horse-Piercing Sword (Zanjin zanbaken, 1929) and Koishi Eiichi's Challenge (Chōsen, 1930) corresponded to this industrial trend. Challenge, which depicted peasant uprisings, was directed in a way faithful to the vibrant labor struggles and strikes of the time. In gendaigeki, we could cite Uchida Tomu's Living Doll (Ikeru ningyō, 1929) and Mizoguchi Kenji's Tokyo March (Tokyo kōshinkyoku, 1929). In the latter, a tennis court atop a hill is contrasted with the slums below through the narration of impressionistic scenes. The most successful tendency film, however, was Suzuki Shigeyoshi's What Made Her Do It? (Naniga kanojo o sō saseta ka, 1930). An orphan girl is sold off to a circus, and then, after coming to see the tragedies of the proletariat in grinding detail, and the suffering caused by male lust and bourgeois hypocrisy, she is placed in a reform school for girls. Yet even the reform school is full of hypocrisy, so she sets out to burn it down. That the film is tense with the feeling of upheaval can be surmised from a single shot toward the beginning of the film— that of the heroine walking up a diagonal incline alongside a train running likewise along a diagonal horizon.

Tendency films were little more than a short-lived trend. With the beginning of wartime aggression against China in 1931 stoking the rise of nationalism among citizens, tendency films quickly vanished. Once Mizoguchi (who was disdainfully described as "having the political consciousness of a junior high school student") learned of the establishment of Manchukuo as a Japanese colony, he quickly made The Dawn of the Founding of Manchukuo and Mongolia (Manmō kenkoku no reimei, 1932) and Suzuki shot The Road to Peace in the Orient (Tōyō heiwa no michi, 1938).

For many Japanese cineastes, any kind of political ideology amounted to little more than a surface decoration. Once they had trifled with the newest ideology for a bit, they quickly moved on, switching to something else. In the late 1920s, various film theories—largely from the Soviet Union and France—were introduced, sparking fierce debate among young cineastes over the ideas of Eisenstein, Shklovsky, and Moussinac. This was likely the liveliest moment of film theory in Japan. In 1928, Eisenstein saw a Kabuki play of *Chūshingura* in Moscow starring Ichikawa Sadanji, finding in it inspiration for new strategies for montage theory.[9] Even as the spread of film theories ensured that the position of directors would remain stable, the Japanese, by and large, did not inherit the decisive influence of any single ideology (e.g., Christianity, Tolstoyism, or Marxism). In the 1940s and 1950s, we would come to see the widespread repetition of this tendency *ad nauseam*.

3

THE FIRST GOLDEN AGE: 1927–1940

INITIAL ATTEMPTS AT TALKIES

Experiments to add voice to optical images were explored immediately following the establishment of film production in Japan. In 1902, Kawaura Ken'ichi of the Yoshizawa Shōten Company tried to create talkies by synchronizing the speed of records with the speed of film. Many different attempts throughout the 1910s to produce "Talking Motion Pictures" used these kinds of sound-on-disc processes, but none managed to go beyond being early experiments.

After the trader Minagawa Yoshizō bought the rights for talkie technology in 1925 from the American Lee de Forest, he developed a revised version—the Mina Talkie—and started the company Shōwa Kinema in 1927. At his request, the film *Dawn* (*Reimei*) was shot, with Osanai Kaoru[1] as director, and composer and conductor Yamada Kōsaku[2] in charge of music, using actors from the Tsukiji Little Theater. It was a short film—thirty minutes in length. By chance, this experiment was conducted in October, at the same time that Warner Brothers put out the first talkie, *The Jazz Singer*.

At this point, however, the technology was deemed unprofitable and so the film was never shown to the public. The first film released by Mina Talkie, Ochiai Namio's The Lieutenant's Daughter (Taii no musume, 1929) was a film version of the shinpa play that featured a young Mizutani Yaeko.[3] In the same year, Makino Masahiro produced The Demon at the Modoribashi Bridge (Modoribashi), which added sound to silent film footage, but this hybrid system disappeared before long. In 1930, Mizoguchi shot Hometown (Furusato) for Nikkatsu, starring the opera singer Fujiwara Yoshie, but the use of both intertitles and sound left it stuck at an intermediate stage—an unfinished talkie.

Japan's first complete talkie—The Neighbor's Wife and Mine (Madamu to nyōbō)[4]—was produced in 1931 by Shōchiku and directed by Gosho Heinosuke, adding sound with the Tsuchihashi System. A writer who suffers from writer's block moves into a suburban neighborhood. Because the jazz music that the young people are playing next door is so loud, he goes to protest; however, he is met by the "madame" next door and ends up being smitten by her. As he comes to like jazz, the writer regains his ability to write and completes his manuscript. The film ends with the writer deciding that a Japanese-style "wife" is fine, but an American-style "madame" is attractive as well. The interest of the general public in American-style modernism—symbolized by jazz—was viewed genially and positively and was combined with the newest of mediums: talking pictures.

Incidentally, it would become increasingly difficult to embrace both Japanese tradition and Western modernity. I will go into detail later, but this would come to an end with 1937's New Earth (Atarashiki tsuchi), which brought cultural nationalism to the forefront. Subsequently, the West would come to be seen as an object of disdain. Moreover, during the war, in 1942, there was a conference centered on Kyoto-based philosophers dubbed "Overcoming Modernity." This was the world's first debate on postmodernism. The period from the late 1920s through the early 1930s was a brief, happy interlude when Japan could freely enjoy modernist culture.

MAKING REAL TALKIES

Let us return to the discussion of talkies. As with the film reform movement that took place ten years previously, Nikkatsu once more lagged behind Shōchiku, having to wait until 1933 for the appearance of their first talkie—Itō Daisuke's *Tange Sazen*—with sound based on the Western electric system.

Movies did not change totally to talkies overnight. Rather than a clear movement from one to the other, it is better to think of it as two forms of film—silent and sound—coexisting throughout the 1930s. Major studios sought to switch to sound as quickly as possible, and by 1935, the production of silent films was already over. In contrast to Mizoguchi Kenji, who was eternally obsessed with the new, Ozu Yasujirō remained skeptical, clinging to silent films as long as he could. But by 1936, even Ozu had to say farewell to silent films.

For smaller-scale independent production companies, however, investment in new equipment was a financial burden, and production of silent films continued sporadically through 1938. Hayabusa Hideto's action films for Daito Eiga, Konoe Jūshirō's *chanbara*,[5] and Oyama Debuko's comedies, to cite some examples, continued to be shot as silent films. Another consequence of the burden of the production of sound films is that the independent production companies established by *jidaigeki* stars were absorbed by major studios' talkie divisions one after another. In terms of mass-producing quickly shot, low-budget B movies, the existence of small production companies in the 1930s is comparable to that of Pink Films in more recent years. These cheaply produced movies became perfect seedbeds to raise new, young cineastes in a way major studios never could; Itami Mansaku, for example, is one of several directors who came out of Kataoka Chiezō's production company.

In Japan, unlike in Hollywood, the talkie revolution did not result in the widespread ruin of actors' careers. Also, because linguistic differences were not as severe as they were in China between Mandarin, Shanghai dialect, and Cantonese, there was no need to

prepare several versions of a single film to accommodate each language. Rather, the reason for the delayed spread of talkies in Japan, in addition to the problems of investment in equipment mentioned previously, lay in the existence of the unique cultural figure of the *benshi*. When talkies first arrived in Japan from the West, because the majority of viewers could not understand foreign languages, the authority of *benshi* increased considerably, but this was a short-lived phenomenon. *Benshi* would lower the volume of the soundtrack of the film and supplant it with their own explanations. After Josef von Sternberg's *Morocco* was screened in Japan in 1931 with Japanese subtitles, this logical argument for the existence of *benshi* disappeared. *Benshi* fought desperately to protect their vested rights at theaters, and as a result, the advance of talkies was hindered in some places. But in the end, *benshi* were powerless in the face of technological trends. Some among them became comedy actors; some displayed their voice skills on the radio; others became film producers. With sound, live musicians also became unnecessary. Some of the musical groups that belonged to specific theaters converted into *chindonya*[6] bands. When writer Miyazawa Kenji passed on in 1933, he left the story *Gauche the Cellist*, about a movie theater musician, but had Miyazawa lived longer, he would have had to change the setting of the workplace for his cello-playing protagonist from a movie theater because musicians in movie theaters no longer existed.

The talkie revolution spurred an influx of actors from hitherto distant fields, as well as the appearance of new genres. Performers from a panoply of narrative arts—Asakusa operettas and vocal mimicry (*seitai mosha*); Osaka comedians, *rakugo* and *naniwabushi*—emerged one after another and flourished on screen. Examples include musical comedy superstar Enomoto Ken'ichi, known popularly as "Enoken," the Western-style intellectual comedian Furukawa Roppa, the modern *manzai* team of Entatsu and Achako, and *rakugo* storyteller and eventual actor Yanagiya Kingorō. Film melodramas garnered even more popularity through the circulation of a pop song used in *Love in the Storm* (*Aizen Katsura*, 1938). From around the mid-1930s, as talkie technology matured, film adaptations of

literary works—*bungei eiga*—circulated. This was due to the fact that the text of the literary work could freely be rendered as dialogue. But operetta films, setting aside exceptional films such as Makino Masahiro's *Lovebirds' Song Contest* (*Oshidori uta gassen*, 1939), and a string of popular-song films produced for Photo Chemical Laboratory (PCL), did not develop as the core of the national film industry, as they did in India and Egypt. Perhaps the highly formalized music and dance in traditional popular theater like Kabuki and *Bunraku* puppet theater did not lend themselves to popular musical movies.

What changed the most with the arrival of talkies was the sphere of reception—the quality of experience for film viewers. The disappearance of *benshi* swept away the character of improvised theatrical performance from film experience and transformed viewers into anonymous beings with no connection to any particular film theater. Cinema here at last became the same as in the West, achieving a pure space of representation of sound and optical images. In fact, however, the experience of viewing film in Japan was still not exactly the same as in the West. It is true that as far as Japanese films were concerned, movies came to be composed from optical images and sound; however, in the case of foreign films, dialogue was translated into Japanese, and appeared in subtitles as written language. In Italy and Germany, dubbing remains widespread; but in Japan and France, dubbing was opposed on principle. As a result, up to the present day, rather than experiencing foreign films as pure cinema, viewers experience them as something closer to manga with word balloons.

GENDAIGEKI WITH TOPKNOTS

More concretely, what kind of films were shot during the 1930s? In *jidaigeki*, I must address three directors who had debuted at the independent productions of *jidaigeki* stars—at Kataoka Chiezō Productions and Arashi Kanjūrō Productions—and then transferred to Nikkatsu's Uzumasa Studio in Kyoto. They are Itami Mansaku, Yamanaka Sadao, and Inagaki Hiroshi. The studio at Uzumasa had

an intimate ambience, where a collective screenwriter group close to those three directors assembled, writing their scripts under the group name of "Narutakigumi." This new generation shared a commitment to small-scale *jidaigeki* as opposed to the large-scale tradition of the past.

Itami Mansaku (1900-1946)[7] had a playful, humorous sensibility, overflowing with a parodic spirit. The works he shot utterly eschewed the usual morality informing conventional *jidaigeki*, like consciousness of belonging to a community, or heroism based on personal advance. As someone who reviled the sword-fighting scenes in *jidaigeki*, Itami would always shoot these off-sound, or in an extremely parodic fashion if they were absolutely necessary for the narrative. *Peerless Patriot* (*Kokushi Musō*, 1932) is a bizarre comedy in which a true swordsman squares off repeatedly without success against a young false swordsman who has appropriated his name. *The Letter* (*Akanishi Kakita*, 1936), an adaptation of a short story by Shiga Naoya, is a parody of a famous Kabuki play in which all of the characters are named after different kinds of fish. Kataoka Chiezō plays two roles: one, a powerful samurai performed in the highly formalized style of Kabuki, and the other, a dim-witted buffoon. *A Tale of Giants* (*Kyojinden*, 1938) reworks Victor Hugo's *Les Miserables* as a tale of defeat set in Kumamoto during the Seinan War in 1877. In this long film, rich with a modern parodic spirit, all the actors, including Hara Setsuko, speak in English and the subtitles are inserted. At a time when Japan's invasion of China was intensifying, Itami was directing works of an astonishingly bold liberal outlook.

Yamanaka Sadao (1909-1938) could be called "the Japanese Jean Vigo." The care with which he depicted his characters down to the finest and most subtle details was unmatched. In Yamanaka's *Tange Sazen*, a series that was once the pet of Itō Daisuke, the titular character appears as a goofy uncle, beloved by children, with no trace of humiliation or grotesquerie. The petty thieves to whom Kabuki playwright Kawatake Mokuami had given such grandeur were returned to petty, humorous rascals in Yamanaka's styling of these classic characters. The best examples of this orientation appear in

Chūji's Debut/Chūji uridasu (dir. Itami Mansaku, 1935).

Tange Sazen and the Pot Worth a Million Ryo (*Tange Sazen yowa: Hyaku-man ryō no tsubo*, 1935) and *Kōchiyama Sōshun* (sometimes known as *The Priest of Darkness*, 1936).

In contrast to Itami's intellectual nihilism, Inagaki Hiroshi (1905–1980) shot cheerful and warm-hearted *jidaigeki*. In his triptych from *A Life of Wandering* (*Hōrō Zanmai*, 1928) to *Kunisada Chūji* (1933), he displayed a profound sympathy for those outcasts, wandering from region to region. The characters in his films, while undeniably adorned in Edo-era garb, nonetheless acted no differently, psychologically speaking, from contemporary people. Consequently, his films were sometimes called "*gendaigeki* with topknots." Inagaki planned the first adaptation of *Great Bodhisattva Pass* (*Daibosatsu tōge*) in 1935, in collaboration with Yamanaka Sadao. Furthermore, he shot *The Life of Matsu the Untamed* (*Muhō Matsu no isshō*, 1943) based on a script by Itami. As boastful propaganda films were flooding screens, Inagaki quietly directed his compassionate gaze at the life and death of an anonymous everyman.

COSMOPOLITAN SHŌCHIKU AND NATIVIST NIKKATSU

Although it was possible to complete the shooting for a silent film within a week, once the talkie era began, it more commonly took a month to shoot a film and existing facilities came to feel limiting. Tokyo once again became a major area for film production. Nikkatsu moved their production facilities to Tamagawa in Chōfu, a suburb of Tokyo, in 1934, and Shōchiku moved to Ōfuna in nearby Kanagawa Prefecture in 1936. Nikkatsu returned to Tokyo for the first time since they closed up their studio at Mukōjima after the Great Kantō Earthquake eleven years previously. More consideration was given to the need to make contemporary films in Tokyo dialect.

Following the silent period, Shōchiku focused primarily on *shōshimin* films with a sophisticated, urban air, whereas Nikkatsu specialized in a more real, solemn, or—in a negative sense—boorish style. Following are some examples of representative filmmakers.

Shimazu Yasujirō, at Shōchiku, by no means possessed an original style, but with home dramas such as *My Neighbor Miss Yae* (*Tonari no Yae-chan*, 1934), he supported the basic ideals of Shōchiku. Nomura Hiromasa's *Love in the Storm* (*Aizen katsura*, 1938) achieved unprecedented popularity. This was a melodrama about a single mother who works valiantly as a nurse while hiding the fact that she has a child; ultimately, she falls in love with the son of the hospital director.

Ozu Yasujirō had already established his style during the silent period, but his style became even more pure once he began making talkies. This style included a penchant for eliminating fades and dissolves as well as for emphasizing the integrity of each shot. Ozu took up the quiet and modest sense of family in the hearts of lower middle-class Japanese in his first talkie *The Only Son* (*Hitori musuko*, 1936) and in the modern lifestyles of the bourgeoisie in *What Did the Lady Forget?* (*Shukujo wa nani o wasureta ka*, 1937). Instead of an analysis of social contradictions, these films looked on philosophically at the pathos underlying human existence, and this became

I Graduated, But (dir. Ozu Yasujirō, 1929).

Ozu's constant theme. The kind of Japanese depicted by Ozu, with their political apathy, did not contribute to national policy and were powerless and submissive in the face of an advancing crisis.

The most original figure at Shōchiku in the 1930s was Shimizu Hiroshi (1903–1966). In the late 1920s, he developed avant-garde techniques, with unexpected camera placement and unusual ways of linking shots; but by the 1930s, he gradually shifted to a way of making films with a strongly improvisational quality. Eschewing sets, he privileged location shooting. He increasingly cast nonprofessional actors, especially children. Even in the postwar period, this orientation remained unchanged; he used nonprofessional performers and

often gave them no more than a simple explanation of the basic situation before appearing together with a big star like Ōkōchi Denjirō. This kind of approach would have been totally unimaginable for, say, a director in Nikkatsu's *jidaigeki* division. *Mr. Thank You* (*Arigato-san*, 1936) is a cheerful road movie, but Shimizu's camera captured migrant laborers from colonial Korea in an improvisational manner, making it an exception in prewar Japanese film. Furthermore, with *A Star Athlete* (*Hanagata senshu*, 1937), he deployed a subjective shot from a running student athlete, capturing the surrounding landscape receding into the distance through a long take.

Shōchiku in this period did not have the big group of mythical stars that Nikkatsu's *jidaigeki* studio had, but even so, they managed to gather actors with originality and a modern sensibility. Shōchiku actors included Sano Shūji who played shy but reliable youths and Uehara Ken who by contrast played men who were simultaneously gentle and strong. Saburi Shin built a career on roles of gruff sincerity. Tanaka Kinuyo was an actress who was both cute and down to earth. Kuwano Michiko was modern and cheerful, while Takamine Hideko specialized in roles of young, spirited women.

At Nikkatsu, Uchida Tomu (1898–1970) and Kumagai Hisatora (1904–1986) deserve mention. With *Theater of Life* (*Jinsei gekijo: Seishun hen*, 1936), Uchida offered a *bildungsroman* focusing on a college student who encounters the yakuza way of life. This experience allows him to grow as a person as he faces the conflict of social obligation and human feeling. This story has been remade innumerable times. In *Earth* (*Tsuchi*, 1939), Uchida depicted the poverty and harsh laboring life of farmers with a solemn, realistic sensibility. He eliminated dramatic elements to focus on the shifting flow of nature. All of his scenarios were written by Yagi Yasutarō. Although Uchida's work presented anxiety in the face of radically changing social conditions, it also came at a time of rising agrarianism in politics. In 1940, to commemorate the so-called *kigen*—the twenty-six hundredth year anniversary founding of Japan by the mythical first emperor Jinmu—Uchida paired up with the cameraman Yokota Tatsuyuki to shoot the three-part series *History* (*Rekishi*). The film is set

at the end of the Edo period and offers a lyrical portrait of the life of a samurai from the Aizu domain. A soldier in a rebel army just before the Meiji Restoration, he finally comes to be a merchant in his hometown, before heading off to the Seinan War as a police officer of the new government.

Kumagai was a fierce idealist, and he shot films driven by the desire to bring social contradictions into the light. With *The Japanese* (*Sōbō*, 1937), based on Ishikawa Tatsuzō's prize-winning novel, he confronted the issue of abandoning one's nation by depicting the conditions at a Japanese migrant camp just before the farmers set sail for Brazil. When he moved to Tōhō, he made *The Abe Clan* (*Abe ichizoku*, 1938), adapting the story by Mori Ōgai but giving it an entirely different interpretation—converting it into a critique of samurai ethics. By the 1940s, Kumagai would turn toward making propaganda films, and as the head of an organization driven by mysticism and ultranationalism, he extolled an anti-Semitism rare in Japan. Both *The Abe Clan* and *History* were promoted as "history films" rather than as conventional *jidaigeki*.[8]

THE EXPANDING WORLD OF MIZOGUCHI KENJI

Mizoguchi Kenji moved around studios during the 1930s, and at Nagata Masaichi's Dai'ichi Eiga studio, he shot *Osaka Elegy* (*Naniwa erejii*, 1936) and *Sisters of the Gion* (*Gion no shimai*, 1936), which established his realistic style. Working aggressively to accurately incorporate the dialects of Osaka and Kyoto, he expanded his critical view of social contradictions (especially those concerning the position of women) that he had developed during the age of tendency films, into richer works with a more mature style. He pursued strong women who survive through perseverance, resisting the servile desires and scheming of men—fathers, lovers, or husbands. Mizoguchi was able to realize such ideals with the help of Yamada Isuzu[9]—a genius as an actress. Formally, he came to rely increasingly on sequence shots, studiously avoiding close-ups. Later, Mizoguchi

The Story of the Last Chrysanthemum (dir. Mizoguchi Kenji, 1939).

theorized this orientation as rooted in tendencies of Japanese painting that deviated from Western painting styles.

 Although he offered a critical reflection on *shinpa* with his *Straits of Love and Hate* (*Aienkyō*, 1937), Mizoguchi dared to return to *shinpa* with 1939's *The Story of the Last Chrysanthemum* (*Zangiku monogatari*), a myth-like tale that he set in the world of Kabuki during the 1890s, focused on the journey undergone by a young, elite man to achieve the fame worthy of his family name. By this point, Mizoguchi's style had reached a high and subtle degree of development. To show a scene of great emotional pain, instead of Hollywood-style close-ups, he took the opposite approach and pulled back to show it in long shots. But for this Japanese director, born the same year as Brecht, this distancing was not to create a place for cool criticism; it was to create an overwhelming experience.

FROM PCL TO TŌHŌ

In the 1930s, a third major studio emerged alongside Nikkatsu and Shōchiku: Tōhō. Tōhō is famous to this day for being timid with any materials opposed to mainstream morality. Originally this company grew out of PCL, which was established in 1931 as a research institute for talkies. This research institute began to recruit staff, moving into film production in 1933. Kurosawa Akira and Honda Ishirō were two of the recruits. PCL adopted a liberal, modern business policy, without relying on conventional networks—familial, feudal, or personal; they were the first studio in Japan to use the producer system. Many people got their start at PCL who are not necessarily associated with the film industry, from surrealists like Takiguchi Shūzō to the future co-founder of Sony, Ibuka Masaru. For them, PCL proved to be a kind of refuge for youth associated with left-wing or avant-garde arts movements. The films produced there truly ran the gamut, from Enoken's operetta-style human comedies to *gendaigeki* with a sharp critical spirit.

The first person to really distinguish himself at PCL was Kimura Sotoji. With *Youth Across the River* (*Kawa mukō no seishun*, 1933) and *Older Brother, Younger Sister* (*Ani imōto*, 1936), often called the last tendency films, Kimura depicted individual resistance to the entrenched relations between the family and the social system. Naruse Mikio (1905–1969), while more reserved, specialized in depicting the complex feelings of disquiet amidst the petty bourgeois; he developed an original sense of composition that emphasized the depths of the image. Initially, Naruse had been at Shōchiku, but when he was told, "we don't need two Ozu's," and his contract expired, he moved to PCL where he developed his prodigious talents. *Wife, Be Like a Rose!* (*Tsuma yo bara no yō ni*, 1935) would become the first Japanese movie to have an official release in New York. Ishida Tamizō also should be noted. His *Fallen Flowers* (*Hana chirinu*, 1938) was set in Kyoto's Gion district during the final years of the Tokugawa shogunate; solely through a depiction of the hermetic world of geisha, he was able to convey the severe political changes outside that world. While subtle, it was also a work with many experimental features.

PCL went through an initial period of struggle because at the beginning, it did not own any theaters. In 1937, by affiliating with the Kansai Railroad magnate Kobayashi Ichizō, who ran the all-female revue Takarazuka, PLC changed its name to Tōhō (since it was based in Tokyo, the name means "Eastern Takarazuka") and overcame its financial difficulties. Tōhō faced a formidable rival in Shōchiku, but in the war years, by actively participating with the military, Tōhō emerged on top.

COPRODUCTION WITH NAZI GERMANY

In 1931, Japan's military invaded a region of what is now northeastern China and established the state of Manchukuo there the following year. From 1937, war spread across China. In addition, in the same year, Italy and Germany forged the Anti-Comintern Pact, and it was out of this fascist movement that the league of Axis powers was established. In bringing this chapter to a close, I would like to address a propaganda film co-produced by Japan and Germany.

In 1936, Arnold Fanck, a director of mountain films (bergfilme) and the discoverer of Leni Riefenstahl, visited Japan. Fanck came to make a film centered on mountain scenery in Japan. Itami Mansaku, who was chosen to codirect with him, was a director who had specialized in parodic humor, however, and he was not amenable to the kind of romantic sublime aesthetics Fanck extolled. As a result, in 1937, two versions of the same film were completed. Fanck's version, The Samurai's Daughter (Die Tochter des Samurai, Samurai no Musume) was popular when it opened in Germany, and Goebbels praised it. Itami's version, The New Earth (Atarashiki tsuchi) was a resolute failure, and he avoided referring to this movie for the rest of his life.

The narrative of The New Earth is imbued with an extreme cultural nationalism. A youth played by Kosugi Isamu finishes his studies in Germany and returns home to Japan with his German fiancé. Newly awakened to the beauty and wisdom of the Japanese woman to whom he had been betrothed before his study abroad, he abandons

the German woman. The Japanese couple wed auspiciously, and when they head for Manchukuo, they burn with a pioneering passion for "A New Earth" under the protection of the Japanese military.

Fanck chose Hara Setsuko as the heroine. To that point, she had played only a bit part in Yamanaka Sadao's *jidaigeki*, *Kōchiyama Sōshun*, but now found herself suddenly put in the spotlight. She would later be mythologized in Japan as an actress with the physique and features of a Westerner; but in this case, she appeared as the "quintessential Japanese woman," as if she walked right out of the dreams of the orientalist Fanck. Later, she would be brought to face the contradictions of her image in this film. In any event, Hara Setsuko flourished from the late 1930s and throughout the war as the beautiful young girl of fascism. No doubt she was under the heavy influence of her stepbrother, the director Kumagai Hisatora, who we discussed earlier in this chapter.

4

JAPANESE CINEMA DURING WARTIME

SETTING UP THE WARTIME SYSTEM

Before 1941, Japan was the second-largest filmmaking country after America, producing nearly five hundred films each year. By 1945, however, that number had dropped to twenty-six films. Needless to say, this reduction can be attributed to conditions during the Second World War when Japan was fighting America and the Allied powers and to the widespread devastation wrought by the war on Japanese soil, which brought about the forced unconditional surrender of Japan. Here, I would like to take up this peculiar four-year period. In the postwar period, among progressive cultural critics reflecting on this "dark age," some said that because state directives for wartime film eliminated any freedom of production, virtually no works produced in that period were worth watching. Conversely, scholars like Noël Burch offered an opposite interpretation. They praised the Japanese cinema produced during wartime as having achieved a high level of pure formal perfection precisely because it was cut off from the influence of foreign films. They see the dismantling of these controls in the postwar period as meaning the dissolution

of this formal perfection.[1] In the postwar period, the film world avoided conducting thorough historical research on the activities of people in the film industries during the wartime period. It is an undeniable fact that this dearth of solid research adds to a complicated sense of ambivalence toward wartime Japanese cinema.

Film censorship began before the war. The film law promulgated in 1939 was fundamentally different from previous systems, however. It had the goal of complete state control of Japanese cinema by creating an approval system that would regulate production and distribution. Directors and actors had to be registered and licensed, and works were censored from the stage of the script. Needless to say, this system was a childish imitation of film regulations in Nazi Germany. Among cineastes, there were those like Iwasaki Akira who were opposed to this system and who were imprisoned for their opposition; but the vast majority was in favor insofar as the film law protected their existing position and eliminated competition from new companies. Even the supposed leftist Kimura Sotoji worked on a committee for the law's enactment, as though hoping that its passage would eliminate all vulgar movies. Some filmmakers expected that this law would give validity to the then-despised genre of cinema and allow for its social value to be recognized. What happened in fact was that without any noticeable increase in the respectability of cinema, the state now had total and merciless control.

In 1941, when the ABCD line[2] of the Allied nations imposed economic sanctions on Japan, the Eastman Film that had been imported from America to that point was in short supply. Because raw film produced in Japan was designated for military use, this placed severe restrictions on its civilian use, creating a life-and-death issue for film companies. Integrating companies was thus seen as an urgent matter. Tōhō, as the new power, was able to survive by becoming useful to the military with innovations in aerial photography and other new technology as well as by its enthusiastic response to the military's demand for documentary films. The fact that Tōhō lagged behind other studios in both *jidaigeki* and *gendaigeki* turned out to be fortunate. Tōhō became a pioneer in opening up the

marketplace for war films, and throughout the war, no company produced greater quantities of war films. By contrast, older companies like Nikkatsu and Shōchiku found it much more difficult to change direction to ally with the military. As a result, in 1942, when Nagata Masaichi, the strategist of Shinkō Kinema, established the Daiei studio (*Dai nihon eiga*) by merging existing film companies, it actually absorbed Nikkatsu. This made three film companies—Tōhō, Shōchiku, and Daiei—and all were forced to quickly reduce the scale of their operations. In affiliation with the military, many filmmakers were dispatched to the southern colonies and Manchukuo[3] to produce propaganda films. For example, it is said that Ozu Yasujirō went uncomplainingly into military service and participated in the fighting with poison gas in China, but when he saw Orson Welles's *Citizen Kane* (1941) at a theater appropriated by the Japanese military in Singapore, he was convinced that Japan would lose the war.[4] Mizoguchi was sent abroad but complained that he was not treated as a commissioned officer. Aware that he was ill suited to the job, he nonetheless struggled to make films for nationalist goals. Long before that, Yamanaka had died of disease on the battlefields of China. Itami Mansaku, while bedridden with tuberculosis, wrote an essay titled *To Hope for the End of the War*. Abe Yutaka went to the South Pacific, and Uchida Tomu went to Manchuria. Imai Tadashi and Toyoda Shirō made propaganda films in Korea.

THE CHARACTERISTICS OF JAPANESE WAR FILMS

Many filmmakers contributed to the war effort. However, when we look at the films that took war as a theme from the perspective of our time or at the films that depicted Japanese soldiers or common people under wartime conditions, we see that all of them are not necessarily purely films promoting the war. A couple of concrete examples can illustrate this assertion.

With *Five Scouts* (*Gonin no sekkōhei*, 1938), Tasaka Tomotaka (1902–1974) demonstrated his sharp observation of human beings against

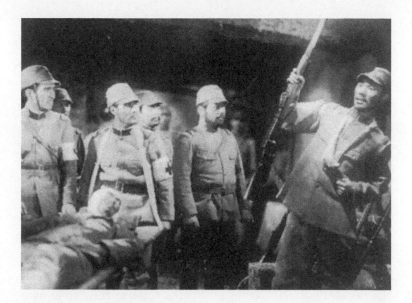

Five Scouts (dir. Tasaka Tomotaka, 1938).

a backdrop of war. He shows a captain of the Japanese Army on the battlefront in China who is deeply beloved by the soldiers under his command. His men go out to observe enemy positions, but when they do, one of the soldiers does not return. The worried troops stay up all night waiting for him, and when he returns, they set out for a new battlefield. By focusing on the themes of anguish and trust on the battlefield, Tasaka avoided celebrating the heroism of war and made a film that was strongly imbued throughout with moral sensibility. *Five Scouts* was a prizewinner that year at the Venice Film Festival. In 1939, Tasaka presented *Earth and Soldiers* (*Tsuchi to heitai*). The film depicts the Japanese troops as they move day after day, marching toward their deaths, not wavering even as soldiers continually desert. In neither film does the enemy—whether Chinese nationalist or communist—ever appear. Tasaka's focus was always on anonymous Japanese soldiers who bear tremendous difficulties and do not back away from self-sacrifice; his showing us this

morality makes it possible for us to see how Japanese fascism can have a certain unique beauty.

The vast majority of Japanese unconsciously considered the war not as a battle against a threatening other, but rather as an action that they knew only through the great austerities that they had to undergo. This shared hardship affirmed their sense of belonging to a community. In her analysis of Japanese wartime cinema, the American anthropologist Ruth Benedict argued that these films emphasized the misery of battle and the suffering of soldiers to such an extent that if this appeared in the context of an American film, it would be interpreted as being antiwar.[5] This is a fascinating perspective, but in fact, by emphasizing the tragic beauty of war, Japanese filmmakers urged the Japanese people to have gratitude and sympathy for soldiers and, in that way, strove to cooperate with national directives. There were almost no propaganda films about the necessity of vigilance against a fearsome enemy. Yoshimura Kōzaburō's *The Spy Has Not Yet Died* (*Kanchō imada shisezu*, 1942) is a rare exception. In Japan, it was not particularly necessary to depict the enemy as monstrous or evil. What was important was to use images of the suffering of the Imperial Army to convey the moral message of the infinite obligation to the emperor and the necessity of repaying that obligation. Here we can see a decisive difference that separated Japanese and Western views of war at the time. Incidentally, Japan underwent modern unification around the same time as Italy, from the middle of the nineteenth century. Both were newly emergent nations, late to the game of colonial acquisition; unlike Italy, however, Japan never saw any resistance movements among the people.

In *The War at Sea from Hawai'i to Malaya* (*Hawai mare oki kaisen*, 1942), Yamamoto Kajirō realistically depicted the harsh training of young Japanese soldiers. He was assisted by special effects director Tsuburaya Eiji. In this film, Tsuburaya beautifully recreated the attack on Pearl Harbor and the destruction of America's pacific fleet with miniatures. Tsuburaya would demonstrate his extraordinary talents once more at Tōhō during the postwar period by making monster

movies (*kaijū eiga*). In *Army* (*Rikugun*, 1944), Kinoshita Keisuke shows a sickly young man who manages to recover and join the military. Kinoshita's camera follows the boy's mother every step of the way as she anxiously rushes after her son as he is marching in a solemn military parade, just before being sent off to the battlefield. As an extraordinary expression of pathos, the scene is successful. Although the film incurred the wrath of some in the military, it is too ambiguous to be interpreted as a work of resistance to the war.

The director most enthusiastic about making films in support of the government's war policy was Kumagai Hisatora. Both *Shanghai Brigade* (*Shanhai rikusentai*, 1939) and *A Tale of Leadership* (*Shidō Monogatari*, 1941) are relentless hymns in praise of militarism. Many directors who also made national policy films actually began in left-wing movements in the early 1930s or had made tendency films, including Tasaka Tomotaka, Imai Tadashi, and Yamamoto Satsuo. After the war, many of these directors changed direction quickly, advocating democracy, and participating in leftist movements. Thus, the direction of ideology shifted to its opposite, but in both cases, America remained the enemy.

CINEMA AND THE "OVERCOMING MODERNITY" DEBATE

At the same time that many propaganda films were encouraging the war spirit, some intellectuals felt that the future of Western modernity had reached its limits, and there was an attempt to return to Japanese aesthetic traditions. In 1942, a symposium called "Overcoming Modernity" focused on Kyoto-based philosophers. It constituted one of the world's first debates on the idea of "postmodernism." In the two sessions of the symposium, the dominant idea was that, for the "sublime spirit" of Japan, neither European culture now seen to be in decline nor a trivial American culture of "material civilization" were of any use. (During the symposium, word came that the Nazis had occupied Paris and inevitably this encouraged

the feeling that the symposium had a "world historical mission.") The only one to oppose this idea was the film critic Tsumura Hideo, who urged his fellow participants not to underestimate the effects of American culture. He also cautioned against an overzealous belief in spirit that would lead them to take technology too lightly. Tsumura alone was able to operate within the ideological currents of the age. At the same time, through his rich experience with Hollywood and European film, he was still able to look at things soberly.[6]

THE DISGUISE OF KAMEI FUMIO

Within these conditions, the work of documentary filmmaker Kamei Fumio (1908–1987) was well outside the norm. Kamei had studied at the Leningrad Film School, and in The China Incident (Shina jihen, 1937), a film planned by the Ministry of Education and Culture, he simply displayed compliance with the policy of promoting the war. However, his following film, Shanghai (1938), while seeming to follow the producers' intention to make nationalist propaganda, contained a deeply antiwar subtext. He included extensive quotations from actual Chinese newsreels, boldly explaining them away as being examples of enemy propaganda. Furthermore, he showed the faces of the colonized people as they gazed at Japanese soldiers on the march, allowing the scene to unfold at length using a moving camera and without cuts. Through his depiction of the tense gazes of the people, he showed the politics and violence not only of the military invasion but also of the act of filming. In addition, Kamei himself did not go to Shanghai, but rather he acted as director by taking the rushes provided by his cameraman Miki Shigeru and editing them in Tokyo. In Fighting Soldiers (Tatakau heitai, 1938), Kamei focused on endless shots showing the exhaustion on the faces of soldiers at the front. Of course, there was a limit to the effectiveness of Kamei's subterfuges and this was the end. Screenings of Fighting Soldiers were banned; he was stripped of his filmmaking credentials and arrested.

HOW FILM DIRECTORS RESPONDED TO WARTIME

Even with films that do not treat war as a central theme, one can clearly see the influence of wartime conditions. During this period, Inagaki Hiroshi shot a series of films between 1940 and 1942, featuring the national hero and swordsman Miyamoto Musashi as the protagonist.[7] To make a work extolling such an austere spiritual seeker embodying the way of the warrior is clearly a response to the demands of the age.

The *jidaigeki* dominant to that point were produced for the purpose of entertainment and had nonsensical stories. When these films came to be rejected by the censors, filmmakers voluntarily changed to making lyrical works with a sublime and solemn air. As one example, Mizoguchi Kenji shot *Genroku Chūshingura* between 1941 and 1942, with a massive budget. Because he was aware that *Chūshingura*, as a popular theme for entertainment movies, had become entirely separated from the historical facts, when he planned the work, he constructed sets for Edo Castle that reproduced the actual dimensions of the original buildings, sets that include the pine corridor where the sudden attack by Asano Takuminokami on Kira Kōzukenosuke took place. The film is one long series of scenes of warriors debating what to do and solemn ceremonies repeated over and over with the element of imperial ideology introduced as a kind of justifying fig leaf. The work was shot as an authentic expression of Japanese ideology, but strangely, the final attack on Kira's mansion that is usually the highlight of any *Chūshingura* movie was left out, and contemporaries saw the work as a failure. Nonetheless, in this nearly four-hour film, we can see the formalism of Mizoguchi's sophisticated long takes and his consciousness of spatial continuity attain near-sacred levels. Mizoguchi forced himself to shoot a film about Miyamoto Musashi, like Inagaki, but without much success.

Makino Masahiro circumvented national policy but in a different way from Kamei Fumio. Even after he shot Japan's first operetta film *Lovebirds' Song Contest* (*Oshidori uta gassen*, 1939), he continued

to direct entertainment works that mixed witty modernism with humanist sentiment, making use of stars like Hasegawa Kazuo and Furukawa Roppa. As the tinge of wartime became stronger, he directed a new adaptation of Izumi Kyōka's novel *A Woman's Pedigree* (*Onna keizu*, 1942), changing the protagonist's profession from a German literature specialist working for the military bureaucracy as a translator into an explosives researcher. Additionally, he remade D. W. Griffiths's *Orphans of the Storm* as *Opium War* (*Ahen sensō*, 1943), shifting its setting to mid-nineteenth-century Guangzhou. At first glance, it certainly appears to extoll the idea of the East Asian Co-Prosperity Sphere, but at its heart, it is actually an homage to that Hollywood master from the enemy country.

Sugata Sanshirō (dir. Kurosawa Akira, 1943).

The most important new director to debut in the first half of the 1940s was Kurosawa Akira (1910–1998). In *Sugata Sanshirō* (1943) and its sequel (1945), set in an age when the traditional art of jiujutsu was changing into the modern sport of judō, he presented a narrative of a youth who continuously undergoes austere training, a modern character reminiscent of Miyamoto Musashi. He falls into moral quandaries from his inborn sense of justice, but when at dawn he sees a lotus blooming in a mud puddle—suggesting the ability to maintain your purity even when your surroundings are filthy—he achieves enlightenment. From his first film, Kurosawa already had a consistent theme that he depicted with powerful brushstrokes. This theme was learning how to avoid a false problem right before our eyes (e.g., how he should combat the karate techniques of his archrival) and to devote oneself to resolving a single question of truth (how to achieve enlightenment in this life). In the spring of 1945, when Japan's defeat appeared an imminent possibility, Kurosawa was considering a film adaptation of the story of Jeanne d'Arc, *The Powerful Princess* (*Arahimesama*) starring Hara Setsuko. In the absence of raw film, this work, which could have been a call to arms in a time of emergency, was shelved. Before long, Japan lost and the war ended.

5

FILM PRODUCTION IN THE COLONIES AND OCCUPIED LANDS

I n this chapter, I touch very simply on film production in the colonies and places occupied by the Japanese Empire up to the end of the Second World War. More concretely, I will look at the following places: Taiwan, Korea, Manchuria, Shanghai, Indonesia, and the Philippines.

THE FILM INDUSTRY IN TAIWAN

Japan acquired Taiwan from the Qing Empire after winning the Sino-Japanese War in 1895—the same year that the Lumière brothers invented the cinema. This tells us that Japanese modernity and Taiwanese colonization ran parallel to Japanese film history. In 1901, the first film screening in Taipei was conducted by a Japanese named Takamatsu Toyojirō. Entrusted by the governor general with the pacification of the Taiwanese population, he would later travel throughout the island to spread the Japanese language carrying his camera equipment with him. More than anything else, cinema was

considered an effective cultural apparatus for colonization and Japanization. In 1921, a Japanese man visited Taiwan and shot an education film about nutritional hygiene called *Preventing Cholera* (*Yufang huòluàn* in Chinese, *Yobō kakuran* in Japanese). This was the first footage shot on the island, and this fact shows the colonial function of film. The first permanent film theater in Taipei was erected in 1907, but the screenings there were mostly of films from the Japanese "homeland,"[1] and it was only much later that mass entertainment films were produced in Taiwan. The first film produced by a Taiwanese person was Liu Xiyang's *Whose Fault Is It?* (*Shui zhi guo*) in 1925. This was the story of a geisha and a banker passionately in love with each other whose relationship is endangered by a gangster. This film ends with the banker saving the geisha. Although the film is long since lost, it is not hard to detect the influence of Japanese *shinpa* and action plays and movies.

To Japanese directors in the "homeland" seeking exoticism, Taiwan consistently provided auspicious material. The first example of this was *Song of Sadness* (*Ai no kyoku*), shot in 1919 for Tenkatsu Studios by Edamasa Yoshirō, a director who had been sympathetic to the Pure Film Movement. This is a melodrama with a ridiculous plot about a young girl living in Tokyo who is kidnapped and sold off to the circus. Ten years later, she finds herself in Taiwan, having been raised as daughter of the chieftain of the indigenous Takasago tribe. The film was produced with the most modern techniques and technologies at the time. Notably, it directed attention to Taiwan (even if no actual location shooting occurred there), a peripheral region of the Japanese Empire that most people did not notice. Reform movements in film history that take as their subject heretofore unknown remote regions are not rare, as evidenced by Luis Bunuel's *Land Without Bread* (*Las Hurdes: Tierra Sin Pan*, 1933) and the Chinese Fifth-Generation filmmaker Tian Zhuangzhuang's *The Horse Thief* (*Dào mǎ zéi*, 1986). Even though the film borrows modernist forms, *Song of Sadness*'s narrative repeatedly shows events as the working out of karma, suggesting that this film was still no more than an extension of the early sideshow films.

FILMS TO ENLIGHTEN THE TAIWANESE NATIVES

Tasaka Tomotaka's 1927 film for Nikkatsu, *Hero of Alishan* (*Arisan no kyōji*), was actually shot in Taiwan. In the film, an indigenous youth, while belonging to a savage tribe, is presented as a proud human being. That said, we cannot necessarily conclude simply that *Song of Sadness* is a discriminatory film and that *Hero of Alishan* is not. It is first necessary to scrutinize the structure of Orientalism that stretches across the background of both films. The Japanese were not the only ones to make films featuring an air of exoticism. In 1929, Bai Da Film Company's *Blood Stains* (*Xie Hen*) directed by Zhang Yunhe was set in a trading post in the "savage region" of a mountainous area where a young girl, dressed as a boy, boldly avenges her late father. In the 1920s, not only were films imported into Taiwan from the "homeland" and from Hollywood, but Shanghai films were also imported, passing through Amoy and Tainan (where they had to undergo brutal censorship). In *Blood Stains*, we can detect the influence of Kyoto *jidaigeki* along with Shanghai *wuxiapian* (stories of martial heroes).

In *Gohō, the Righteous Man* (*Gijin gohō*, 1932), directed by Andō Tarō, the drive to enlighten blends beautifully with exoticism. The superiority of civilization to savagery is proclaimed in this tale of a righteous Taiwanese man who chooses to sacrifice himself to stop the Takasago tribe from headhunting. At the same time, however, we should not ignore the fact that the protagonist embodies the ideal character as praised by Confucius and seems to have no connection to a modern Japanese ethos. In the 1943 wartime film *Sayon's Bell* (*Sayon no kane*) by another Japanese director, Shimizu Hiroshi, the circumstances are completely different. In a village that has accepted the values of the Japanese Empire, a daughter of the Takasago Tribe, played by Ri Kōran,[2] shows her devotion to the departing soldiers and sacrifices her own life. The setting is no

longer that of a remote backwater rampant with savagery but rather is an idealized space, a utopia.

After Hokkaido and Okinawa, Taiwan was Japan's third-oldest colony, but unlike Korea, as I will explain, filmmaking by Taiwanese was not well developed. In the 1930s, films with *shinpa*-style stories were produced there, such as *Spring Breeze* (*Wang chunfen*, 1938), directed by Andō Tarō and Huang Liangmeng, but by 1941, the governor general had established the Taiwan Motion Picture Association. As controls were tightened, Taiwanese filmmakers were forced into silence.

TAIWANESE CINEMA AFTER LIBERATION

In 1945, when Japan withdrew from Taiwan and Nationalist Party rule began, the government quickly tried to ban the screening of Japanese films, but they were not able to achieve this because of popular opposition. Mandarin-language films began to be produced through the auspices of the government, but ordinary Taiwanese who used Hokkienese-related dialects of Taiwanese as well as Hakka could not warm up to these films. In 1956, when nongovernment film production in Taiwanese began, it was immensely popular right away. Japanese films continued to be supported by the masses and many coproductions were made until official relations between Japan and Taiwan ceased. In the 1970s, Taiwan's young generation, which could not understand Japanese, enjoyed Japanese films through a person who explained the movie in Taiwanese when it was screened. This custom was rooted in Japanese *benshi*. Indeed, Wu Nien Chen's *A Borrowed Life* (Tò-sàng, 1994), which depicts the filmmaker's relationship with his father, includes a scene in which the director—as a young boy—is taken by his father to see the Shōchiku film *Kimi no na wa* (1953) at a theater in a mining town, and the screening is accompanied by a *benshi*'s interpretation.

THE FILM INDUSTRY IN KOREA

Japan annexed the Great Korean Empire in 1905, and in 1910 began to rule it as a colony. But the rule over Korea did not go as smoothly as that over Taiwan, and nationalist movements incessantly hassled the governor general, who suppressed the movements through harsh means. The film industry run by Koreans was extremely active in comparison with that of Taiwan and had produced innumerable filmmakers. They were, moreover, deeply connected with rising nationalist sentiments in various ways.

The first Korean production was *The Righteous Revenge* (*Uirijeok gutu*) directed by Kim Do San in the colonial capital of Keijō in 1919. Just the fact that the film was rooted in the *rensageki* form that was enormously popular in the "homeland" during the 1910s, testifies to how much Korean cinema from the beginning was under the influence of Japanese *shinpa*. Since that time, even after Korean independence, the influence of *shinpa* has been overwhelmingly strong. Although calls were made to eliminate any trace of colonial coloring through government policy, it could not be wholly eradicated. Resonating with popular songs and the vocal art of *pansori*[3] from the Joseon dynasty (1392–1897), *shinpa* found a soul mate in the Korean melodramatic imagination.

In Korea, as with Taiwan, the governor general at first planned to carry out education and enlightenment through film, having the former head of a mass theater troop, Yun Baek-nam, direct *Plighted Love Under the Moon* (*Wolha-ui maengseo*, 1923) to encourage personal savings. After that, however, the impulse toward making films by Korean people was stronger than that of government-supported film, and when a Japanese man opened up Chōsen Kinema in 1924, Korean independent productions flourished as if in opposition. This took place around the same time that independent directors were emerging one after another in Kyoto.

KOREAN CINEMA'S GOLDEN AGE

The most important director throughout the 1920s was Na Woon-gyu. A figure connected with anti-Japan movements, Na directed, wrote, and starred in *Ariran* (1926), a powerful film that raised national pride and resistance. The protagonist, a young man, goes to prison for killing the minion of a member of the Japanese military police who has humiliated his younger sister. "Because I was born here in Korea, I have killed a crazy man," the *benshi* improvised, explaining that seven years ago during the nationwide anti-Japan movements, he became deranged on account of being tortured by the Japanese military police.[4] Audiences were electrified and police in the theater demanded an end to screenings of the film. Near the end of the film, when a singer stood and sang the theme song, a newly composed song in the style of a folk song, the entire audience raised their voices in unison. The melody of *Ariran* is familiar even today. Na directed seventeen films altogether and passed away at thirty-six years of age.

Several additional directors were active from the 1920s through the 1930s. Yi Kyŏng-son caused a stir with *Long Cherished Dream* (*Changhanmong*, 1926), his adaptation of the Japanese novel *The Golden Demon*, but he eventually left Korea through Shanghai and went into exile in Bangkok. Lee Gyu-Hwan, who had studied at Shinkō Kinema in Kyoto, directed *The Ownerless Ferryboat* (*Imjaeobtneun naleutbae*, 1932) in Keijō. A strongly anti-Japanese film, it tells the story of a poor and old ferryman who loses his job because of the construction of a bridge by the occupying Japanese. The man ends up killing a Japanese engineer who tried to rape his younger sister. Even so, apart from individual films that were critical of Japan, the trends of Korean cinema largely followed those of Japanese films on a smaller scale. If *shinpa* films were popular in the "homeland," then they would be made in Korea; if tendency films were popular

in the "homeland," then they would be made in Korea, and so on. Although produced in overwhelming numbers in the "homeland," however, *jidaigeki* alone never developed in Korea. The first talkie in Korea was produced just a bit later than that in the "homeland," appearing in 1935: Yi Myongho's *The Story of Chunhyang* (Chunhyangjeon). The film, a celebrated story from the repertory of the traditional vocal art of *pansori*, became a national story not unlike Japan's *Chūshingura*. At present, including both South and North Korea, the story has been filmed more than fifteen times since 1923; this popularity speaks to the fact that in Korea, in the interest of self-recognition and national belonging, melodrama works at a more profound level than political ideology.

THE DECLINE AND REVIVAL OF KOREAN FILM

In the late 1930s, a second generation of filmmakers appeared, including Bang Han-Jun and Yun Bong-chun, who both trained as assistant directors in the "homeland," and who worked to incorporate a modernist, enlightenment spirit removed from stock *shinpa* tropes. However, with Japan on the imperialist march, in 1940 a film law was established in Korea as well, eliminating almost all possibilities for Koreans to take a leading role in filmmaking. For those who wanted to direct at any cost, they had to abandon the adult world, which was subject to strict censorship, and instead had to entrust their ideas to the children's world. Choi In-Kyu's *Tuition* (*Su-eop-ryo*, 1940) depicts the warm-hearted relationship between a teacher and a poor elementary school student who cannot pay his fees. His next film, *Homeless Angel* (*Jibeopneun cheonsa*, 1941), features a young orphan who looks after street urchins. In similar ways, these filmmakers were forced to turn to the world of children in Taiwanese cinema in the early 1980s and in Iranian cinema in the 1990s.

In 1942, all Korean studios were closed down, and in their place, the governor general established the new Chōsen Cinema (Chō'ei).

Tuition (dir. Choi In-Kyu, 1940).

Filmmakers from the "homeland" arrived one after another and directed several films, using Koreans, who had been the center of Korean cinema, as staff on site. Hinatsu Eitarō's *You and I* (*Kimi to boku*, 1941) and Toyoda Shirō's *Figure of Youth* (*Wakaki sugata*, 1943) acted as an extension of the imperialization policies at the time, praising the drafting of Korean students to the front. In addition, Imai Tadashi made *Suicide Troops of the Watchtower* (*Bōrō no kesshitai*, 1943) for Tōhō. Shot like a Hollywood western, the film narrates the story of a Japanese policeman, his family, and their Korean servants, as they risk their lives trying to overcome *kyōhi* (anti-Japanese partisans).

When Japanese colonial rule ended in 1945, film production in the Korean language resumed immediately. Choi In-kyu directed *Hurrah! For Freedom!* (*Jayu manse*, 1946) to celebrate the one-year anniversary of national liberation, and a rush of anti-Japanese films followed. Kang Hon-sik's *My Home Village* (*Nae Kohyang*, 1948) was the first film made in North Korea, which was occupied by the Soviet

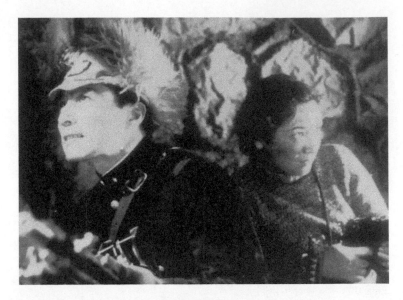

Suicide Troops of the Watchtower (dir. Imai Tadashi, 1943).

Union. South Korea is one of the rare nations in the world that has gone for so long without officially screening any Japanese films (the ban did not end until 1998). Even so, the influence of Japanese cinema permeates every crevice of South Korean film, with innumerable Korean re-makes of Japanese films. Ironically, at the same time, the Japanese film world featured a great presence of *zainichi* performers. In fact, during the postwar period, the percentage of roles played by *zainichi* Korean actors and stars was so high that Japanese made them the standard of beauty for the men and women of the era for well over half a century.

ESTABLISHING MANCHURIAN CINEMA

In 1932, Japan established the state of Manchukuo in what are now the three northeastern provinces of China and appointed Pu'i, the last emperor under Qing China, as its emperor. In 1936,

the Manchurian Film Corporation (Man'ei) was established in Shinkyō (now Changchun). Man'ei set out to produce national policy films whose primary purpose was the civilization of the Manchurian people.

When it was established, Japanese celebrated Man'ei as the studio with the largest land holdings in all of East Asia. In the postwar period, however, it was called the "shame of Japanese film history," and up to this point, film history has treated the topic of Man'ei as taboo. The paucity of extant films also has proven to be an obstacle to research. However, when we consider the fact that it was returnees from Man'ei in the postwar period who built the foundation for Tōei films in Japan, that the Chinese Communist Party administration made use of its facilities and technologies, and that its personnel have spread out as far as Hong Kong and Taiwan, we might ask whether it is time to reexamine, within the larger context of Asian film history, the merits and demerits of this studio that ran for more than nine years.

At the time of its establishment, Man'ei relied on both technology and personnel from Tōhō. The studio found Chinese newcomers as actors, and in 1938, produced its first feature film. This studio, however, would begin to display its truly unique features the same year with the arrival of Negishi Kan'ichi and Makino Mitsuo from Nikkatsu. In the following year, 1939, Amakasu Masahiko[5] became the head of Man'ei, and from around this time, a motley bunch of former leftists, rightists, and military men who found it increasingly difficult to be in the homeland arrived at Man'ei in search of a new paradise in which to live, looking like the proverbial procession of monsters.

Broadly speaking, Man'ei produced two kinds of films: educational films and entertainment films. The former were culture films for propaganda purposes, aimed at civilizing the native population—the original purpose of Man'ei. The latter were regular feature films, and these gave birth to the star Ri Kōran. By around 1941, Man'ei established a regular course of making thirty entertainment films annually. Several of the films produced by Man'ei showed in the

"homeland" as well, but they were not particularly highly regarded. The Manchurian people, who were subjugated in their native lands, were by no means fond of the films. This lack of popularity in China was because these films were produced by Japanese who had no interest in or knowledge of the differing lifestyles of various ethnic groups in China. To most Japanese, all of these peoples were identically exotic. Even if it did not bother Japanese, for people in China, it would feel unnatural for a Manchurian actor to play a role speaking the Chinese language. The expression for an apology in Japanese, *gomen nasai*, was rendered directly into Chinese as *toipuchi*, a word that no one would ever use, so the films of Man'ei were contemptuously called "*toipuchi* films" by native Manchurians.

THE EMERGENCE OF RI KŌRAN

Ri Kōran (1920–2014) was Japanese, but she was raised as a Chinese person in Manchuria and Beijing. She not only was beautiful but also was blessed with an extraordinary capacity for languages and an ability to sing; when she became a star at Man'ei, she came to star opposite the "homeland" star Hasegawa Kazuo at Tōhō. In this film, she plays a "daughter of China" in the anti-Japanese camp; however, she comes to love the earnest character of Hasegawa, and after some stormy drama, she finally switches to the pro-Japan camp, giving the films a happy ending.

The film that truly made her famous was Fushimizu Shu's *China Nights* (*Shina no yoru*, 1940). With the heady atmosphere of its cosmopolitan port-town setting, the gangs, action, and a pure-hearted daughter, the format of the film anticipated Nikkatsu's borderless action (*mukokuseki*) films by twenty years. The primary principle of Ri Kōran's films is that the invader is always a man, while the person from the invaded country who is obedient and loyal to the invading power, is always a woman. If it were the opposite, a love story between a Chinese man and a Japanese woman, the film likely never would have even made it through the planning stages. Most Japanese

Ri Kōran [Yamaguchi Yoshiko].

viewers unquestioningly believed that she was Chinese. As long as a person's actions fit with the Japanese stereotype, nationalism would confirm that interpretation. Later, Ri would go on to play the daughter of a Taiwanese indigenous person as well as a Korean daughter in Japanese films. Once Japan surrendered, she went to Hollywood in the 1950s, and under the name Shirley Yamaguchi, she played the role of a Japanese war bride. In this instance as well, she plays a woman from the invaded country. As an actress, Ri Kōran has occupied an extremely important place within the context of numerous issues, including colonialism, nationalism, and gender both in what she herself has done and what her image has meant to different people at different times. Moreover, in the 1970s, she went to Beirut to help shoot interviews with Yasser Arafat, the head of the Palestinian

Liberation Organization, as well as with members of the Japanese Red Army, garnering a prize from a Japanese television station. Ri Kōran's unusual life is currently being mythologized as an original Japanese musical, causing a stir not only in Japan but also in China.

THE END OF MAN'EI

Let us return to the discussion of Man'ei. After 1942, there were shortages of raw film in Japan, and with this as one of the reasons, several filmmakers—from Kimura Sotoji to Uchida Tomu— left the homeland for Manchuria. The film My Nightingale (Watashi no uguisu, 1944),[6] a coproduction of Man'ei and Tōhō directed by Shimazu Yasujirō, scripted by Iwasaki Akira and starring Ri Kōran, was a melodrama in the musical mode and almost entirely in the Russian language. Although completely unthinkable in the homeland, this production shows that the spirit of "Five Tribes Working in Harmony"—touted as the national policy of Manchuria—had a kind of life among a certain coterie of filmmakers.

When Manchukuo collapsed in 1945, the occupying Soviet Army quickly seized Man'ei's equipment and film. The Eighth-Route Army that arrived next turned it into the first Chinese Communist Party studio, requesting technical assistance from remaining Japanese staff. Many Manchurian staff fled and sought refuge in Hong Kong and Taiwan. Negishi and Makino, who had returned to the "homeland" early, built the foundations for today's Tōei and welcomed returnees from Man'ei. In this way, Man'ei planted the seeds for regional cinema through a large part of East Asia. A figure who followed one of the strangest and most convoluted paths within this configuration was the cameraman Nishimoto Tadashi. Returning to post-defeat Tokyo, he spent the 1950s at Shin Tōhō and shot films there about Emperor Meiji. He then made his way to Hong Kong in the 1960s and became the cameraman for anti-Japanese productions from King Hu and Bruce Lee. Man'ei thus became the source for wandering film personnel for half a century during the postwar period.

CHINESE FILM STUDIOS IN SHANGHAI

Shanghai was the center of Chinese film production from the 1910s. After Japan established Manchukuo in 1932, filmmakers there began actively producing anti-Japanese films. In 1937, the Japanese Army occupied Shanghai, but because the film studio was in the French concession, they were largely able to continue producing independent films after that. The Japanese Army then asked Kawakita Nagamasa of Tōwa Trading to take control of Chinese film. Kawakita began by having Suzuki Shigeyoshi shoot *The Road to Peace in the Orient* (*Tōyō heiwa e no michi*, 1938) to placate the Chinese population. When Kawakita established the China Movie Company in 1939, he went so far as to welcome the secretly anti-Japanese Zhang Shankun to produce the "National Defense Film" *Mulan Joins the Army* (*Mokuran jūgun*). Moreover, in 1942, he consolidated twelve studios to make China United Productions Limited. Kawakita had heard that criticism was leveled at the film studio at Man'ei; in response, he adopted a policy of avoiding production plans that placed only Japanese in leadership positions, provided raw film stock for Chinese films made by Chinese, and avoided commentary on content. Of course, regardless of how liberal a policy this might have been, Kawakita could not erase the fact that Japanese, with the support of the military authorities, ruled the world of cinema in China during this period. Again a coproduction with Man'ei starring Ri Kōran, *Eternity* (*Wàn shì liú fāng*, 1943) stirred great interest. Against the backdrop of the Opium War, the film tells the story of Lin Zexu, who fought heroically against the violent oppression of the British military. In an odd coincidence, Makino Masahiro shot *The Opium War* (*Ahen sensō*) in the same year.

In 1945, when the Japanese were defeated and the Chinese Nationalist Army returned, the Chinese filmmakers who had worked there, beginning with Zhang Shankun, were branded as traitors and fled to exile in Hong Kong, thus establishing the foundation for a flourishing film industry there in the postwar period.

FILM PRODUCTION IN SOUTHEAST ASIA

Finally, I would like to touch briefly on film production in Southeast Asia, in particular, in places occupied by the Japanese during the Second World War, from 1942 to 1945.

In Indonesia, film production by the native population was forbidden, and propaganda films were made by Japanese under the rule of the Japanese military. These films were made to teach Indonesians the Japanese language and to encourage them to form neighborhood associations based on the Japanese model to learn about the Japanese spirit.

Calling Australia (1944), a film shot in Jakarta by Hinatsu Eitarō, who I discussed in the section on Korean film, was a fake documentary produced with the aim of hiding the abuse of prisoners of war by the Japanese Army. This work, which appeared to be shot autonomously by an Australian prisoner, was sent to the allied nations through the Red Cross. After the war, Australia reassembled the prisoners of war who were forced to appear in it and made a documentary to expose the film's mendacity. Hinatsu had a Japanese name, but in fact he was a Korean named Huh Young, and he remained in Jakarta even after he received notice of the resurrection of his Korean homeland. When Indonesia became independent, he made several melodramas there under the name Dr. Huyung. He is remembered in Indonesian film history as being the first director in that country to shoot a kiss scene.

The circumstances in the Philippines were drastically different from those in Indonesia. This nation, which had been a direct colony of the United States, was already making musicals and melodramas with a strong Hollywood influence in the 1930s. As part of a larger colonial policy, the United States had planned to set up Manila as the Hollywood of Asia. In Indonesia as well, the Japanese military forced prisoners of war to appear in films. *The Dawn of Freedom* (*Ano hata o ute*), a 1943 film made through the auspices of the Japanese military, was a coproduction directed by Abe Yutaka

and Herald De Leon. Abe had studied in Hollywood in the 1920s, but even so, could achieve only a rigid directing style. Leon had a much more classical Hollywood touch, steeped in the techniques of light, dreamy melodramas. The difference between the two directors is clear at a glance. The contrast vividly demonstrates the differences between Japan and the Philippines in the depth of their experience of American film. *Dawn of Freedom* aimed to praise the Japanese Army's driving the United States out of the Philippines, but ironically, it drew its most impressive and moving episodes from an American movie: John Ford's *How Green Was My Valley* (1941). Under the Great East Asian Co-Prosperity Sphere, filmmakers encountered Hollywood in numerous forms and then made films based on those memories. When Japan was defeated, the cameraman Miyajima Yoshio burned the negative for *The Dawn of Freedom* to destroy the evidence so the facts about prisoner abuse would not be discovered. As a result, in spite of his transgressions, he flourished as a central figure in left-wing movements in the postwar Japanese film world.

6

JAPANESE CINEMA UNDER AMERICAN OCCUPATION: 1945–1952

FILMMAKERS AT THE END OF THE WAR

In August 1945, Japan surrendered unconditionally to the Allied nations, bringing the Second World War to an end. For Japan, this marked the end of a long fifteen years of war, a period that began with the military invasion of northeast China in 1931. In September 1945, GHQ[1] rule over Japan began, and it continued until 1952. Japan lost its colonies—Korea, Taiwan, and the islands in the South Pacific—and Okinawa was seized and put under the jurisdiction of American military powers. As a result of the loss of these colonies, the Japanese Empire lost any obvious trace of ethnic and cultural diversity, and the postwar ideology of Japan as an ethnically homogenous, unified linguistic unit gained currency. Emperor Hirohito made his declaration that he was human, and the emperor became a symbol of the state under the new constitution. It was the beginning of so-called postwar democracy.

WHAT WERE JAPANESE FILMMAKERS DOING WHEN THE WAR ENDED?

Thanks to the efforts of his father, Kurosawa Akira avoided going to war. He was in the middle of filming *The Men Who Tread on the Tiger's Tale* (*Tora no o o fumu otokotachi*, 1945) when the war ended. He ignored the end of the war and managed to continue until the film was complete, but he was not allowed to screen the film publicly. Tasaka Tomotaka was exposed to radiation at Hiroshima, and as a result, endured a painful struggle against the illness that lasted many years. He accepted this as retribution for his transgressions. Mizoguchi Kenji completely lost all sense of direction, while his disciple, Shindō Kaneto, welcomed the arrival of a new age. Makino Masahiro quickly took out musical instruments that had been stored away at the studio and hastily organized a jazz band to welcome the occupying army. In a prisoner-of-war camp in Singapore, Ozu Yasujirō watched Hollywood movies day after day. And Uchida Tomu, after witnessing the suicide of Amakasu Masahiko, remained in Manchuria for the following eight years. After he was sent to a mine for labor, he instructed Chinese filmmakers in the use of film technology. This is the way that postwar Japanese cinema began.

In October 1945, Shōchiku released the first postwar Japanese film, Sasaki Yasushi's *A Gentle Breeze* (*Soyokaze*). It featured a huge hit with *The Apple Song* (*Ringo no uta*), which Namiki Michiko sings in a fruit orchard in her family home in the countryside far removed from the devastation of Tokyo.

CENSORSHIP UNDER THE OCCUPATION

Also in October 1945, the Civilian Information and Education Division (CIE), a subsidiary organization of GHQ, came to manage the entirety of the Japanese film industry. The CIE was given

absolute authority over censorship of all the films that were produced. Japanese producers had to have all proposals and scripts translated into English and receive permission before they could begin filming. The completed film underwent a second censorship through the Civil Censorship Detachment (CCD). At the core of the CIE were American civilians, but the CCD was composed of military figures, which meant that ultimately this was military censorship.

On one hand, the United States preached freedom and democracy to the Japanese, but on the other, they resolutely carried out censorship on films that were not advantageous to them. This contradiction affected the entire process, bringing grief not only to Japanese filmmakers but also to the American censors. In addition, the policies of GHQ were clearly different between the beginning and end of the Occupation. Initially GHQ had a socialist orientation and carried out agricultural reform and the dissolution of the *zaibatsu* economic cartels. At the end of the Occupation, anti-communism was prioritized. The basis of censorship changed in accord with these shifts.

In November 1945, David Conde, the chief of CIE, assembled a list of thirteen things that were banned from Japanese films, based on the perception of wartime Japanese cinema as extolling militarism and renouncing Western individualism. The list began with things that offered praise for nationalism, patriotism, or fealty to feudal thought, but it also included such categories as revenge stories, stories praising suicide, or any works that encouraged cruelty and immoral violence. Finally, as though it were perfectly natural, any film that opposed GHQ directives was also subject to censorship. This latter had no connection with the aforementioned categories and indicated that GHQ could freely ban anything. Incidentally, throughout the Occupation, GHQ took extreme care to hide the fact that this censorship was being carried out.

With this GHQ directive, it became effectively impossible to produce *jidaigeki*. It is true that there were exceptions, like Kinoshita Keisuke's *Ghost Stories of Yotsuya: A New Interpretation* (*Shinshaku Yotsuya kaidan*, 1949). This work, however, did little apart from applying a weak psychological explanation from a contemporary

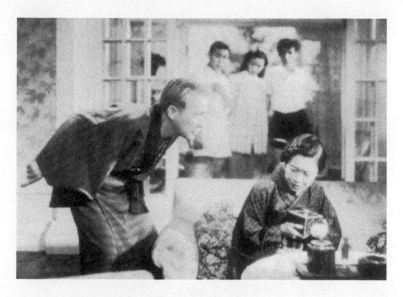

Broken Drum (dir. Kinoshita Keisuke, 1949).

standpoint to Tsuruya Nanboku's original Kabuki play. The sense of dynamism and beauty of pathos that are so much a part of pre-war *jidaigeki* as a genre were utterly absent. *Jidaigeki* without using a sword—conceived as a means of short-circuiting censorship rules— could never earn the support of the masses. As a result, long-time stars of *chanbara* movies were compelled to move over to *gendaigeki* films. Kataoka Chiezō played a detective with so many disguises that he was known as the "man with seven faces" in the *Tarao Bannai* series (1946–1960), and Bandō Tsumasaburō played a caricature of the patriarchal father whose meaning would be merely humor-ous within postwar society. Curiously, masters of *chanbara* such as Inagaki Hiroshi and Itō Daisuke directed *gendaigeki* masterpieces, such as *Children Holding Hands* (*Te o tsunagu kora*, dir. Inagaki, 1948) and *The Shogi Master* (*Ōshō*, dir. Itō, 1948).

Film censorship by GHQ also applied to past films. With great strictness they inspected those prewar films that managed to sur-vive the wartime firebombing and any scenes considered improper

were summarily cut. For this reason, many films, including Mizo-guchi Kenji's *The Water Magician* (*Taki no shiraito*, 1933), now exist only in incomplete form. *Genroku chūshingura* remained intact only because it was immediately confiscated by the United States. It was returned to Japan in complete form twenty years later.

IDEA FILMS

The occupying army did not simply ban a list of forbidden subjects. They actively encouraged production of "idea films," in the inter-est of enlightening the population about American-style democracy. Those filmmakers who had hitherto been directed by the military

No Regrets for Our Youth (dir. Kurosawa Akira, 1946).

to make films to boost militarism were now being confronted with demands by the United States to shift direction and make works extolling democracy. Let us look at some of these idea films.

Kurosawa Akira's *No Regrets for Our Youth* (*Waga seishun ni kuinashi*, 1946) tells the story of the daughter of a professor who, during the prewar period, is removed from his university post for participating in antiwar movements. The daughter marries one of her father's pupils—an antiwar activist—and after he dies in prison during the war, she continues his legacy. The daughter in the film—played by Hara Setsuko—lives in a farming village where the family home of her late husband is located and continues to work on the farm trying not to succumb to the persecution directed at her as an antipatriot by angry villagers. With the defeat of militarism, she stands at the head of an agricultural reform movement, struggling to erect a new Japan. The man in charge of the script, Hisaita Eijirō, was a leftist in the prewar period, but he cooperated with the authorities during wartime. It may not be so difficult to read this narrative as one of his personal "regrets of youth." Some film critics criticized Hara's performance in the film as being overly stiff. Viewers who were accustomed to Hara playing the bride of a military officer or police officer during the war accepted her with a mixture of confusion and anticipation.

Kurosawa was upset that—under pressure from the labor union of Tōhō, the production company—he had to append a section at the end of the film depicting Hara's participation in the agricultural reform movement. Looking at it now, however, even though the impetus to include these scenes was leftist, what actually resulted in the final scenes from *No Regrets for Our Youth* are strikingly similar to those from the Nazi film *The New Earth* she had starred in nine years earlier. This episode is a good illustration of the nature of postwar leftist movements.

For several years during the occupation, Hara Setsuko enjoyed a reputation as a goddess of democracy. In Yoshimura Kōzaburō's *Ball at the Anjō House* (*Anjōke no butōkai*, 1947), she played the role of the eldest daughter of a family brought down with the collapse

of the nobility; she urges her aging father to seek out new ways of living for a new age. In Imai Tadashi's *The Blue Mountains* (*Aoi san-myaku*, 1949), in the role of a progressive teacher newly assigned to a rural high school, she earns the respect of her students for defeating the feudal powers of the town. Curiously, where Arnold Fanck once unstintingly praised her as the prototypical Japanese woman, Hara was taken as a metaphor for a new Western era for viewers of a defeated nation on account of her large stature. No one publicly criticized her ideological about-face perhaps because, to some extent, in the postwar era, without exception, everyone was forced to make similar accommodations.

THE PROBLEM OF WAR RESPONSIBILITY

As was the case with literature and theater, as well as music, the problem of war responsibility in the world of cinema was intentionally rendered ambiguous, and by the time it was settled at a formal level, people could no longer dare to make any claims. Kamei Fumio, who had endured life in prison after making *Shanghai*, released *A Japanese Tragedy* (1946) through Tōhō, in which he handled the conversion of Hirohito from a figure in military garb into a man in a suit with a slow lap dissolve. The claim of this work is that it is the Japanese military that should be prosecuted, while citizens were merely duped by the military. This logic was highly convenient for Japanese people to break off from the past and face a new era. Kamei, who had shown his astonishing skill in deconstructing ideology with *Shanghai*, fell into mere dogmatism with *A Japanese Tragedy*. He was unable to interrogate whether the democracy Japanese people were now ostensibly enjoying was truly their own. Incidentally, through the policy of GHQ, screenings of the film were quickly banned and then the film was seized by the United States.

As part of a unified Occupation policy, it was demanded that those who were in a leadership position within the wartime film industries would be purged from all public positions. This accusation, however,

was extremely difficult to make. In Japan, unfortunately, there was no one like Elia Kazan to inform on his friends one after another. Thus, a difficult situation arose: whenever they did to try to put together a list of wartime collaborators, those who put people on the list ultimately wound up added to it themselves. Itami Mansaku, who had contributed to Nazi film when he codirected *The New Earth*, insisted on the impossibility of determining who were war criminals. It was not that the deceivers were bad and that those deceived were good—according to Itami's logic, the act of being deceived in itself was bad and disqualified the deceived from accusing others. Of course, it is unlikely that this argument would have convinced GHQ. The occupying army understood the situation as one in which a small number of managers gave orders to a large number of people who, because they did not make the decisions, were considered innocent. It is true that Kawakita Nagamasa, Negishi Kan'ichi, and Kido Shirō, who produced inflammatory propaganda films, were famously purged in 1947. This punishment was lifted in 1950, and they resumed their positions as bosses of big studios, and their authority did not change in the slightest from the prewar days.

WHAT KIND OF FILMS DID INDIVIDUAL DIRECTORS SHOOT DURING THIS PERIOD?

Saitō Torajirō, who shot the slapstick comedy *Five Men from Tokyo* (*Tokyo gonin otoko*, 1945) soon after the war ended, appealed to viewers by making them laugh heartily at the postwar chaos. Kinoshita Keisuke, with *Morning for the Ōsone Family* (*Ōsoneke no ashita*, 1946) revealed the cowardice of a former soldier. Film studios were compelled by Conde to film a kiss scene among Japanese people akin to that in American cinema. This fell to the actors in Sasaki Yasushi's *Twenty-Year-Old Youth* (*Hatachi no seishun*, 1946) who had to conduct the first kiss scene in Japanese cinema, anguished and with gargling cup in hand. Ozu returned to Japan to make a humanist picture set in Tokyo's *shitamachi* area, but he could not recover the feeling of

regarding life philosophically with humor that had animated his prewar works. Just as Mizoguchi Kenji had forced himself to learn the philosophy of the emperor system, he now studied postwar democracy, making one film after another about women's liberation. That said, these were stylistically a far cry from the works he had made during the wartime, amounting to little more than a proof that he was fundamentally ill suited to abstract political ideals.

THE RISE OF KUROSAWA AKIRA

The person who emerged at the forefront during this period was Kurosawa Akira. In *Drunken Angel* (*Yoidore tenshi*, 1948), he cast newcomer Mifune Toshirō as a gangster with tuberculosis, and urged a philosophy of hope that does not disappear even in the face of solitude and despair. Around the same time, based on a script by Kurosawa, Taniguchi Senkichi shot *Escape at Dawn*

Escape at Dawn (dir. Taniguchi Senkichi, 1950).

(*Akatsuki no dassō*, 1950) with Yamaguchi Yoshiko (the Japanese name of Man'ei's star Ri Kōran). Had it been directed according to the original script, this work would have been the first Japanese film to depict Korean comfort women; however, after more than a dozen rounds with CIE censors, it changed in content such that any trace of the original story was lost.

In bringing this chapter on the late 1940s to a close, I touch on the labor disputes at Tōhō. Tōhō was the studio that was coziest with the military authorities during the war; however, it was also a hive for those leftists who only pretended to convert. In the postwar period, Tōhō's labor union first tried to get the company to admit their responsibility for what they had done in wartime. Once they realized this was not possible, they pressed for allowing the participation of the union in production, administration, and planning. The union would produce the films independently and distribute them as works of Tōhō. With the intervention of the Japanese Communist Party, however, the union split up into factions. Most of the stars and veteran directors left the union, and Tōhō established a new company—Shintōhō ("New Tōhō")—for them in 1947. One year later, in 1948, Tōhō announced mass layoffs in its battle against the union, and they entered into a prolonged strike. This became a symbolic action on the part of Japanese leftist activists in the postwar period, one in which tanks from the occupying army were mobilized.

With the outbreak of the Korean War in 1950, the occupying army, which had transformed from a reforming force into a barricade against communism, carried out a red purge within the film world. Directors who were members of the Japanese Communist Party, such as Kamei, Imai, and Yamamoto Satsuo, were urged to fight by the party. Kurosawa, Naruse Mikio, and others temporarily transferred to new companies to keep making films. Thus, the first postwar independent production movement emerged out of this purge. Strangely, no filmmakers thought to make documentary films about these mass-scale struggles.

Insofar as Japanese cinema was managed and controlled through foreign institutions for the first time, the seven years between

1945 and 1952 constitute a peculiar period within Japanese film history. It is only when we compare the censorship of the postwar era with that which was carried out prewar, or that of the governor general in colonial Korea, that the contradictions and singularity of GHQ censorship become clear. It is difficult, however, to provide a conclusion to the question of what kind of material changes were undergone by Japanese cinema as a result of censorship. It is true that it was Japanese people who extolled democracy in idea films, but in 1952, once *jidaigeki* were permitted once more, it was those same Japanese people who applauded new versions of *Chūshingura*. Assessment of the pros and cons of the events during this time varied, as they do even now when over a half century has passed. This is true not only of cinema but of all of the conditions in the society surrounding cinema as well.

7

TOWARD A SECOND GOLDEN AGE: 1952–1960

THE END OF THE OCCUPATION SYSTEM

In 1951, the San Francisco Peace Treaty was ratified, and the following year, Japan regained its independence. GHQ film censorship was eliminated, and the complicated stipulations binding Japan's film industry up to this time were abolished. The idea films of the immediate postwar period disappeared, and at the same time, the *jidaigeki* that had been de-facto banned quickly blossomed, gathering mass popularity. Although independent productions championing socialist realism saw a temporary boom, films that beautifully depicted nostalgia for the war were also produced one after another. As Japanese films swept up prizes at international film festivals, works came to be produced with the hope of gaining this recognition. Tōei grew with personnel returning from the old Man'ei taking a central role, and Nikkatsu began film production again, making for a six-studio system all mass-producing program pictures—films to be distributed as full programs with major and minor features (including shorts and newsreels) or as double-bills.[1] In 1958, an unprecedented 1,127,000,000 Japanese went to the movies, and Japanese cinema

was embarking upon a second golden age. Cinema became the king of entertainment, a gathering place for mass enlightenment, and the ultimate medium to restore the cultural pride that had been lost in the international arena.

The first films to be produced soon after the end of GHQ censorship were films that focused on the atomic bombings. Under the Occupation, as a general principle, any films that referred to the bombings of Hiroshima or Nagasaki were strictly banned, unless it was steeped with Christian sentiment like Ōba Hideo's *The Bells of Nagasaki* (*Nagasaki no kane*, 1950). *The Effects of the Atomic Bombs on Hiroshima and Nagasaki* (*Genshi bakudan no kōka—Hiroshima • Nagasaki*, 1946), produced in the immediate postwar by a group led by Iwasaki Akira, was seized for a long time. Of course, Iwasaki, knowing well that if it were discovered he would be sentenced to hard labor in Okinawa, hid the print of the film (parts of it were released at last in 1967). Yoshimura Kōzaburō and Shindō Kaneto formed an independent production company called the Modern Film Association (Kindai eiga kyōkai), through which they produced and directed *Children of Hiroshima* (*Genbaku no ko*, 1952), a film that focused on the aftereffects of the bombs on children. Incidentally, this was also the year in which a flood of literature was related to the atomic bombs.

SHIFTS IN WAR FILMS

Major shifts also could be detected in the film images of the Second World War. The simple schema in which a war based on militarism was purely evil was jettisoned, and in its stead, innumerable works appeared that showed the war experience sentimentally. In *Listen to the Voices from the Sea!* (*Kike wadatsumi no koe*, 1950), Sekigawa Hideo depicted the anguish of students drafted into service as soldiers, and in *Tower of the Lilies* (*Himeyuri no to*, 1953), Imai Tadashi showed the young girls who fought and died fighting intensely on the battlefields of Okinawa, both films showing this experience movingly and beautifully. Kinoshita Keisuke's *24 Eyes* (*Nijūshi no hitomi*, 1954)

narrated the sad fate of elementary school students from the view of their female teacher, while Ichikawa Kon's *Harp of Burma* (*Biruma no tategoto*, 1956) offered a requiem for the souls of Japanese soldiers sent overseas. These films were not just movies; they were received as important events in Japanese society. What they held in common was the confirmation of the consciousness of the Japanese people of themselves as war victims. For example, in *Tower of the Lilies*, there is no mention of how modern Japan seized Okinawa, or how it exploited the educational system to make Okinawans into citizens of the Japanese Empire. *Listen to the Voices from the Sea!* and *Harp of Burma* totally erase the voices of the Burmese who were invaded by

Emperor Meiji and the Great Russo-Japanese War (dir. Watanabe Kunio, 1957).

Japanese soldiers. That is to say that the idea that only the deaths of Japanese are worthy of having their souls comforted is one that somehow feels very good to the Japanese people, and this idea has continued in different forms up to the 1990s to be used as an appeal by neoconservatives.

The 1950s also saw the production of many films that exalted nostalgia for the war, such as *Battleship Yamato* (*Senkan yamato*, 1953), *Eagles of the Pacific* (*Taiheiyō no washi*, 1953), and *Admiral Yamamoto and the Allied Fleet* (*Gunshin Yamamoto gensui to rengō kantai*, 1956). The significance of these films is difficult to evaluate and even critics at the time argued over whether such films should be considered "antiwar" or "prowar." For the general audience, that was not a particularly pressing issue. They simply wallowed in stories of the war, which had been banned. *Tower of the Lilies*, along with its appeals for peace and against war, also served unconsciously to inflame sentiments of revenge for America's cruel acts. On the surface, postwar leftist Japanese filmmakers were adamantly antiwar, but underneath they were anti-American patriots and ethnic nationalists. This has similarities to the complex consciousness found in *Tower of the Lilies*. The appearance of Watanabe Kunio's *Emperor Meiji and the Great Russo-Japanese War* (*Meiji tennō to nichiro dai sensō*, 1957), produced at Shin Tōhō, was an extension of such nostalgic sentiment. Casting Arashi Kanjurō—who had played the Robin Hood–like hero Kurama Tengu for so many years—as Emperor Meiji, proved tremendously successful. This film took on the emperor system, which in the prewar period was considered untouchable and sacred, and turned it into a commodity. This conversion perfectly symbolizes Japan's postwar society.

THE ADVANCE INTO INTERNATIONAL FILM FESTIVALS

The 1950s was the first time in which Japanese films were exposed in a real way to the gaze of those outside Japan—especially to that of Europe. In 1951, Kurosawa Akira's *Rashōmon* won the Grand Prix at the

Venice Film Festival. Mizoguchi Kenji followed this by winning prizes at the Venice Film Festival three times between 1952 and 1954 for *Life of Oharu* (*Saikaku ichidai onna*), *Ugetsu* (*Ugetsu monogatari*), and *Sanshō the Bailiff* (*Sanshō dayū*). The year 1954 was especially significant, because Mizoguchi's *Sansho the Bailiff* competed with Kurosawa's *Seven Samurai* at Venice. In addition, Kinugasa Teinosuke's *Gate of Hell* (*Jigokumon*) was submitted to the Cannes Film Festival in the same year, where it was crowned with the Grand Prix. European critics and audiences were astonished at these films that had arrived from an unknown land in the far East, and at the same time, this gave birth to the myth of the "Great Master," a myth that continues to be the way of thinking about film directors to this day.

Why is it that such works gained the world's attention during this period? Apart from the question of the quality of the individual works, we can consider three causes.

The first is that such films were all set in prewar Japan; the presence of *kimono* and *samurai* gave them a character that readily fulfilled Orientalist desires. Had these films been set in the present, there almost certainly would not have been so many prizewinners. One bit of proof is that the films of Ozu Yasujirō and Kinoshita Keisuke were not introduced until much later. Second, the trend toward auteurism emerged among the new Western critics—represented by *Cahiers du Cinema*—in accord with the rise of international film festivals in postwar Europe. As a result, all manner of filmmakers that had been out of the spotlight—from Hollywood B directors of the past to new directors from India and Sri Lanka—were equally designated as auteurs. The critics' darlings were masters in the realist vein, like Rossellini and Renoir; Mizoguchi, with his distinct and sophisticated film grammar, was considered a perfect fit for this category. Third, with an eye on international film festivals, Daiei's Nagata Masaichi produced films with themes and narratives that were sure to draw the interest of "foreigners." *Gate of Hell* is the perfect example of such a film. Nagata then expanded his ambitions into South East Asian markets, having Mizoguchi shoot *Princess Yang Kwei-Fei* (*Yō Kihi*) as a coproduction with Hong Kong.

Of course, any time one discusses 1950s Japanese cinema, it is never acceptable to focus exclusively on this handful of mythologized films. Behind *Seven Samurai* lay countless B-level *jidaigeki* films, and *Ugetsu* shows how Mizoguchi's tale of cruelty was achieved only after a long struggle with *shinpa* melodrama. In what follows, I take a closer look at the conditions of cinema at the time.

A BOOM IN INDEPENDENT PRODUCTIONS

In the aftermath of the McCarthyism that began in the American Senate in 1947, a red purge was carried out in the Japanese film world in 1950. Directors including Kamei Fumio, Yamamoto Satsuo, Imai Tadashi, Miyajima Yoshio, and Katō Tai, alongside actors from the leftist Kabuki theater troupe *Zenshinza*, were expelled from major studios. Yamamoto shot *City of Violence* (*Bōryoku no machi*, 1950), a film produced by the union, which had battled in the Tōhō strikes. Imai teamed up with *Zenshinza* to make *And Yet We Live* (*Dokkoi ikiteru*, 1951). Focused on the poorest day laborers, the film exposed contradictions and class discrimination in postwar society. The following year, 1952, saw the releases of the aforementioned *Children of the Atom Bomb* by Yoshimura and Shindō, as well as Yamamoto Satsuo's *Vacuum Zone* (*Shinkū chitai*), and an independent production boom was born. It was a time when the Korean peninsula was almost entirely occupied by the Communist Army, and the Communist Party in Japan was consumed by factional struggles. In any event, the boom was not sustainable and ended around 1955. Its collapse was due to the fact that the socialist realism championed by the films was swallowed up by political formalism, which led to boring films, and the system of film production for the major studios had been restructured at this time.

The person who was at the center of these movements in the early 1950s was Imai Tadashi. Imai had a hit at Tōhō in 1949 with *Blue Mountains* (*Aoi sanmyaku*), and in 1950, he made *Until We Meet Again* (*Mata au hi made*). The latter is an antiwar film depicting youth

during the war, based on a piece of short fiction by Romain Rolland. The reason why they went to the trouble of sourcing the material from a European novel is obvious: in reality, effectively no strongly antiwar college students in Japan during the war could serve as a model. The film was criticized as being a kind of pretty fairy tale, but it attracted attention because it had a scene in which two people, separated by a window glass, kiss. Imai gave up on Tōhō and left, throwing himself into independent production, and it was just after this that he made *And Yet We Live*. While skillfully navigating between independent production and major studios, he had a hit with *Tower of the Lilies*, and with *Darkness at Noon* (*Mahiru no ankoku*, 1956), he dealt with a true story of false accusation in a criminal case, preserving his commitment to being a director of social justice films. Imai was the director who throughout the 1950s received the most number-one film awards in the annual polls by the journal *Kinema Junpō*, among the most authoritative periodicals of the film world at the time.

SAMURAI AND *KAIJU* AT TŌHŌ

The major companies from during the wartime—Tōhō (including Shin Tōhō), Daiei, and Shōchiku—were in the process of establishing a system to distribute program pictures at the start of the 1950s. Tōei joined this system in 1951, and in 1954, pulled ahead of the other companies with double-bill programs, which consisted of two feature films. Finally, in 1954, Nikkatsu restarted its production, but it was prevented from getting the actors it sought by the Five Company Agreement between the major studios. Using this exclusion to its advantage, Nikkatsu began producing action films, which is discussed at the end of this chapter.

The three characteristic features of Tōhō during this period are as follows: (1) the *Shachō* series, (2) Kurosawa Akira (1910–1998), and (3) *kaiju* movies. The *Shachō* series showed a dynamic but hapless company president and his loyal group of assistants.

This quintessential product of Japan in its time of economic growth would continue into the 1960s. Morishige Hisaya, who played the protagonist "Shachō" (company president) from the middle of the series, defined the character of businessman comedies made by Tōhō in the 1960s—its fundamental atmosphere was full of bright, cheerful, humanist sentiment. This atmosphere at Tōhō expanded the world of *shōshimin* films made by Shōchiku in the 1930s by recasting them within the postwar era of high economic growth. The worldview of the urban petit bourgeoisie became an anchor for film companies in the wake of the dissolution of the system of militarism.

Kurosawa Akira raced through the 1950s as though nothing could stop him. After writing numerous screenplays, beginning with *Escape at Dawn* (*Akatsuki no dassō*, 1950) for Taniguchi Senkichi, he continued to direct a series of works without pause: *Ikiru* (*Ikiru*, 1952), whose title means "to live"; *Seven Samurai* (1954); *Throne of Blood* (*Kumo no sujō*, 1957), whose title means "the spider's nest castle"; and *The Hidden Fortress* (*Kakushi toride no san'akunin*, 1958). *Ikiru* relays the story of an old man who, when informed he has little time left to live, anguishes over the question of how best to spend his remaining time. The hole in his body from cancer, the hole in his spirit, and the hole of the abandoned wetland in the middle of town, overlap with one another as objects that the man must confront in a process of self-healing. The old man is played by Shimura Takashi, and through a performance that complicates the figure of the serious and purely righteous man by filling him with doubt, showed Japanese people an alternate way of aging in contrast to the more philosophic and resigned way of Ryū Chishū in Ozu Yasujirō's films. *Seven Samurai* provided the template for numerous action films. To be sure, both Kurosawa's way of establishing characters, and the striking battle scenes are breathtaking, and the phony samurai played by Mifune Toshirō, as both heroic and childish, is an extremely compelling figure. What Kurosawa was truly interested in pursuing, however, was the defeat of the samurai, who until the end were never really trusted by the local peasants, and mourning for

warriors killed in battle. Kurosawa must have felt remorse for the facile way in which the protagonist joined the agricultural enlightenment movement at the end of *No Regrets for Our Youth*. *Throne of Blood* is an extraordinary adaptation of *Macbeth*, incorporating multiple formal aspects of *mugen* Noh[2] into its narrative construction. Finally, *The Hidden Fortress*—the film that was the inspiration for *Star Wars* (1977)—displays the most dynamic sense of space among Kurosawa's works.

Although he may have a tendency to get lost in the shadow of Kurosawa's vibrant activity, Naruse Mikio (1905-1969) shot a number of extremely subtle, mature films adapted from the writings of Hayashi Fumiko. In complete contrast to Kurosawa, Naruse liked to portray protagonists who are always indecisive and melancholic, existing solely in their relations with others. If any director within Japanese cinema could properly be called a "woman's" (*joryū*) filmmaker, it is hard to imagine anyone other than Naruse during this period.

In 1954, the year that *Seven Samurai* was released, *Godzilla* was unleashed on the world by Honda Ishirō (1911-1993), who had entered PCL at the same time as Kurosawa. Tsuburaya Eiji, who was in charge of special effects, had worked as an assistant director to Josef von Sternberg the previous year on *Anatahan* (1953). If the chiaroscuro was especially striking when the ancient monster was revived through hydrogen bomb tests, and crossed Tokyo Bay at night to attack greater Tokyo, that is probably because this member of the crew was trained by the director who had used such striking and singular lighting to present Marlene Dietrich before the world.

Godzilla would go on to be a huge moneymaker for Tōhō, launching the globally unprecedented genre of the *kaiju eiga*, but it was originally an antinuclear film with an ecological perspective. The idea of a threat to Tokyo, born in the south seas, is unthinkable without considering the air raids by the American forces that scorched the Japanese archipelago just nine years before the film was shot, as well as offering repose for the Japanese soldiers sent to the south seas. Here, too, the presence of the war can be seen. In the wake of

Mothra (dir. Honda Ishirō, 1961).

Godzilla, for more than half a century, Tōhō would produce films about monsters attacking Japan, monsters like Matango, Radon, Mothra, and King Ghidorah. The characterization of Godzilla continued to change gradually throughout its serialization. In *King Kong vs. Godzilla* (1962), he stood on the side of Japanese nationalism, squaring off against the giant ape that came from the United States. In that work, he no longer bore the slightest trace of that frightening threat he once presented in his first movie appearance.

At Shin Tōhō, which began as a subsidiary and then became independent of Tōhō to forge its own management policy, there was an atmosphere that indulged all kinds of absurd movies. Ichikawa Kon (1915–2008), with *Pu-san* (1953), drew attention for his freshly humorous sensibility. He later shot the Izumi Kyōka classic

Nihonbashi (1956) at Daiei, making bold use of gaudy colors at the center of the frame against a black background, casting a distancing effect on viewers accustomed to *shinpa*. At the same time, Nakagawa Nobuo (1905–1984), a veteran who had shot Enoken comedies during the prewar period, filled the screen with a sense of the grotesque rooted in Japanese views of life and death with his version of a Kabuki ghost story in *The Ghosts of Yotsuya* (*Tōkaido Yotsuya kaidan*, 1959) and *The Afterworld* (*Jigoku*, 1960). He displayed a penchant for peering into the abyss of evil in Japanese people.

DAIEI MOTHER FILMS AND MIZOGUCHI KENJI

Under the leadership of Nagata Masaichi, Daiei took their first postwar steps away from the production of crude melodramas with a series of "mother films" (*haha mono*) featuring Mimasu Aiko. The origins of this series go back to Henry King's *Stella Dallas*. The films are based on stereotypical narratives of an uneducated but pure-hearted mother, played by Mimasu, who hides her emotion with a stoic face through everything as she hopes for her children to rise in class. Beginning with Mori Kazuo's *Wildcat Lady* (*Yamaneko reijō*, 1948), thirty-one films were produced in the series through the late 1950s. What put a definitive end to this series, as I will detail, was Mizoguchi Kenji's 1956 film *Street of Shame* (*Akasen chitai*).

At the same time that Daiei produced excellent films by prewar veterans Inagaki Hiroshi and Itō Daisuke set in contemporary times like *Children Holding Hands* (*Te o tsunagu kora*, 1948) and *The Shōgi Master* (*Ōshō*, 1948), the studio also poured their energy into *jidaigeki* during the 1950s. At the heart of this movement was the *Zenigata Heiji Detective Series* (*Zenigata heiji torimonochō*, 1951–1961) by Hasegawa Kazuo. They also seized a golden opportunity by employing new actors with contrasting personalities—the handsome young star Ichikawa Raizō and leading man Katsu Shintarō. In terms of actresses, Wakao Ayako, with the healthy, friendly face of ordinary Japanese people, was just beginning to distinguish herself.

With the success of *Jigokumon*, as the first film in Japan to use Eastman Color, Nagata Masa'ichi had its director, Kinugasawa Teino-suke, direct four full-color *shinpa* melodramas starring Yamamoto Fujiko, a great beauty who was originally Miss Nippon. Within this postwar period of high economic growth, this ended up as a grandi-ose anachronism. *Shinpa* films based on Kyōka's writings had long constituted the core of Japan's melodramas, but when Misumi Kenji shot the fifth and final version of *A Woman's Pedigree* (*Onna keizu*) in 1962 with Ichikawa Raizō, this trend truly came to an end.

Few would dispute that the single most important figure for Daiei during this period was Mizoguchi Kenji (1898–1956). He was overly conscious of the new democratic ideals of thought under the occupa-tion, of which he had only a simple-minded understanding, and that kept him from projecting his view of women adequately on screen. However, *Life of Oharu* (*Saikaku ichidai onna*, 1952), which he shot at Shin Tōhō, marks a turning point, after which he would direct eight additional films in the four remaining years of his life. Each of these works would boost his reputation as a master filmmaker. *Ugetsu* (*Ugestu monogatari*, 1953) is replete with elegant camera movement and a sense of ghostly presence, a direct display of the ideals of the culturally Japanese construction of space he saw in Japanese paint-ings, especially scroll paintings (*e-makimono*). The director clearly projects himself into his work in *Sanshō the Bailiff*, a work that reinter-preted its literary source—Mori Ōgai's neo-Confucian historical fic-tion version of a medieval *sekkyō bushi* ballad—through the lens of a Buddhist sense of impermanence. In his final film, *Street of Shame*, he depicted the vicissitudes of a varied group of women on the margins, assembled at a Tokyo brothel. After Mizoguchi devoted his life to gaz-ing on woman as the other, this is a work he could finally make now, at the end of his career. Here, he ventured to cast the star of maternal melodramas Mimasu Aiko as a crazed, old prostitute, depicting the cruel encounters she has with her grown son. A grotesque parody of the ideology of getting ahead (*risshin shusse*), the ideology at the heart of modern Japan, *Street of Shame* served at the same time as the explication of the logical conclusion of the melodramas that he had previously directed with such passion.

SHŌCHIKU MELODRAMA: KINOSHITA AND OZU

In the postwar era, Shōchiku's production focused on humanist stories of the common folk and on melodramas for women. Ōba Hideo's *What Is Your Name (Kimi no na wa*, 1953–54) provided the model. A man and woman who are strangers to one another happen to meet on a bridge in Ginza during the wartime. During the postwar chaos, they look for one another throughout Japan, but they keep missing each other. This three-part work, whose introduction recalls Mervyn LeRoy's *Waterloo Bridge* (1940), ends with a sightseeing map covering the entire nation put up on screen for the viewers. Conversely, the person who embodied Shōchiku's human comedies most authentically was Shibuya Minoru. With works such as *Crazy Uproar (Tenya wanya*, 1950), *Freedom School (Jiyū gakkō*, 1951), and *Crazy Village (Kichigai buraku*, 1957), he managed to depict the tumult of postwar society with tremendous humor.

Throughout the 1950s, the director Japanese people trusted most was Kinoshita Keisuke (1912–1998). With the cooperation of Fuji Film, he shot Japan's first color film, *Carmen Comes Home (Karumen kokyō ni kaeru*, 1951). He cast Takamine Hideko as a cheerful stripper with a heart of gold, depicting her triumphant return to her hometown in all its radiance. In *Times of Joy and Sorrow (Yorokobi mo kanashimi mo iku toshitsuki*, 1957), he developed what might be called his own "theory of the essence of the Japanese" (*Nihonjinron*)[3] by depicting the life of a lighthouse keeper who wanders through the hinterlands of Japan.

In the immediate postwar years, like his colleague Shibuya, Ozu Yasujirō (1903–1963) tried to focus on the gentle humor that wafts through the lives of everyday people, but this did not seem to match his natural inclinations. Apparently, postwar society was already too complicated for him to film remakes of the Kihachi films he specialized in during the prewar period. Thus, following *Late Spring (Banshun*, 1949), he shifted the scene to Kamakura, or to the bourgeois residences of the tonier parts of Tokyo, polishing his philosophical mode of resignation even more than he previously had. What *Tokyo*

Story (*Tokyo monogatari*, 1953) presents is nothing other than the gradual collapse of the family system. Ozu's film boldly depicted this collapse through rigorous attention to the size of the figures within the frame. He consistently used reverse cuts—in which the camera shifts back and forth across the 180-degree axis[4]—filming characters head-on from a frontal angle. The dialogue was so distilled it would be impossible to eliminate even a single word. It must be the most austere film in Japanese film history. By appearing in Ozu's films, Hara Setsuko, the goddess-like figure of postwar democracy, utterly reversed her myth as an actress. She switched from her role as an activist urging the destruction of feudalism to being the last to embody a traditional pure and virtuous woman in the second conversion in her life as an actor.

PERIOD FILMS AT TŌEI

In the immediate wake of the war, Tōei was under the wing of Tōyoko films, which had been scraping along. Tōei was newly established as a production company in 1951, with Man'ei's Negishi Kan'ichi jumping on board. Negishi brought in his former colleagues, who had returned from the continent, one after another as film personnel, putting Makino Mitsuo in charge of production. He did not hesitate to welcome leftist film personnel who had been abandoned by other companies during the red purge, including Imai Tadashi, Sekigawa Hideo, and Ieki Miyoji. We could even say that Man'ei's legacy served as the undercurrent for Tōei.

In establishing itself, Tōei made use of prewar *jidaigeki* stars, who had been making mostly films set in contemporary times, like the *Tarao Bannai* series, as they were unable to find work elsewhere. Once the studio truly opened in Kyoto, however, the proportion of *jidaigeki* grew considerably, with Kataoka Chiezō's *Tattooed Magistrate* (*Irezumi hankan*) and Ichikawa Utaemon's *The Idle Vassal* (*Hatamoto taikutsu otoko*) both becoming series. In 1952, when Japan regained its independence, it was Tōei who quickly put out the Kataoka Chiezō

vehicle *Akō Castle* (*Akōjō*, 1952) and had Hagiwara Ryō direct. When they acquired the "new faces" of Nakamura Kinnosuke, Azuma Chiyonosuke, and Ōkawa Hashizō, Toei became a temple of *jidaigeki* program pictures, far surpassing Nikkatsu's output during the 1930s. These actors displayed none of the brutality and intensity of prewar stars like Bandō Tsumasaburō or Ōkōchi Denjirō, and instead, they created a bright, cheerful *chanbara* style. This can be called the manifestation of *après-guerre* in *jidaigeki*. Classic *jidaigeki* stories were remade in this mood as with Katō Tai's *In Search of Mother* (*Mabuta no haha*, 1962) and Yamashita Kōsaku's *Yakuza of Seki* (*Seki no yatappe*, 1962), which both featured Kinnosuke in the lead.

Uchida Tomu, who stayed in Manchuria for eight years after Man'ei collapsed, helping Chinese film crews learn film technologies, was welcomed by Tōei when he returned to Japan. Although he worked vigorously to make *jidaigeki* with a somber sensibility, such as *Bloody Spear on Mount Fuji* (*Chiyari fuji*, 1955), the three-part series *Sword in the Moonlight* (*Daibosatsu tōge*, 1957-1959), and the five-part series, *Miyamoto Musashi* (1961-1965), he also shot the film *A Fugitive from the Past* (*Kiga kaikyō*, 1964), starring Mikuni Rentarō and set in contemporary times. Running throughout each of these works is the director's sharp awareness of human karma and discrimination, and he was there able to grasp an extremely real sense of evil. Uchida's existence was decidedly idiosyncratic from the perspective of Tōei's brighter *jidaigeki* program pictures, but he is extremely important as a link between prewar and postwar *jidaigeki*.

NIKKATSU'S STEADY ADVANCE

The biggest event in the film world of the 1950s was brought about when Nikkatsu, Japan's oldest film studio, announced that it would be resuming production. Quickly, young directors and staff were gathered from all over, but as far as actors were concerned, because of an agreement between the existing five major companies, the studios refused to let them work for Nikkatsu. The late-developing

Crazed Fruit (dir. Nakahira Kō, 1956).

Nikkatsu was forced to hold auditions for "new faces." This turned out to be a rather auspicious development, turning Nikkatsu into the greatest creator of program pictures.

In 1956, Furukawa Takumi adapted *Season of the Sun* (*Taiyō no kisetsu*), the novel by Akutagawa Prize-winning author Ishihara Shintarō that sent shock waves through Japan. This film depicted the decadence and everyday lives of bourgeois youth who hang around the beaches of Shōnan. The film was not quite as much a sensation as the novel, but it did provide the launching pad for the author's younger brother, Ishihara Yūjirō, into the film world. Yūjirō was catapulted into a leading position with his next film, *Crazed Fruit* (*Kurutta kajitsu*, 1956), and he quickly began to build a myth as an action star. The first condition for Japanese actors, from Onoe Matsunosuke to Hasegawa Kazuo, was always a large face with

distinguished features. But Yūjirō was different. He managed to seize hold of audiences not through his face, but through his height and his long legs. His most flattering shot was not a low angle, but a long shot, and the sharp, lively camerawork of the new director Nakahira Kō proved a perfect match. The second new feature of Yūjirō lay in the fact that, along with being the perfect manifestation of the individualism Japanese longed for in the postwar period, he was the very epitome of self-awareness: talking to himself, suddenly breaking into song, aimless wandering. Nikkatsu's various characters, the personalities of its action stars—Shishido Jō, Kobayashi Akira, Akagi Keiichirō, and Watari Tetsuya—took Yūjirō's "cool" self-consciousness as their starting point and then developed in their own distinctive ways from there. What they all shared was a certain difficult-to-grasp contradictory quality, a dandyism and solitude available only to those who had been abandoned by the communities of the family and the state.

Although it is only a coincidence, Francois Truffaut, who happened to see this work in Paris (this was before he directed *The 400 Blows*), quickly penned a long review praising it. In my opinion, *Crazed Fruit* also likely exerted a certain influence on Claude Chabrol's *Cousins* (1959).

Two brothers fight over a single woman, and it all comes to a climax on board a motorboat. When *Crazed Fruit* was attacked for being against the public morals of the time, Nikkatsu ended the Sun Tribe Films line and had the veteran director Tasaka Tomotaka make the contemporary set film *The Baby Carriage* (*Ubaguruma*, 1956) and *A Sunlit Street* (*Hi no ataru sakamichi*, 1958), both starring Yūjirō. Kawashima Yūzō, when he was assigned to work with Yūjirō, boldly joked that he would make a *jidaigeki* Sun Tribe film, and he shot *A Sun Tribe Myth from the Bakumatsu Era* (*Bakumatsu taiyōden*, 1957).

Young, talented directors gathered at Nikkatsu in the late 1950s. I will discuss each of them individually in the following chapter. Like their peers in France, they were enamored by Hollywood film noir to no end, although they explored the possibilities for action films set in Japan. But they differed from the French nouvelle vague in

that they had to produce their works at a fixed schedule as craftsmen, thoroughly ensconced within the studio system. This fact can be detected in Nakahira's casual response whenever he was asked what he thought of the nouvelle vague: it is "amateurism."[5] In the contemporary moment, however, so many years after the genre reached its end, it is not overly difficult to see a certain historical parallelism between the two.

8

UPHEAVAL AMID STEADY DECLINE: 1961–1970

THE PEAK OF THE STUDIO SYSTEM

In 1960, 547 Japanese films were produced, and this was the peak of glory for Japanese cinema as an industry. A full 99 percent of these were program pictures, made by the six major studios and shown to viewers at the rate of about two per week. But this turned out to be its highest point, and the film industry then began a precipitous decline. Shin Tōhō could not keep up with this pace and ceased producing films in 1961. The number of viewers had already peaked in 1958 at more than 1.1 billion; after that, the numbers of people watching movies got smaller gradually, but steadily, and by 1963, it was already less than half that, dropping to more than 500 million.

The cause for this decline was the same as it had been in America ten years earlier—the rapid spread of television. Japanese television, which had begun broadcasting in 1953, was a part of most ordinary households by 1959, a trend spurred by the wedding of the Crown Prince and Princess. In 1964, color sets became common because of the Tokyo Olympics. Cinema tried to retain its audience by incorporating attractive innovations that could not be copied by television.

Cinemascope[1] was developed, and through the 1960s, widescreen movies were produced that filled the large, rectangular screens of movie theaters. What is fascinating is that in the 1980s, this trend was completely reversed. Keeping secondary content for television and video in mind, production companies started shooting in standard size or Vistavision[2] from the start. Color became another factor. In 1960, the percentage of films in black and white was still higher than in color. To keep down production costs, some studios shot only certain important scenes in color, dubbing this "part color," something that later became a common practice in the world of Pink Film. By 1970, just ten years later, black-and-white films were almost nonexistent, and, apart from using black and white for specific scenes for some special reason, black-and-white filming disappeared altogether.

Yet, in spite of all its efforts, the film industry could do little to halt its decline. In 1969, Nikkatsu sold off its studios and, by 1971, had to cease production. Daiei also ended production in 1971.

It probably will seem overly generalized to present it all at once in this way. But provisionally, we can summarize the atmosphere of each company during the 1960s as follows. Tōhō presented the bright world of the petit bourgeois, that is, the urban world of private university students and businessmen. The world of Daiei was somewhat more countrified, focusing on people from rural areas. Shōchiku concerned itself with the warm, human atmosphere of the *shitamachi* neighborhoods of Tokyo. Tōei concentrated on traditional rural cities. And Nikkatsu largely focused on either cosmopolitan harbor towns or on people living in the country where space was sufficient to ride around on horseback.

This decade was an age in which a whole group of the *après-guerre* generation of directors appeared at once and immediately started doing excellent work. These directors include Nakahira Kō, Suzuki Seijun, Masumura Yasuzō, Kurahara Koreyoshi, Ishii Teruo, Okamoto Kihachi, Imamura Shōhei, Ōshima Nagisa, Matsumoto Toshio, Yoshida Yoshishige, Shinoda Masahiro, Yamashita Kōsaku, Fukasaku Kinji, and Teshigahara Hiroshi. In this group of new and

vibrant directors who made their debut between 1956 and 1962 and produced noteworthy films, some of them voiced their complete rejection of such preceding masters as Mizoguchi or Ozu and others sowed the seeds of scandal with every new work. There were a variety of relationships with the existing studio system. If there were some who remained within the system of program pictures without abandoning their commitment to a particular thematic concern, there were others who were fired abruptly by their companies, or broke out of the system to immediately forge their own production companies.

Even though the new filmmakers were extremely varied, they were all decisively distinct from the directors who got their start in the independent productions of the 1950s. They no longer held any hope or fantasies for social realism or the enlightenment of the masses. They did not have a naive faith in ideas of democracy. Those with wartime experience did not view it simply with the existing stereotyped responses but still held onto that wartime experience as something vital and formative. Those who saw postwar society as an empty sham criticized it cynically. With the example of contemporary Hollywood and the New Wave before them, these directors wanted to seal off and ignore the legacy and traditions of prewar Japanese cinema as much as possible. The renovation of the themes, narrative styles, and language of Japanese cinema by these directors, even as they often worked under difficult conditions, is what characterizes the 1960s.

A COLORFUL VARIETY OF FILMS AT TŌHŌ

At Tōhō, following the *Shachō* series, the *Musekinin* (Irresponsible) and *Nihon ichi no—otoko* (The top—man in Japan) series began.[3] Both series featured Ueki Hitoshi and the comical musical group Crazy Cats, and Furusawa Kengo directed most of them. These were bright, nonsense musical comedies that made gentle fun of Japan during the era of high economic growth, and they

captured quite keenly the feeling of those days. The *Big Man on Campus* (*Wakadaishō*) series, starring Kayama Yūzō, was a remake of the cheerful university sports stories that Shōchiku specialized in during the 1930s. These series at Tōhō were welcomed by ordinary middle-class Japanese holding fantasies of someday achieving this kind of carefree prosperity.

Both *kaiju* films and Kurosawa Akira were as vigorous as ever. In the fight scenes in *Yojinbo* (1961)—the title literally means, "the bodyguard"—Kurosawa used new, extreme filming techniques, which had not appeared in conventional *jidaigeki* sword-fighting scenes. These techniques came to exert a strong influence on martial arts films throughout the world and spaghetti westerns and Hong Kong *wuxiapian* responded right away to them. With *High and Low* (*Tengoku to jigoku*, 1963), Kurosawa created a schema of total opposition, something rare in Japanese cinema, and he followed it up with *Red Beard* (1965), a surprisingly successful effort to make a *jidaigeki* without sword-fighting scenes. The protagonist, played by Mifune Toshirō, a doctor helping out people of every station, lived by the ethical ideal that he should heal not only the bodies of individuals but also that of society as a whole; he was a figure Kurosawa had long fantasized about. Meanwhile, Mishima Yukio mocked Kurosawa's humanism as "philosophically at the level of a junior high school student."[4] In 1970, Kurosawa set out to make his first color film, *Dodesukaden*, a work that depicts the daily life of people who live in a garbage dump on the outskirts of Tokyo. In everything from the clothing of the characters to the color of the soil, the director used artificial colors, completely eschewing the use of natural colors.

Okamoto Kihachi (1924–2005) gave the war film genre his own touch, making the nonsense comedy *Desperado Outpost* (*Dokuritsu gurentai*, 1959), which satirized both the Japanese and Chinese armies. He liked to gaze at the vulgar comedy of human desire, and his sensibility approached that of the most interesting spaghetti westerns; however, he was also recalling his own experiences as a student soldier. He shot *Japan's Longest Day* (*Nihon no ichiban nagai hi*, 1967) at Tōhō, a film that depicted the process leading up to

Japan's unconditional surrender, but he was totally dissatisfied because it had to be made in accordance with the standards of an officially approved production. In reaction, with his own funds, he made *The Human Bullet* (*Nikudan*, 1968), a comedy about a student soldier who is called up to be a kamikaze pilot just before the end of the war.

DAIEI'S STAR SYSTEM

Daiei, which was the most ambitious studio in terms of developing color films during the 1950s, produced the seventy-millimeter epic *Shaka* (directed by Misumi Kenji) about the historical Buddha Sakyamuni in 1961, beating out the other studios. They constructed enormous sets and went as far as India for location shooting, making it arguably the peak of Daiei's achievements. During the 1960s, Daiei focused on producing series—the *Bad Name* (*Akumyō*), *Blind Swordsman* (*Zatōichi*), and *Hoodlum Soldier* (*Heitai yakuza*) series starring Katsu Shintarō and the *A Certain Killer* (*Aru koroshiya*), *Sleepy-Eyes of Death* (*Nemuri Kyoshirō*), and *Nakano Spy School* (*Riku-gun Nakano gakkō*) series starring Ichikawa Raizō. In addition, he produced the *Great Demon God* (*Daimajin*) series that featured a giant *haniwa* statue of an ancient warrior that comes to life and the *kaiju* series *Gamera*.

Katsu Shintarō (1931–1997) was initially brought into Daiei as a leading actor, but while Ichikawa quickly became a charismatic star, Katsu's path to stardom was not quite as smooth. As a result, he chose to play neither the handsome matinee idol nor the lead, but rather, a character belonging to neither category—the *zatō*. A *zatō* was a blind man during the Edo era who had a nominal rank as a Buddhist priest and usually worked as a masseur. In Mori Kazuo's *The Blind Menace* (*Shiranui Kengyō*, 1960), he played the lead, an evil *kengyō*,[5] and it would be a major turning point for him for it gave birth to the *Zatōichi* series (1962–1971). The titular Ichi, a blind man, wields his brutal cane-blade like a master and is without peer

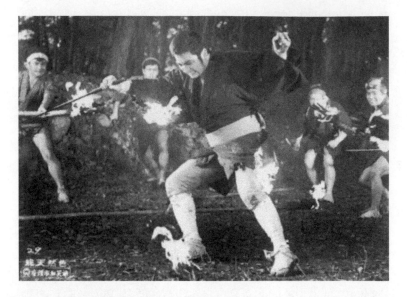

Fight, Zatoichi, Fight (dir. Misumi Kenji, 1964).

at the gambling table, a man monstrous and terrifying. Ichi wanders throughout Japan, dispatching evil power mongers across the land and helping mothers reunite with their children—this narrative constituted the core of the series. The series, which featured a handicapped outlaw as its protagonist, was even adapted for television during the 1970s, and it earned popularity from several countries in Asia and Latin America. That a blind master of *wuxiapian* would appear in Hong Kong cinema was also thanks to the *Zatōichi* series. In 1989, what could be called the definitive version of *Zatōichi* was directed by none other than Katsu Shintarō himself.

ICHIKAWA KON AND MASUMURA YASUZŌ

Ichikawa Kon (1915–2008) demonstrated his prowess by making movies at Daiei starring Ichikawa Raizō set in the contemporary age. Such works as *Conflagration* (*Enjō*, 1958), a film version of

Mishima Yukio's *Kinkakuji* (*The Golden Pavilion*) and *Broken Commandment* (*Hakai*, 1961) based on Shimazaki Tōson's classic novel about discrimination against the former outcast class, were part of Daiei's string of adaptations of famous literary works. In addition, Ichikawa directed a remake of *Yukinojō Henge* as *An Actor's Revenge*, its vibrantly colorful palette serving to commemorate the three-hundredth role of its star, Hasegawa Kazuo (1908–1984). It had been nearly thirty years since Hasegawa had first appeared in Kinugasa Teinosuke's *Yukinojō henge*. For the same actor to perform on screen in the same narrative separated by such a gulf of time was something globally unprecedented, to say nothing of the fact that in both films he played the role of a Kabuki *onnagata*, a man who must look beautiful and feminine. That no one thought this strange reveals the continuing influence of Kabuki's way of thinking about theater. Ichikawa was then tapped to direct a documentary about the Olympics in Tokyo the following year, 1964, which he did by deploying extremely avant-garde techniques and showing little concern for Japanese gold medals. As a result, he was harshly criticized by nationalists, and he was forced to re-edit it against his will, inserting several scenes in which Japanese players triumphed.

If one had to choose one director to represent Daiei in the 1960s, that honor would undoubtedly fall on Masumura Yasuzō (1924–1986). Masumura, who studied filmmaking at the Centro sperimentale di cinematografia in Rome, gave a merciless critique of Japanese film upon his return, citing its tendencies toward sentimentalism, harmony, and a sense of resignation. He became an assistant director to Mizoguchi Kenji, but the barbs of his critique were aimed even at his great teacher. Debuting in 1957 with *Kisses* (*Kuchizuke*), Masumura passionately depicted Japanese actresses in a way akin to actresses in Italian films, as independent subjects of desire. With *A Wife Confesses* (*Tsuma wa kokuhaku suru*, 1961), *Manji* (1961), adapted from the 1928 Tanizaki Jun'ichirō novel *Quicksand*, and *Seisaku's Wife* (*Seisaku no tsuma*, 1965), all starring Wakao Ayako, Masumura was as ambitious and dynamic with her as Von Sternberg was with Dietrich, and his direction is overflowing with vivacious eroticism.

Mizoguchi and Kinugasa had once turned to the *shinpa of* Izumi Kyōka as a source for their films. Masumura eschewed the frailty of Kyōka and aimed to recreate the world of Tanizaki Jun'ichirō in cinema. A onetime classmate of Mishima Yukio at Tokyo University, he shot *Afraid to Die* (*Karakkaze yarō*, 1960) starring Mishima as the protagonist, the personification of a man who wants to be in the limelight. Mishima himself gave further life to his experiences of that time, penning the short fiction *Star* and directing himself in his own work, *Patriotism* (*Yūkoku*, 1966).

Partly because Daiei owned few theaters for the exhibition of its films, it could not survive the decline of the film industry, and it finally collapsed in 1971. Masumura's *Play* (*Asobi*, 1971), produced during the studio's final days, ends with the scene of a young man and woman who climb into a boat with a hole in it, rowing out aimlessly. We can see in this the dedication of Daiei's staff who sought hope within the prevailing despair.

THE SHŌCHIKU NOUVELLE VAGUE

At the end of the 1950s, Shōchiku lost vigor and direction. Producer Kido Shirō, having produced *shōshimin* films in the 1930s, now went to search for talent from the new generation to ward off the innovations of Tōei and Nikkatsu. When Ōshima Nagisa (1932–2013) caused controversy with the release of his film *Town of Love and Hope* (*Ai to kibō no machi*, 1959), journalism dubbed this the Shōchiku Nouvelle Vague, raising expectations for several directors with him in the lead. The next year, Ōshima released *Night and Fog in Japan* (*Nihon no yoru to kiri*, 1960). It was a work in which students who failed to prevent the passage of the U.S.-Japan Security Treaty in 1960 and citizens of the generation who had experienced despair when the Japanese Communist Party changed its policies in 1952 happen to be at the same wedding, debating one another as they share their reflections on their respective experiences. The film employed experimental techniques, including the extensive use

of sequence shots—a long take that constitutes a single scene in one shot—as well as shots in which time moves freely back and forth within a single shot. Just at that time, a deep sense of pessimism floated among young people following their defeat in the battle against the security treaty, and it was considered politically an extremely delicate issue for someone to direct a film that took this as a theme. Ōshima, as far as this point was concerned, was an exemplary forerunner of the Greek director Theo Angelopolous, who shot *The Travelling Players* (*O Thiassos*, 1975). Shōchiku stopped the screening of the film four days after its release, and Ōshima resigned in protest.

In the wake of this event, Ōshima started his own production company (Sōzōsha) and with *Violence at Noon* (*Hakuchū no tōrima*, 1966), Ōshima depicted the moment at which sex, violence, and madness cross paths by assembling nearly two thousand shots. When we consider that *Battleship Potemkin*, the film that pioneered montage theory, was composed of fifteen hundred shots, we can see how daring Ōshima's plans were. Furthermore, with *Sing a Song of Sex* (*Nihon shunka kō*, 1967) and *Three Resurrected Drunkards* (*Kaette kita yopparai*, 1968), Ōshima took up *zainichi* Koreans, a subject that had been verboten in Japanese film to that point, going so far as to have one of his characters make the scandalous remark that the origins of the emperor system are in Korea. This tendency of Ōshima's reached its peak with *Death by Hanging* (*Kōshikei*, 1968), which constitutes the moment when Japanese cinema came closest to Brechtian burlesque. As the decade wore on, Ōshima deviated ever further from the conventions of cinematic narrative. In *The Man Who Left His Will on Film* (*Tokyo sensō sengo hiwa*, 1970), which he made with the cooperation of an eighteen-year-old filmmaker named Hara Masato, the aesthetic concern with cinematic self-reflexivity came to overlap with political radicalism, and its very frame as a work of art was pushed nearly to the point of its own dissolution.

In the end, the Shōchiku nouvelle vague did not last more than a few years, but it did produce excellent directors in addition to Ōshima. They remained at Shōchiku for a period, but once they left it,

they largely borrowed the 10-million-yen-film system by Art Theater Guild (ATG) and made experimental works. Shinoda Masahiro (1931–), with Terayama Shūji (1935–1983) as his screenwriter, depicted the loneliness of a terrorist youth in *Dry Lake* (*Kawaita mizuumi*, 1960), and then he shot independently *Love Suicide at Amijima* (*Shinjū ten no amijima*, 1969) based on Chikamatsu Monzaemon's puppet play. He introduced the representative system of the classical Japanese art of *Bunraku* puppet theater into film in a critical manner, while also demythologizing Chikamatsu melodrama. In addition, with *Akitsu Hot Springs* (*Akitsu onsen*, 1962), Yoshida Yoshishige (1933–) made a love story, making full use of the potential of the actress Okada Mariko. Simply by depicting the eroticism of water as a material thing, Yoshida ensured that his name would be remembered in Japanese film history. His vivid sense of direction stands in stark contrast to the quiet sense of the master Ozu Yasujirō. This film raises the antagonism between the aesthetics of Ozu and Yoshida to the level of myth. As for Yoshida, once he left Shōchiku, he pursued the points of contact between eros and terrorism that had appeared in modern Japanese history, standing on a point offering a grand view of the past, present, and future with the works *Eros Plus Massacre* (*Erosu purasu gyakusatsu*, 1969), *Heroic Purgatory* (*Rengoku eroika*, 1970), and *Coup d'etat* (*Kaigenrei*, 1973).

SHŌCHIKU TURNS REACTIONARY

Following the departure of these directors, Shōchiku returned once more to tedious melodramas and to a world of everyman comedies that could be summarized with the words "Sunny *Shitamachi.*" Taking the name from the location of one of the branches of the studio, these were referred to as the "Ōfuna style." Nomura Yoshitarō, with *Dear Emperor* (*Haikei tennō heika sama*, 1963), had Atsumi Kiyoshi play a poor, simple youth who is thankful that no place is more comfortable to study than the army. Nomura's pupil, Yamada Yōji, gave the role of a good man of a low class ripe with human sentiment

who is optimistic and boorish (this typical Japanese character first appeared in Inagaki Hiroshi's *Muhō Matsu the Rickshaw Man* in 1958) to Hana Hajime in *A Complete Fool* (*Baka marudashi*, 1964). The offspring of this convergence was the *It's Tough Being a Man* (*Otoko wa tsurai yo*) series, directed by Yamada and starring Atsumi Kiyoshi, which first appeared in 1969.[6]

If one more director at Shōchiku during the 1960s should be noted, it is Kobayashi Masaki (1916–1996). From his focus on those falsely accused of low-level war crimes in *The Thick-Walled Room* (*Kabe atsuki heya*, 1956), all the way to *Tokyo Trial* (*Tokyo saiban*, 1983), he remained steadfastly committed to the question of wartime responsibility. After completing the six-part series *The Human Condition* (*Ningen no jōken*, 1959–1961), with its epic unfolding against the backdrop of the Japanese military invasion of China, he confronted directly the code of the samurai itself with *Harakiri* (*Seppuku*, 1962). With *Kwaidan* (1964), he teamed up with the composer Takemitsu Tōru, creating an experimental symphony of sound and imagery. The theme of his life's work was the tragedy and pathos of the individual crushed under institutions and power, which was rooted in his experience as a war prisoner during the battle of Okinawa.

TŌEI'S IDEALIZED GANGSTERS

Throughout the 1950s, Tōei Kyoto steadily continued to compete with *jidaigeki*, but at the beginning of the 1960s, a new trend emerged: *ninkyō eiga*—films about idealized yakuza (gangsters). These films were set between the prewar and postwar periods and featured yakuza as protagonists.

Sawashima Tadashi's *Theater of Life: Hishakaku* (*Jinsei gekijō: Hishakaku*, 1963), costarring Tsuruta Kōji and Takakura Ken, often is taken as the beginning of *ninkyō* yakuza film. The combination of Tsuruta, as a type that is anguished over the disappearance of human relationships based on traditional society, stoic in the face

of adversity, and the younger quick-tempered Takakura, who, even as he is conflicted by his social obligations and personal desires, recklessly sacrifices himself in the end, appealed to audiences that were getting tired of *jidaigeki*. Once this combination was joined by actress Fuji Junko, whose pure spirit shone all the more brightly in the shadow of all the masculine virtuosity, and Wakayama Tomisaburō, who tended to play a crude but sentimental buffoon, this world was complete. Series such as *Cruel Stories of the Showa Era* (*Showa zankyōden*), *The Walls of Abashiri* (*Abashiri bangaichi*), and *Red Peony Gambler* (*Hibotan bakuto*) flourished between 1965 and 1972.

Ninkyō yakuza films were not terribly diverse in terms of narrative. In a typical story, the protagonist, a wandering yakuza, gets caught up unexpectedly in some conflict, obligated because he has accepted a meal and a night's lodging. Between the factionalizing of his cowardly comrades, as well as the betrayal of the boss he had trusted, the hero bears repeated affronts until he finally sets out on a raid of the bad boss's gang. At this point, another man appears unexpectedly and offers to join him. The protagonist, after surviving the grand raid, winds up being sent back to prison.

Several significant directors made *ninkyō* yakuza films. The veteran Makino Masahiro (1908–1993) was the person most conversant with the lifestyle of yakuza, and his films had a humanist flavor. Yamashita Kōsaku presented a solemn world, whereas Katō Tai deployed a baroque formalism, and Suzuki Norifumi maintained a humorous, parodic spirit.

Films from the prewar period with rebellious late Edo period heroes, such as Kunisada Chūji or Jirōkichi the Rat, as protagonists had already evoked a populist spirit. Around 1930, directors like Itō Daisuke, who sympathized with those communists who were driven underground when the Communist Party was declared illegal, would even send hidden signals of support to them when shooting films about outlaw bandits hounded by military police. The currents of *ninkyō* yakuza film during the 1960s, however, were different from the tales of outlaw bandits in *jidaigeki*. To be sure, the protagonists in both cases were imbued with a warm, humanist sentiment,

embodying a Confucian sense of values with a particular Japanese sensibility. Although these stories were historical nonsense, yakuza were depicted as if they were the sole inheritors of Edo-period samurai morals living in the post-Meiji modern era. Modernization here was nothing but a moral backwardness. The good gangsters, always dressed in traditional Japanese garb and wielding short swords (*dosu*), faced off against the bad gangsters, who invariably wore cheap Western suits and used guns as their weapons. They aimed to return to traditional communities based on a sense of honor lost to today's society, and it was this consciousness in the world of *ninkyō* yakuza film that stoked the highest utopian spirit. Such nostalgia for the premodern era was not possible in *jidaigeki* in the prewar and postwar periods. It was only after undergoing high economic growth in the 1960s that this kind of sentimental perversion appeared. Those who enthusiastically supported *ninkyō* yakuza films were student radicals of the new left and Mishima Yukio. The reason for this is simple. Both were in search of a community they could sink into without abandoning their individualism, and a ritual-based system that could guarantee their self-identity was nowhere to be found for these children of the postwar era.

NIKKATSU BORDERLESS ACTION FILM

In contrast to Tōei's fall into pre-modernism, Nikkatsu, through action films, continually affirmed the present moment of the postwar world. In the first half of the 1960s, this took on an increasingly cosmopolitan air and strong sense of hybridity, making free use of everything from Hollywood westerns to Italian neorealism, to the French nouvelle vague, all remade according to Japanese style. The tendency is to limit Nikkatsu cinema during this period specifically to "borderless action" (*mukokuseki akushon*) films and to refer to Nikkatsu cinema more generally by that term. The prototype of borderless action was the *Wandering Guitarist* (*wataridori*, "wandering bird") series, which was produced between 1959 and

1962. With guitar in hand, the drifter played by Kobayashi Akira visits various regional towns. There he witnesses Asaoka Ruriko being exploited by an evil local operator, and he becomes her ally. As the archenemy, Shishido Jō gets caught up in this entanglement, like Burt Lancaster in *Vera Cruz* (1954). In the end, after he has rescued Ruriko, he sets off once more for parts unknown. It is perfectly obvious that this narrative pattern is a rehashing of the western *Shane* (1953), directed by George Stevens. Hokkaido, or the base of Mt. Aso, served as a setting for such Japanese-style westerns, while trading port cities like Yokohama or Kobe were the preferred setting for gangster films.

Ishihara Yūjirō began to transform his image away from the aimless youth of Sun Tribe films, and by the mid-1960s, acted in sweetly sentimental love stories dubbed "mood action." Ezaki Mio was the most representative director of such films and made *Thank You Again Tonight, Evening Fog* (*Yogiri yo kon'ya mo arigatō*, 1967), a superior adaptation of Michael Curtiz's *Casablanca* (1942). It is a story in which Yūjirō does his best to help smuggle Southeast Asian revolutionary Nitani Hideaki out of Yokohama. Shishido Jō was touted sensationally by the ad-copy as the "third fastest draw in the world!" and would come to walk the hardboiled path alone. In Nomura Takashi's *A Colt Is My Passport* (*Koruto wa ore no pasupōto*, 1967), we can see him as the most austere manifestation of nihilism. Viewers called him "Joe the Ace."

What supported Nikkatsu action were the workman-like directors, such as Saitō Buichi, Masuda Toshio, and Kurahara Koreyoshi. The one who stood out the most, however, was Nakahira Kō (1926–1978). He was responsible for Yūjirō's debut, and once he had sufficiently turned Yūjirō into a mythical, larger-than-life figure, Nakahira then went on to establish Nikkatsu's "pure heart" line of pictures (*junjō rosen*), beginning with *A Pure Heart Spattered with Mud* (*Doro darake no junjō*, 1963), starring Yoshinaga Sayuri and Hamada Mitsuo. Just as he finished shooting *Plants in the Sand* (*Suna no ue no shokubutsu gun*, 1964), he moved to Hong Kong during the late 1960s, and then worked in South Korea during the early 1970s,

remaking his own films and, in this way, expanding the world of Nikkatsu action throughout Asia. During this period, not only Nakahira but also Inoue Umetsugu actively shot in Hong Kong and both frequently organized coproductions between Hong Kong and Japan. The seeds would come to fruition with the great flowering of Hong Kong *noir* in the 1980s and finally with the great expansion of Hong Kong film personnel in the world of Hollywood action films during the 1990s.

NIKKATSU'S ECCENTRIC GENIUSES

We cannot forget one true genius in the world of action: Suzuki Seijun (1923–2017). Suzuki, while continuing to shoot B pictures for Nikkatsu, which is to say, the bottom half of a double-bill, became an idol to cinephiles through his mannerist attention to surfaces, combined with a grotesque imagination. With such works as *Tattooed Life* (*Irezumi ichidai*, 1965) and *Branded to Kill* (*Koroshi no rakuin*, 1967), he built a highly eccentric world, deploying an assemblage of garish primary colors, extreme close-ups, highly formalized killing scenes in the style of *gekiga*,[7] and an apocalyptic sense of nihilism. In 1968, when Nikkatsu forcefully removed him from his contract for making incomprehensible films, cinephiles took to the streets, stirring up a ruckus akin to the Henri Langlois incident in France.[8]

Nikkatsu's glory did not last long, however. When confronted with the sensational *ninkyō* yakuza films produced by Tōei, Nikkatsu was compelled to shift its own programming little by little. The genre of the idealized gangster in a series like *The Symbol of a Man* (*Otoko no monshō*, 1963) was perhaps more suited to the later emergence of Takahashi Hideki; and the *Burai/Zenka* (*Outcast/Criminal Record*) series, which began in 1968 and starred Watari Tetsuya, was full of dark, bloody battles, utterly removed from the kind of idyllic shootouts that characterized the initial output of Nikkatsu action films. This trend was called "New Action" and gave Sawada Yukihiro and Fujita Toshiya their start as new directors.

Before finishing the discussion of Nikkatsu, I will address two essential filmmakers who bore no connection to action films: Imamura Shōhei (1926–2006) and Urayama Kirio (1930–1985). Imamura held tight to a worldview affirming the earthiness of women as a source of vitality in such films as *Pigs and Battleships* (*Buta to gunkan*, 1961) and *Insect Woman* (*Nippon konchūki*, 1963). He then came to be charmed by the pathos-laden, premodern world of rural customs gradually disappearing from Japan during the process of modernization. After leaving Nikkatsu, he went to Okinawa where he shot *Profound Desire of the Gods* (*Kamigami no fukaki yokubō*, 1968), in which he layered over the present a narrative of incest between a brother and sister that appears in world creation myths (needless to say, the villagers that Imamura filmed were completely dumbfounded by the sentiments of this man who had traveled there from the mainland). Gradually, Imamura would come to shoot everything himself, including interiors, on location, and his interest would shift gradually from theatrical feature films to documentaries. After he shot *Postwar History as Told by a Bar Hostess* (*Nippon sengoshi: Madamu onboro no seikatsu*, 1970), he disappeared from the world of film for a while.

Urayama Kirio awakened Yoshinaga Sayuri as an actress with *Foundry Town* (*Kyūpora no aru machi*, 1962), and with *The Woman I Abandoned* (*Watashi ga suteta onna*, 1969), he depicted the consciousness of sin and the profound gulf that separates men from women. These were films that brought a logical end to the long line of Nikkatsu melodramas beginning with *My Sin* (*Ono ga tsumi*),[9] based on Leo Tolstoy's *Resurrection* (1899). Urayama was far from a prolific artist, but in the 1970s, he made a two-part film, *Gate of Youth* (*Seishun no mon*), in which he presented the life of a character based on details from his own biography.

In 1971, Nikkatsu temporarily ceased production. The last film to be released that year, Fujita Toshiya's *Wet Sand in August* (*Hachigatsu no nureta suna*), featured amoral high school students aboard a yacht in the coastal Shōnan region, quite strongly reminiscent of Nakahira's Sun Tribe film *Crazed Fruit* (1956).

INDEPENDENT PRODUCTION AND ATG

At the start of the 1960s, the major studios completely controlled the market through a block-booking system; as a result, only one or two independently produced works were produced each year. Once the film industry began its decline, however, opportunities for talented directors to work independently outside the studio system began to increase slowly but surely. Shindō Kaneto (1912–2012) of the Kindai Eiga Kyōkai (Modern Film Association) put out such ambitious works as *The Naked Island* (*Hadaka no shima*, 1960), *Onibaba* (1964), and *Live Today, Die Tomorrow!* (*Hadaka no jūkyūsai*, 1970) while contending with economic hardship. Among those filmmakers who learned

Woman in the Dunes (dir. Teshigahara Hiroshi, 1964).

their trade under Mizoguchi Kenji, Shindō followed a path that was directly opposite that of Masumura Yasuzō. His passion leaned not toward the affirmation of individual desire itself, but rather toward the observation of desire as a class product within a social context. Teshigahara Hiroshi teamed up with Abe Kōbō to present works such as *Pitfall* (*Otoshi ana*, 1962), *Woman of the Dunes* (*Suna no onna*, 1964), and *The Face of Another* (*Tanin no kao*, 1966). Each film was based on a biologistic perspective that viewed human beings as though they were biological specimens, a perspective reminiscent of Bunuel, depicting a world replete with absurd black humor.

In 1962, the Japan ATG was formed. That it held its own theaters in urban centers dedicated to art-house cinema had tremendous significance in terms of the distribution of Japanese independent productions. ATG's production budget was 10 million yen, around one-fifth that of the major studios, and they adopted a policy of tapping experimentally minded directors to make a single film at a time. This is how the aforementioned avant-garde films by Ōshima, Shinoda, and Yoshida were produced. This is also how Matsumoto Toshio's *Funeral Parade of Roses* (*Bara no sōretsu*, 1969) and Jissōji Akio's *This Transient Life* (*Mujō*, 1970) were made, the first films in Japan to deal openly and directly with queerness, gender, and incest. In addition, although it is not a product of ATG, we must also note the anti-American film *Black Snow* (*Kuroi yuki*, 1965). Its director, Takechi Tetsuji (1912–1988), incorporated his profound insights into traditional arts into his filmmaking.

THE KING OF PINK FILM

Finally, I would like to touch on the genre of Pink Film, which was established during the middle of the decade. By 1970, it had come to occupy nearly half of film output as a whole. In Japan, pornographic films, by traditional definition, had been made since the prewar era. Postwar, in the 1950s and 1960s, the collective known as "Kurosawa Group" formed in the city of Kōchi, secretly shooting and producing

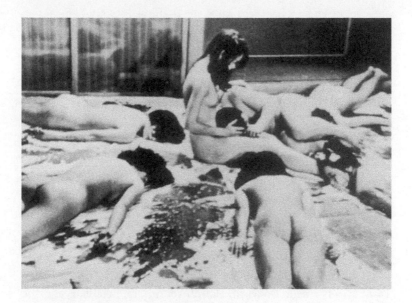

Violated Angels (dir. Wakamatsu Kōji, 1967).

eight- and sixteen-millimeter films depicting sexual acts between men and women. This is an important fact for the history of personal film in Japan. While dealing with sex scenes, Pink Film bore no relation to these underground movements; instead, they were produced for theatrical release by small production companies like Shin Tōhō, Ōkura, and Wakamatsu Pro. It is significant that this genre, up to the present day, has maintained in its own way the studio system of program pictures, even while filming under poor working conditions with minuscule budgets and fast shooting schedules.

Within this world, Wakamatsu Kōji (1936–2012) was a director who was dubbed the "king of the Pinks." When his work *Secret Within Walls* (*Kabe no naka no himegoto*) was screened outside Japan's officially represented works at the 1965 Berlin Film Festival, Japanese journalism was in an uproar over this national scandal. Unbowed, Wakamatsu went on to make such works as *The Embryo Hunts in Secret* (*Taiji ga mitsuryō suru toki*, 1966), *Violated Angels* (*Okasareta hakui*, 1967),

and *Violent Virgin* (*Shojo geba geba*, 1969)—films full of violence, sex, and rebellion as well as the desire to return to the womb. He assembled numerous young talents under him, including Okishima Isao, Adachi Masao, and Yamatoya Atsushi, creating an atmosphere akin to the Ryōzanpaku or Mt. Liang, the mountain hideout of the bandits in the Chinese novel *Water Margin* (*Suikoden*), where all the strongest fighters gathered.[10]

Adachi, who presented a string of filmic images overflowing with tension with *Closed Vagina* (*Sain*, 1963), ultimately left the world of film, and in the 1970s, joined the Palestinian fight for liberation as a soldier of the Japanese Red Army. Wakamatsu worked with Adachi to direct the documentary *PFLP: Declaration of World War* (*Sekigun—PFLP: Sekai sensō sengen*, 1971).

An array of personal filmmakers in the 1960s nested at the Sōgetsu Cinemateque, founded by Teshigara Hiroshi. They included Takabayashi Yōichi, Ōbayashi Nobuhiko, Iimura Takahiko, and the scholar of Japanese film Donald Richie. Finally, when Hara Masato debuted at seventeen years of age with *A Parade of Sorrow, Colored by Sadness* (*Okashisa ni irodorareta kanashimi no parēdo*, 1968), many took this as a sign of hope. After inspiring Ōshima Nagisa, who was working as his assistant director, Hara completed the eight-millimeter work *The Sacred God of Japan* (*Hatsukuni shirasusumera mikoto*, 1973). Through a steady gaze at the typical landscapes of Japan, he interrogated their political meaning.

Between the late 1960s and the early 1970s, a storm of protest movements swept through the world, with students at its center. Japan was no exception, and the influence of these movements appeared immediately in film. Students within the new left, enamored of *ninkyō* yakuza films, called out from their seats as if they were watching Kabuki in a theater. Theories of political agitation appeared frequently in film journals. Film critique became much more lively, expanding in an interdisciplinary fashion. When we look back over the twentieth century, this period, alongside that of the late 1920s, convulsed with avant-garde and experimental impulses around the world contemporaneously. What destroyed the

glory of the 1920s was fascism, but what brought down the glory of the 1960s was a highly organized consumer society. The Italian film-maker Pier Paolo Pasolini condemned the latter as the new face of fascism, before his untimely death in 1975. Japanese cinema of the 1960s continued to spiral downward as an industry, but in terms of the production of idiosyncratic filmmakers, it was a most fruitful decade indeed. People optimistically held out hope that the political and artistic avant-gardes could work together, but when the film fanatic Mishima Yukio killed himself by *seppuku* in 1970, the act seemed to dash their hopes.

9

DECLINE AND TORPOR: 1971–1980

JAPANESE CINEMA DURING THE YEARS OF LEAD

Two events signaled an end to the turbulent years of the 1960s. In 1970, the writer Mishima Yukio committed ritual suicide after the failure of an apparent attempt to mobilize the Self-Defense forces in a right-wing coup. And in 1972, the United Red Army not only took hostages at a lodge on Mt. Asama, but also, as would be revealed later, killed some of its own members out of revolutionary fervor. With these two events, the student movement quickly lost momentum, and society became basically conservative once more.[1] Within the cultural arts as well, the experimental and scandalous withdrew from the forefront, and criticism became increasingly cynical and aloof.

In the world of Japanese cinema, by this time, the decline of the studio system was clearly unstoppable. In 1971, 367 films were produced for theatrical release. Going by numbers, this amounted to 70 percent of 1961's output. But the six studios dropped to five, and the number of films these studios would produce dropped more precipitously from 520 to 160. In their place, the low-budget Pink

Films that had just emerged came to occupy 40 percent of film production with 159 works. In contrast, only forty-eight works were produced independently, a marked increase from a decade earlier. Let us begin with a brief overview of the trends of Japanese cinema in the 1970s.

Nikkatsu went bankrupt, but it restarted with the union at its center. From 1971, it made a firm decision to concentrate on a program of producing Roman Porno films, which ultimately led to their ability to buy back the studio. Daiei was also revived in 1974, but it was never able to have its own studio and remained a small, independent production company. Tōhō and Tōei rationalized their production and concentrated on making spectacle films and war epics, but these are not significant in terms of film history. Shōchiku got through this decade by clinging to its money-making *It's Tough Being a Man* (*Otoko wa tsurai yo*) series.

But it was not only the studio system that was on the verge of extinction. The star system died along with it during the 1970s. Actors no longer belonged exclusively to production companies and came to sign new contracts with each work. Stars formed their own production companies one after another. The film world was just getting by and was no longer capable of developing new talent and so, instead, it called in television celebrities and singers. The training of technical personnel was increasingly unstable from around this time.

The 1970s was also characterized by the fact that all of the directors who showed such astonishing vigor during the 1960s fell quiet or were otherwise stifled. Kurosawa ceased shooting in Japan with Japanese capital and sought producers abroad. Ōshima did the same. Imamura moved away from film and toward television documentaries. Suzuki Seijun, Yoshida Yoshishige, and Teshigahara Hiroshi were all silent, and Nakahira Kō died in mid-career. Aside from at Nikkatsu, no new outstanding film artists appeared. In contrast, both documentary and animation showed considerable development, which laid the foundations for their contemporary flourishing.

NIKKATSU ROMAN PORNO

When the newly revived Nikkatsu announced its entry into the production of Roman Porno[2] films, many of the actors and directors that had belonged to Nikkatsu—Japan's oldest film studio—abandoned it. Kobayashi Akira and Watari Tetsuya switched over to Tōei where they continued to star in action films, and Shishido Jō became famous by appearing in dramas on television about gangsters. Meanwhile, many of the directors who had long been serving their apprenticeship in the shadows and who had no opportunity to direct feature films emerged into the light. The studio began to gather actresses who were willing to do primarily nude scenes—actresses like Miyashita Junko, Katagiri Yūko, Isayama Hiroko, Tani Naomi, Shirakawa Kazuko, and Kazama Maiko. Roman Porno followed the example of Pink cinema but had budgets several times the size of the typical Pink Film. As long as it included a certain number of obligatory sex scenes, directors were free to make the rest of the movie as they wished. This was enormously appealing to young directors, and many films were filled with anarchic energy in the early days. In 1972, three films were seized by the Metropolitan Police Department for violation of public decency, but this claim was rejected in a subsequent court case. Roman Porno is extremely important as these films continued to be made until 1988, at a pace of two films every two weeks. In the following, I introduce some of the most outstanding directors.

The theme running through all the works of Kumashiro Tatsumi (1927–1995) is the way that Japanese people have always accepted sexuality with an indulgent openness and a festival spirit. His representative works include *Ichijō's Wet Lust* (*Ichijō Sayuri, nureta yokujō*, 1972), which followed the life of a sensational genius stripper who took the world by storm; *The World of Geisha* (*Yojōhan fusuma no urabari*, 1973), which depicted the joys and sorrows of prostitutes in a brothel during the prewar period; and *Dannoura Pillow War* (*Dannoura yomakura kassenki*, 1977), an absurd Rabelaisian take on the

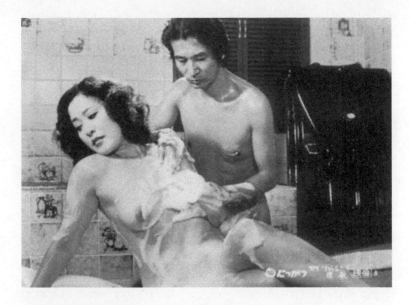

Oh! Women: A Dirty Song (dir. Kumashiro Tatsumi, 1981).

climactic battle between the military Genji and Heike clans in the twelfth century, transposed to the world of the sex lives of aristocrats and samurai. Many women appeared in Kumashiro's films, and they always are colorful, optimistic, and earthy figures who win out with no difficulties. The men, by contrast, are melancholic and cowardly; but sometimes they become the protagonists of picaresque episodes.

Tanaka Noboru (1937–2006) channeled the grotesque and decadent aesthetic of late *ukiyo-e* woodblock prints and became known for his cruel eroticism. In works such as *The Hell-Fated Courtesan* (*Maruhi: Jorō seme jigoku*, 1973),[3] *Secret Report: Sex Market* (*Maruhi: Shikijō mesu ichiba*, 1974), and *Rape and Death of a Housewife* (*Hitozuma shūdan bōkō chishi jiken*, 1978), he depicted the human drama that is produced by extreme conditions of sexuality. Sone Chūsei (1937–2014), with works such as *My Sex Report: Intensities* (*Watashi no SEX hakusho: Zecchōdo*, 1976) and *Angel Guts: Red Classroom* (*Tenshi no harawata: Akai kyōshitsu*, 1979), honed a thrilling style, which he used

to focus on the politics that can become visible only through abnormal sexual acts. Konuma Masaru (1937–), in works such as *Afternoon Affair: Kyoto Holy Tapestry* (*Hiru sagari no jōji: Koto mandara*, 1973); *Noble Lady, Bound Vase* (*Kifujin shibari tsubo*, 1977); and *Wife's Sexual Fantasy: Before Husband's Eyes* (*Tsumatachi no sei taiken: Otto no me no mae de, ima* . . . , 1980), exposed a strange inverted eroticism that recalls Alain Robbe-Grillet. In addition, such veteran directors, including Ohara Kōyū, Nishimura Shōgorō, Takeda Kazunari, and Katō Akira, showed how they could use their craftsmanship in this genre of films as well.

YOUTH FILMS AT NIKKATSU

Nikkatsu also produced excellent youth pictures. Murakawa Tōru, with *The Play of White Fingers* (*Shiroi yubi no tawamure*, 1972), vividly depicted the process of a young woman who is a pickpocket maturing through sex. With the series *Aa!! That Pep Squad* (*Aa!! Hana no ōendan*, 1976–1977), Sone Chūsei earned praise for his humorous narratives of strenuous training and affection in a college cheerleading squad. The youth film director at Nikkatsu who had the strongest support among young people at the time, however, was Fujita Toshiya (1932–1997). Even before Nikkatsu had started making Roman Porno, he had lovingly depicted a small community of young people in their confrontations against the power of adults with the *Stray Cat Rock* series (1970–1971). In 1974, he also shot a trilogy starring Akiyoshi Kumiko—*Red Paper Lanterns* (*Aka chōchin*), *Younger Sister* (*Imōto*), and *Virgin Blues* (*Bājin burūsu*)—that depicted a young girl coming to the big city and, with beautiful lyricism, showed the process of how she found her individuality.

During the 1980s, the initial anarchic appeal of Nikkatsu Roman Porno began to fade, and the films were gradually growing stagnant. Nonetheless, the genre gave opportunities to new directing talent like Ikeda Toshiharu, Nakahara Shun, Kurosawa Naosuke, and Kaneko Shūsuke. If the Nikkatsu of the 1950s and 1960s essentially adopted a male-centered way of making movies, in which

women were always treated as an afterthought, the Nikkatsu of the 1980s might be said, to the contrary, to be making more women-centered films. The designation of the films as "pornos" initially caused befuddlement for more than a few "conscientious" film critics. But it would be impossible to overstate the importance of the role of Nikkatsu during this period, especially given Kumashiro's reception at the Berlin Film Festival in 1990s as Japan's foremost woman's director.

TŌEI: WITHOUT HONOR OR HUMANITY

Once the student movement declined, Tōei Kyoto's *ninkyō* films seemed old-fashioned. Instead, the contemporary action film series from Tōei's Tokyo side that had long been relegated to second-tier status produced fascinating offerings. Naitō Makoto's *Wolves of the City* (*Furyō banchō*, 1969–1971) series was an early example of Japan's Hell's Angels cinema with its picaresque narrative of youth gangs, while Itō Shunya's *Scorpion* (*Sasori*, 1972–1973) series viewed the state and authority from the perspective of female prisoners inflamed with hatred and a spirit of vengeance.

The most notable director to emerge at Tōei in the 1970s was Fukasaku Kinji (1930–2003), director of the five-part *Battles Without Honor and Humanity* (*Jingi naki tatakai*, 1973–1974) series. The style of the Tōei Tokyo studios was epitomized by this series and was called *jitsuroku* ("true record") film, a strong contrast in multiple ways to the conventional *ninkyō* films produced in Kyoto. True record films utterly rejected melodramatic pathos and nostalgia for a traditional, formalized world. *Battles Without Honor and Humanity* portrayed the gangs who came to rule over the underworld of postwar Japan. Every time one of the characters appears on the screen, on-screen titles announce the name of the character as if it were a documentary and, like the news, dispassionately explain what happens to that character after that. The poles of good and bad have disappeared completely; the only reality is the constant

battle for dominance among the gangs, captured with raw immediacy by the movements of the camera. Unlike Takakura Ken, the hero of yakuza films of old, the boss of the new gangs of Hiroshima played by Sugawara Bunta is a ruthless realist who thinks nothing of betrayal. He burns with ambition to overturn the social order. By contrast, Kitaōji Kin'ya embodies the tragic beauty of a yakuza running full bore to his destruction. Fukasaku made parallel works to the series as well, such as *Graveyard of Honor* (*Jingi no hakaba*, 1976) and *Yakuza Graveyard* (*Yakuza no hakaba: Kuchinashi no hana*, 1976). In the Nikkatsu films of the 1960s, Watari Tetsuya was the embodiment of bright cheerfulness, but in these movies, Fukasaku forced him to play an ominous half-crazed yakuza.

Since his film *The Third Leader of the Yamaguchi Gang* (*Yamaguchi gumi sandaime*, 1973), Yamashita Kōsaku (1930–1998) created a stir by making one work after another based on research into the lives of actual yakuza. In *Violent Archipelago Japan: The Killers of Kyoto, Osaka and Kobe* (*Nihon bōryoku rettō: Keihanshin koroshi no gundan*, 1975), Yamashita focused on *zainichi* Korean yakuza, which all of the "conscientious" and "progressive" directors had refused to touch, brilliantly tracing the conditions of those placed at the edges of postwar society. Nakajima Sadao (1934–), in the three-part series *Nihon no don* (1977–1978), aimed at a grand narrative that could be a final compilation of the series of *jitsuroku* films. This aim, however, harbored a certain danger: even the slightest misstep threatened to push the work into the territory of the lyrical epic that was the specialty of social realists like Yamamoto Satsuo, meaning that the kind of force and shock the genre held at the outset had dissipated by the end of the 1970s.

Once the *Battles Without Honor and Humanity* series settled down a bit, Sugawara Bunta appeared in Suzuki Noribumi's *Torakku Yarō* ("The Truck Guy") series, playing a rough truck driver who nonetheless is very human and kind. Aiming to revive their specialty of *jidaigeki*, Tōei had Fukasaku Kinji direct such big-budget historical epics as *The Fall of Akō Castle* (*Akōjō danzetsu*, 1978), *Yagyū Conspiracy* (*Yagyū ichizoku no inbō*, 1978), and *Samurai Reincarnation*

(*Makai tenshō*, 1981). Achieving Tōei's long-held wish to restore the vitality of the 1950s in *jidaigeki*, however, proved to be too much even for Fukasaku.

SHŌCHIKU: THE EMPIRE OF YAMADA YŌJI

At Shōchiku, after the first film in 1969, the *It's Tough Being a Man* series became so popular that it could almost be said that it was beloved by all the Japanese people. The protagonist of the series, Kuruma Torajirō, popularly called "shiftless Tora" (*fūten no Tora*) is a traveling salesman and showman born in the Shibamata neighborhood of the Katsushika area of Tokyo. Each episode is essentially the same. Tora travels through the country and falls in love with a "Madonna" (played by a star actress) in that particular place with disastrous results. Then he returns periodically to his home in Shibamata, causing difficulties for his long-suffering family. When Yamada Yōji (1931–) first created the protagonist, it was clear that he intended this to be a reflection on the history of Japanese performing arts. The name Kuruma recalls that of Kuruma Zenshichi, who ruled over outcaste groups of entertainers known as *gōmune* during the Edo period. Furthermore, the name Torajirō refers to Saitō Torajirō, the preeminent director of comedies at Shōchiku during the prewar period.[4] The series was celebrated for its nostalgia for a no-longer-existing world of *shitamachi*, with its overflowing human warmth, and a worldview that people are intrinsically good; the series thus continued for nearly thirty years, and a total of forty-eight films were produced. As a result, it has been listed in the *Guinness Book of World Records* as the "longest running film series in the world" since 1983.

More important to film history than even Yamada, however, was Morisaki Azuma (1927–), who had been involved as a secondary figure in the earliest days of the *It's Tough Being a Man* series. In contrast to Yamada's praise of the life of the common people as a kind of utopia, Morisaki focused on the hidden rage of everyday life. Ever

since *Comedy: Women Need Guts* (*Kigeki: Onna wa dokyō*, 1969), he has presented comedies that could be described as black humor. What is present in Morisaki and absent in Yamada is the sense of crisis that "the family," or "the people," are no more than ideas that were constructed in the past. After he eventually left Shōchiku, he went on to make *Nuclear Gypsies* (*Ikiteru uchi ga hana nano yo, shindara sore made yo tōsengen*, 1985), setting it in a slum that was rapidly becoming multiethnic, a comedy overflowing with the spirit of anarchism.

At Shōchiku there was also Maeda Yōichi (1934–1998), whose stock in trade was nonsense comedies, which he shot one after another. In particular *Make Way for the Jaguars* (*Susume Jagaazu: Tekizen jōriku*, 1968) was a strange work that will be remembered as Japan's first Godardian slapstick parody. While staying within the tradition of human comedies at Shōchiku, the director Yamane Shigeyuki (1936–1991) was heavily influenced by the sensibilities of Nikkatsu's Suzuki Seijun and enjoyed creating estrangement effects through the use of colors and subtitles on screen. Yamane directed some of the best of the youth pictures starring Gō Hiromi and Akiyoshi Kumiko, including *Farewell to the Summer Light* (*Saraba natsu no hikari yo*, 1976) and *Suddenly, Like a Storm* (*Totsuzen, arashi no yō ni*, 1977).

VETERAN DIRECTORS DEPICT WOMEN

If there is something worth remembering produced at Tōhō, it is the idol films of the pop singer Yamaguchi Momoe (1959–). Nishikawa Katsumi, who had shot the true love films at Nikkatsu in the 1960s starring actress Yoshinaga Sayuri, was called in to direct the same kind of pictures once more, including *Dancing Girl of Izu* (*Izu no odoriko*, 1974), another film based on Kawabata Yasunari's classic novel; *Shouting* (*Zesshō*, 1975); and *Sea of Eden* (*Eden no umi*, 1976). As a singer, Yamaguchi gradually grew increasingly extreme and experimental, but in film, producers never considered her as anything more than an actress suited for remakes of

Sweet Revenge (dir. Nishikawa Katsumi, 1977).

old standards. Nonetheless, with *Flag in the Mist*, which is also known as *Sweet Revenge* (*Kiri no hata*, 1977), Nishikawa had her play an astonishing femme fatale. Yamaguchi retired completely from the entertainment business after her last film, Ichikawa Kon's *Old Capital* (*Koto*, 1980).

Without a doubt, in the 1970s, despite the unstoppable decline in studio pictures, ATG provided the richest creative opportunities for filmmakers.

Masumura Yasuzō, who had completed his final film at Daiei, *Play* (*Asobi*, 1971), showed the almost-frightening perfection of his skills at ATG with *Music* (*Ongaku*, 1972), *Lullabies for the Earth* (*Daichi no komori uta*, 1976), and *Love Suicides at Sonezaki* (*Sonezaki Shinjū*, 1978). Masumura's picture of women with fierce individuality and a desire for life that did not waver even in the face of their own destruction was crystalized in its most ideal form in the actresses Harada Mieko and Kaji Meiko.

ATG AS A BASE FOR PROTEST

Kuroki Kazuo (1930–2006), who started in the field of documentary film, visited Cuba in 1969, where he shot *Cuban Lover* (*Kyūba no koibito*). Just as Masumura was fascinated by desire, Kuroki was obsessed with factional politics. He made *Evil Spirits of Japan* (*Nippon no akuryō*, 1970), which showed the shift in policy of the Japanese Communist Party in the early 1950s in the style of a *ninkyō* film, and then seemingly made a drastic switch with *The Assassination of Ryoma* (*Ryōma ansatsu*, 1974), which focused on terrorism in the political struggles among youth just before the Meiji Restoration. Outside the movie theaters, new left activists isolated themselves from trying to ignite the public and instead were preoccupied with infighting that led to killings. Kuroki experimented with confronting this situation through a *jidaigeki*, showing a similar situation in the past. Higashi Yōichi (1934–), in contrast, shot *No More Easy Life* (*Mō hōzue wa tsukanai*, 1979), which featured a group of men who feel a temporary sense of exhaustion stemming from their despair over the student movement, alongside a group of women of the same generation who doggedly survive by overcoming their idleness. Overnight, Momoi Kaori, who played the heroine, captured the empathy of this generation.

Following the collapse of the studio system, many filmmakers who had been active in independent and experimental cinema were invited into the world of feature film. Takabayashi Yōichi (1931–2012) depicted a world of languorous eroticism in *Doll in the Shadows* (*Hina no kage*, 1964), becoming an independent filmmaker drawing international attention. He shot *Death at an Old Mansion* (*Honjin satsujin jiken*, 1975) and *The Golden Pavilion* (*Kinkakuji*, 1976) for ATG. Ōbayashi Nobuhiko (1938–), who had been shooting pastiches of horror film as independent works since the 1960s, began making vibrant creative work in the world of thirty-five-millimeter feature films with his comedy-horror film *House* (*Hausu*, 1977). At the root of this work was an unending nostalgia for the time of one's youth. This longing for a past that can never return was crystallized

brilliantly in films like *Transfer Students* (*Tenkōsei*, 1982) and *The Girl Who Leapt Through Time* (*Toki o kakeru shōjō*, 1983).

The independent filmmaker whose cinematic talent blossomed most fully during the 1970s was undoubtedly the playwright and poet Terayama Shūji (1935–1983). In the range of his artistic activities and the way he courted scandal, as well as his obsession with his mother, he recalls Pasolini. Originally a poet, Terayama entered the film world at the beginning of the 1960s as a screenwriter for Shinoda Masahiro. He then led an underground theater troupe— Tenjōsajiki—and, using them as a foundation, he made several experimental films in the late 1960s. Many of these films had a conceptual humor at the core—in one, the screen rips open and the character who had been in the film suddenly emerges in the flesh. In another, a hand gropes for the light switch in a dark room. When he finds it and turns on the switch, the lights in the theater all go on and the movie is over. But in the 1970s, Terayama made real feature films. *Throw Away Your Books! Take to the Streets!* (*Sho o suteyo machi e deyo*, 1971) does not actually have a storyline, but it mobilizes all the members of the Tenjōsajiki theater troupe to show urban anonymity and the self-expression of the younger generation in underground culture. Instead of the city, by contrast, *To Die in the Estuary* (*Den'en ni shisu*, 1974) is set in the director's home area of Aomori and focuses on the sinfulness of rural life, the karma of the family, and the attempt to escape from infinite evil.

At the end of the 1970s, ATG experimented with youth films of an even-younger generation. This trend is represented by Ōmori Kazuki (1952–), the director of *Disciples of Hippocrates* (*Hipokuratesu tachi*, 1980). The end of the 1970s saw a dearth of new directors in studio pictures. New figures, however, appeared from Pink Films, including Takahashi Banmei (1949–), Nakamura Genji (1946–), and Izutsu Kazuyuki (1952–). Takahashi made *Tattoo* (*Irezumi ari*, 1982) using materials on actual bank robbers. Izutsu directed two memorable films with a strong style that intensely evoked Osaka's ethnic and cultural diversity: *Empire of Punks* (*Gaki teikoku*, 1981) and *Empire of Punks: A Rowdy War* (*Gaki teikoku: Akutare sensō*, 1982).

TWO DOCUMENTARY FILMMAKERS

Before closing this chapter on cinema in the 1970s, I will discuss the extremely radical developments in documentary cinema that occurred during this period. Two figures were at the center of this development: Tsuchimoto Noriaki (1928–2008) and Ogawa Shinsuke (1935–1992).

In *Exchange Student Chua Swee Lin* (*Ryūgakusei Chua Sui Rin*, 1965), Tsuchimoto showed in great detail the persecution of an exchange student from Malaysia for political reasons by the authorities of Chiba University. He then took up the political struggles of the student movement on the campus of Kyoto University with *Prehistory of the Partisan* (*Paruchizan zenshi*, 1969) before developing a long engagement with the issue of pollution in Minamata.[5] In *Minamata: The Victims and Their World* (*Minamata: Kanjasan to sono sekai*, 1971), a work that focused directly on the anger at the pollution, Tsuchimoto

Sanrizuka: Peasants of the Second Fortress (dir. Ogawa Shinsuke, 1971).

trained his focus on the bitter attacks at a shareholder's meeting at the Chisso Corporation, the company responsible. Coming to feel that it was necessary to research and report on Minamata disease as a medical issue, he made a three-part science film on the topic, before moving on to record with sensitivity the everyday lives, worldviews, and statements of victims in *The Shiranui Sea* (*Shiranui kai*, 1975). Tsuchimoto's long engagement with Minamata continued after that as well, existing not only as a monument of documentary cinema but arguably as a forceful criticism of the century of Japanese modernity *in toto*.

Ogawa also began by shooting a documentary on the topic of student activism with *Forest of Oppression: A Record of the Struggle at Takasaki City University* (*Assatsu no mori: Takasaki keizai daigaku tōso no kiroku*, 1967), but then, rather than turning to fishing villages, as Tsuchimoto had, Ogawa turned toward Sanrizuka, where farmers' battles against the appropriation of their land to build Narita airport were in full swing.[6] As an integral part of his way of filming, Ogawa and his crew settled in the communities where they filmed, and in 1968, he shot *The Battle Front for the Liberation of Japan: Summer in Sanrizuka* (*Nihon kaihō sensen: Sanrizuka no natsu*). Ogawa refused to exploit a hidden camera, and instead, he placed his camera clearly and openly on the side of the farmers, choosing to represent the riot police head-on as the enemy. He continued through 1973, making six additional works in the same manner as a series. Initially, these documentaries were full of fury toward the enemy, but gradually, as the number of films increased, they also took on a calmer tone and an understanding and affirmation of the farming communities as they became increasingly perceptible. Especially around the time of *Sanrizuka: Heta Village* (*Sanrizuka: Hetaburaku*, 1973), greater focus was placed on the lush, verdant paddy fields and the story of each individual farmer, and the film project took on the aspect of anthropological fieldwork. The amount of information on political struggles dropped rapidly. The utopian political vision that originally animated the movement came to seem like science fiction and

was replaced by the reality of the farming community, which could be affirmed unconditionally. This metamorphosis was more than enough to move urban critics, but in the future, it must be carefully examined whether this idealized image of farming villages actually surfaces every time Japanese ideology shifts.

10
THE COLLAPSE OF THE STUDIO SYSTEM: 1981–1990

MAJOR STUDIOS IN DISTRESS

The major characteristic of 1980s Japanese cinema is that the studio system gradually became totally nonfunctional. This became clear in film production, distribution, and exhibition. In 1961, this system had six studios that could make 520 films, but twenty-five years later in 1986, only three studios produced a mere twenty-four films. The block-booking system—in which a film could open simultaneously in theaters devoted to that studio in every town and village in Japan—was simply not possible any more, and the previously standard system in which major studios would use big-budget pictures to keep their grip on the industry had ceased to function.

Nikkatsu changed its name by writing it in the Hiragana syllabary instead of the Chinese characters they previously had used. The studio pursued a rationalized management system; but in 1981, it abolished the exclusive producer system. The spread of video for home use and the emergence of adult video as a genre brought an end to Roman Porno. In 1985, they inaugurated a new line—Roman X—shifting direction to the production of even more hardcore sex films, but this desperate ploy did not achieve anything and was like

pouring water onto burning rocks. In 1988, as a final step, they aban-
doned the Roman Porno films that had been the mainstay for six-
teen years and embarked once more on making films for a general
audience under the name Ropponika. In less than a year, however,
they were forced to cease production again. Nonetheless, Nikkatsu
had done more than any other major studio to develop new direct-
ing talent and to train the next generation of technical staff. During
the 1980s, such directors as Ikeda Toshiharu, Nakahara Shun, Nasu
Hiroyuki, Kaneko Shūsuke, Ishii Takashi, Negishi Kichitarō, and
Morita Yoshimitsu started their careers at Nikkatsu.

Shōchiku, Tōei, and Tōhō did not produce new directors in the
same way as Nikkatsu. Shōchiku in particular spent the 1980s simply
producing Yamada Yōji's *It's Tough Being a Man* over and over again,
covering the same ground without creating anything new. Tōei
and Tōhō did not have comparable salable properties and relied on
the rickety support of films that could mobilize mass audiences to
buy advance tickets. Tōhō followed the success of Moritani Shirō's
Mt. Hakkoda (*Hakkodasan*, 1977) by repeatedly releasing epics that
similarly praised heroism and had a hint of pathos. These works
included Matsubayashi Shūe's *The Imperial Navy* (*Rengō kantai*, 1981).
Every August—the anniversary of the end of the war—with dreary
regularity, Tōei had Masuda Toshio direct works like *The Battle for
Port Arthur* (*Nihyaku-san kōchi*, 1980) and *The Great Japanese Empire*
(*Dai Nippon Teikoku*, 1982). These films tried to stir up a sense of nos-
talgia for the military strength of the Japan of old.

The collapse of the studio system meant the loss of a place for
the training and transmission of technical and production skills in
actual shooting in the fields of cinematography, lighting, sound, and
art. In 1989, during the production of *Zatōichi*, with the star Katsu
Shintarō himself directing, a horrible event occurred in which a
fight trainer died when a real sword was used rather than a prop
sword. This heart-breaking incident not only showed the incapabil-
ity of the assistant director to establish and maintain safety proto-
cols on set but also revealed how far the level of production skills
had dropped in *jidaigeki*.

CHANGES TO THE SYSTEM OF PRODUCTION, DISTRIBUTION, AND EXHIBITION

The system of program pictures was, however indirectly, supported by the world of Pink Film. Even with unbelievably low budgets, awful production conditions, and the contempt of critics, Pink Films continued the radical activity that started in the 1960s and still provided outstanding new directors opportunities to direct their debut thirty-five-millimeter films during the 1980s. Directors like Kurosawa Kiyoshi and Suo Masayuki are two prime examples. Because of their grounding in Pink cinema, directors like Zeze Takahisa, Sano Kazuhiro, Satō Hisayasu, and Satō Toshiki came to be called the "Pink Film nouvelle vague."

The dissolution of the studio system provided chances for corporations that previously had no direct connection to cinema to enter the film world. The first was Kadokawa Publishing, which made itself known in the late 1970s with large-scale productions with massive advertising budgets. In the 1980s, Kadokawa was followed by television stations, trading companies, and retail companies. The spread of video, cable television, and satellite broadcasting provided film images with possibilities for secondary and tertiary use. This finally led to media-image corporations' entry into film production seeking the rights to video software.

Decisive changes in how movies were shown emerged in the 1980s. Repertory cinemas (*meigaza*), usually affiliated with major studios and their program pictures, began to close up one after another. In place of these repertory cinemas, mini-theaters appeared, with seating capacities of around two hundred, in addition to cinema complexes, which combined numerous small screening rooms. Such theaters were not a part of the block-booking system, so as a happy result, they had the ability to choose strongly individual films and could screen them in their own theaters without concern for a repertory schedule imposed by a studio or distributer. During this decade, in Tokyo, it was possible to watch films

ranging from experimental European art-house fare to films from previously unfamiliar Asian countries, far exceeding what could be seen even in Paris or New York. For these ten years, Tokyo was transformed into a film center where it was possible to see the greatest variety of films in the world. This rapid increase in mini-theaters allowed unprecedented opportunities for new talent to shoot new and unique kinds of films.

NEW DIRECTORS WITH NO CONNECTION TO THE STUDIO SYSTEM

New film directors arrived in the world of cinema from many different fields previously unimagined. I have already described Nikkatsu and Pink Films. Additionally, Hara Kazuo (1945–) and Takamine Gō (1948–) emerged from the world of independent filmmaking in the late 1960s. Where Ogawa Shinsuke was committed to filming documentaries based firmly in farming communities, Hara was committed to the standpoint of the individual, to an extent that at times he unavoidably aroused hostility in the people on whom he focused and developed his own brand of "action documentary." But this process produced powerful films like *The Emperor's Naked Army Marches On* (*Yukiyukite shingun*, 1987) and *A Dedicated Life* (*Zenshin shōsetsuka*, 1994). Takamine Gō made *Untamagiru* (1989)—named after a mythical character—in his native Okinawa with dialogue almost entirely in the Okinawan language. When the film first opened, Japanese audiences needed subtitles in the Japanese language to understand it. The 1980s was a time when many regions around the world produced films in minority languages, including Wales, Brittany, and Taiwan. Takamine's film took a traditional picaresque tale about righteous bandits handed down in Okinawa and, being in the Okinawan language, it was a brilliant counterstatement of Okinawan cultural identity against the mainstream narrative celebrating the reunion of Okinawa with Japan in 1972. This is a perfect example of what Fredric Jameson called "national allegory."

The Emperor's Naked Army Marches On (dir. Hara Kazuo, 1987).

From the eight-millimeter independent film movement of the 1970s came directors Ōmori Kazuki, Nagasaki Shun'ichi, Imazeki Akiyoshi, Tezuka Makoto, and Yamamoto Masashi. They were not as radical in terms of methodology as the previously mentioned Hara Kazuo or Takamine Gō, and the content of their films was not so closely tied to their own personal lives as with these two. But their independent films were richly narrative and even at that stage showed a strong affinity with mainstream feature films. The magazine *PIA*, Tokyo's biggest entertainment guide, hosted a film festival and supported their activities. Ironically, the production of the eight-millimeter film stock that gave birth to these films largely ceased in the 1980s and was being replaced by a new genre—video.

In the late 1980s, the economy was unusually prosperous—the so-called bubble economy—and one after another, celebrities from a variety of fields were pulled into making films. Innumerable musicians, actors, writers, painters, and former professional boxers

were mobilized, but few of these people ever made a second film. The number of those who made works significant for film history was even fewer: only comedian Kitano Takashi, Kabuki actor Bandō Tamasaburō, and actor Takenaka Naoto could be counted among them. These three artists became even more visibly active in the indies scene of the 1990s.

RETURN OF THE DIRECTORS OF THE 1960s

Several famous directors who had been vibrant and active in the 1960s, but who were pushed into silence during the 1970s, reappeared in the 1980s to produce extraordinary works. Kurosawa Akira presented large-scale works like *Kagemusha* (1980) and *Ran* (1985), with an even more highly polished lyricism in his style. With *Dreams* (*Yume*, 1990), Kurosawa cooperated with his old friend and director of *kaijū* movies, Honda Ishirō, which allowed Kurosawa to fully realize his long-held love of painting. Kurosawa was referred to with the exalted term of respect "emperor," but this naming also indicated his isolation within the difficult contemporary conditions of film production in the 1980s. Many young directors and critics who were then competing to make a place in the film world were conspicuously unimpressed with Kurosawa. Kurosawa was furious with the lack of understanding at home and had to seek out producers in America and France.

Suzuki Seijun's return was a contrast to the isolation of Kurosawa. This action filmmaker, who had been summarily fired by Nikkatsu in 1968, scored an astonishing comeback with the films he made inspired by the erotic and fantastic spirit of Izumi Kyōka: *Zigeunerweisen* (1980), *Heat-Haze Theater* (*Kagerōza*, 1981), and *Yumeji* (1991), which was named after the Meiji *ukiyo-e* artist Takehisa Yumeji. These three interrelated works demonstrated the most sophisticated aesthetic sensibility achieved by anyone in postwar Japanese cinema, combined with a baroque spirit at its most extreme. Kyōka was the powerful writer who had forged the *shinpa*-esque world at

Heat-Haze Theater (dir. Suzuki Seijun, 1981).

the foundation of Japanese cinema. Seijun, by focusing on those grotesque and fantastic aspects that had been suppressed in the conventional presentation of Kyōka in Japanese theater and film, succeeded in making what he himself called "film Kabuki," a site of overflowing nostalgia and decadence.

Other directors who resurfaced included Yoshida Yoshishige, with *Human Promise* (*Ningen no yakusoku*, 1986), and Matsumoto Toshio, with *Dogura Magura* (1988). Within Japanese cinema, they constituted what Jean-Marie Straub and Danielle Huillet once called the "people who do not compromise." They took the themes that they had created in the experimental season of the late 1960s and, in the 1980s, continued this by making films that deepened and expanded these themes. Terayama Shūji adapted Gabriel García Márquez's *One Hundred Years of Solitude* as *Farewell to the Ark* (*Saraba hakobune*, 1982), shifting the setting to Okinawa. Then he died, leaving the world after forty-seven years of turbulent troublemaking.

The documentarist Ogawa Shinsuke judged that the farmers' struggles against Narita airport, which he had been involved with since the 1960s, had reached a level of settlement and moved with his staff to a village in the mountains of Yamagata prefecture. There they made *"Nippon": Furuyashiki Village* (*Nippon koku: Furuyashikimura*, 1982) and *Magino Village: A Tale* (*1000 nen kizami no hidokei: Maginomura monogatari*, 1987). Both are gentle works that look steadily at the society of rural communities using the measuring stick of immense spans of time. They were created by standing at the crossroads of an ethnographic imagination and a reflexive historical critique of modern Japan. After making these films, Ogawa passed away, but his spirit lives on in the Yamagata Documentary Film Festival, which he helped to create.

A FLOOD OF NEW DIRECTORS

I next touch on a few new directors who became active during the 1980s.

Sōmai Shinji (1948–2001) emerged with films that featured young boys and girls as protagonists, including *Sailor Suit and Machine Gun* (*Sērā fuku to kikanjū*, 1981), *P. P. Rider* (*Shonben raidā*, 1983), and *Typhoon Club* (*Taifū kurabu*, 1985). He had the most aggressive and radical style of any of the new directors who emerged during this period. In single scenes without any cuts, Sōmai kept the camera moving incessantly, presenting unexpected transformations of hazy, noise-filled spaces before audiences. Japanese cinephiles believed that these films, with such violently anarchic techniques, embodied new principles that went beyond André Bazin's thesis of "découpage through spatial depth"[1] from thirty years ago, and to them, this gave Sōmai a sublime cult-like status.

Itami Jūzō (1933–1997), the son of Itami Mansaku the writer and director who had been active in the 1930s, also had experience as an actor in Hollywood during the 1950s. After meticulous preparation, he debuted as a director in 1984 with *The Funeral* (*Osōshiki*). The film

Fancy Dance (dir. Suo Masayuki, 1989).

garnered great attention that year, with its alternately cynical and humorous depictions of a contemporary Japanese family carrying out a funeral. What exerted a decisive influence on Itami was the theory of cinematic quotation, which was the latest trend among film critics at the time, with extensive borrowings from contemporary French thought. *The Funeral* was full of hidden references to film history, quoting everyone from Dreyer to Ozu Yasujirō. Of course, this could not last, and before long, Itami abandoned this methodology. In the 1990s, Itami's fellow filmmakers, Kurosawa Kiyoshi and Suo Masayuki, would have to make a strong effort to break free from the burden of this reified ideal rooted in memories of film history.

I next describe the beginnings and some of the movements in the 1980s of Japanese animation that would later gain popularity throughout the world under the name "Japanimation." The first postwar feature-length anime is said to be *The Tale of the White Serpent* (*Hakujaden*) created in 1958 by Tō'ei *dōga*, Tō'ei's animation

department. Then, in the 1960s, Tezuka Osamu's Mushi Production made several works, and in 1977, Masuda Toshio directed *Space Battleship Yamato* (*Uchū senkan Yamato*) causing a huge boom. Whatever its successes, up until the 1980s, anime never went beyond being considered a genre exclusively for young people. In that sense, the sensational appearance of Miyazaki Hayao in the 1980s was important because it brought adults into the world of anime. Works such as *Nausicaä of the Valley of the Wind* (*Kaze no tani no Naushika*, 1984) and *My Neighbor Totoro* (*Tonari no Totoro*, 1988) featured stories that mixed themes of ecology and nostalgia. Miyazaki's characters flew around freely—the kind of action difficult to achieve in a conventional film—restoring a utopian sensibility to screens that had long before disappeared from literature and film. In the 1990s, his name gained worldwide recognition, and with *Princess Mononoke* (*Mononoke hime*, 1997), he set a new record in Japanese film history for distribution revenue.

For representative new directors of the 1980s, we can mention Yanagimachi Mitsuo, Nakahara Shun, Ōmori Kazuki, and Morita Yoshimitsu. Yanagimachi made two profoundly thoughtful films based on the works of the writer Nakagami Kenji. In particular, *Fire Festival* (*Himatsuri*, 1985) was praised as a work that looks back at Shinto worship of mountains and same-sex eroticism in its depiction of a mass-slaying incident. Nakahara was a director who emerged out of Nikkatsu Roman Porno, making him part of the last generation to experience the Japanese studio system. His constant theme is the fleeting, transitional quality of youth and the rites of passage that punctuate it. We can see the essence of his orientation in two films: *Make-Up* (*Meiku appu*, 1985) and *The Cherry Orchard* (*Sakura no sono*, 1990). The former, inspired by Federico Fellini's *La Strada* (1954), presented a story of a stripper and an intellectually disabled boy, while the latter took up the production of a graduation play at a girl's high school. Ōmori's style was founded on the sentiments of nostalgia and regret, but once he broke with the past, he opened up new pathways for Tōhō's idol films. Then, in the 1990s, he made several films to help revive the *Godzilla* series, and gradually, he moved

closer to being considered a filmmaker for the Japanese people. Morita, with his light humor and philosophical resignation, garnered attention with a floating style that seemed to be completely free of gravity. *Family Game* (*Kazoku gēmu*, 1983) deftly crafted images of the impulses toward death and chaos hidden in the everyday lives of contemporary Japanese. *And Then* (*Sore kara*, 1985), based on the Meiji writer Natsume Sōseki's novel, successfully captured the themes of ennui and lethargy within a contemporary context.

During this decade, the most important film actor was Matsuda Yūsaku. He appeared in Kadokawa blockbusters in the late 1970s, and after that, he gained attention for his portrait of an ascetic and eccentric killer in Murakawa Tōru's action films. In works like Seijun's *Heat-Haze Theater* and Morita's *Family Game*, he played the role of the educated idler to much critical acclaim. An action film he directed himself, *A Hōmansu* (1986)—the title is a combination of the word "*ahō*" for "fool" and the word for "performance"—could be described as a perversely mannerist gang film.

When Matsuda died at the age of thirty-nine in 1989, young Japanese film fans felt that everything had ended, just as many had felt when James Dean died. The same year, however, was also a time of beginnings: the directors Kitano Takeshi, Zeze Takahisa, Sakamoto Junji, and Tsukamoto Shinya all debuted that year. They seemed to emerge at the forefront of the Japanese film world when Matsuda died, like the changing of the guard. This raised the curtain on Japanese film in the 1990s.

11

THE INDIES START TO FLOURISH: 1991–2000

THE COLLAPSE OF THE CINEMATIC BUBBLE

The 1990s in Japan were an era of unprecedented continuous bad economic conditions. With the end of the prosperity of what was called the "bubble economy" of the late 1980s through the early 1990s, corporations suddenly reduced the scale of their economic operations and unemployment rose. Moreover, in 1995, Japan was hit by a string of incidents that left long-lasting psychological traumas. An earthquake of unprecedented scale hit Kobe, while the Aum Shinrikyo religious group scattered poison throughout the Tokyo subway system, committing indiscriminate mass killing. The number of non-Japanese living in Japan illegally increased sharply. These various social currents were signs that the ways of thinking and acting that the Japanese had believed were perfectly normal could no longer function as in the past. Although the effect of these changes was by no means immediate, slowly and steadily they had a tangible influence on the shape of Japanese cinema.

The recession meant that the big business groups that had set up companies to try their hand at film production withdrew their support for cultural activities. The Seibu trading corporation closed its Saison-affiliated theaters as well as their film production and distribution companies. Even though things were still in progress, Seibu largely abandoned its cultural activities. In 1990, a group of six producers, including Sasaki Shirō, gathered to establish Argo Projects and made it to the point of launching the opening of theaters exclusively dedicated to independent film. This plan, however, was also dogged by management difficulties and the theaters were forced to shutter. The Director's Company, founded in 1982 by the new directors Kurosawa Kiyoshi, Sōmai Shinji, and Ishii Sōgo, dissolved in 1992. This cast a vague sense of unease over the future of independent film just as it was beginning to flourish.

At Shōchiku, to break through two decades of malaise, the producer Okuyama Kazuyoshi proposed the Cinema Japanesque line in the late 1980s. It was through this reform movement that artists like Kitano Takeshi and Bandō Tamasaburō were able to venture into a new field as filmmakers. Originally, Shōchiku, unlike Tōhō and the other companies, had been a corporation in which it was rare for producers to be more powerful than directors. Thus, it was groundbreaking that as a producer Okuyama was able to push through this plan. He was also quite driven. When he was dissatisfied with director Mayuzumi Rintarō's work on *Rampo*, a film he was producing about the mystery writer Edogawa Ranpo, he decided to direct it himself and released an alternate version with the same title. In 1997, Okuyama was suddenly driven out of Shōchiku. Around the time that this was happening, the actor Atsumi Kiyoshi died. Atsumi had played Tora-san for so many years that, without him, it proved to be impossible to continue producing the *It's Tough Being a Man* series, which was the backbone of Shōchiku cinema. An opportunity for Shōchiku to revive as a cinematic power was thus snatched away once more.

INCREASING INTERNATIONALISM

At the same time, in the 1990s other incidents also pointed to a renewal of Japanese cinema.

Throughout the decade, around two hundred films were produced annually, and by 1996, that number had reached 289. The number of theaters continued the decline that had begun in the 1960s; however, from 1994 onward, the number began to climb, although slowly, and by 1998, there were 1,988 theaters. This rise showed that multiplexes had become an established presence. They are the convenience stores of the film world. Annual viewership reached its lowest point in 1996 with 119,580,000. After that, it climbed slowly, and in 1998, it exceeded 150 million. Although this increase can be attributed partly to the fact that Miyazaki Hayao's *Princess Mononoke* was a record-breaking hit in 1997, it also gave distributers hope that good enough movies could attract people to movie theaters again. Of course, these changes are solely at the level of aggregate figures. Note also, however, that after these numbers had declined consistently for more than thirty years since around 1960, such an increase, which took place in spite of an overwhelming recession, provided small signs of recovery.

Another striking characteristic of the 1990s is the fact that for the first time since the 1950s, a succession of Japanese films became the focus of attention at international film festivals. In 1997, in particular, there was a cluster of international prizes for Japanese films. In that year, veteran director Imamura Shōhei took the Grand Prix at the Cannes international film festival with *Unagi*, and the new director Kawase Naomi received the New Director's Prize for *Suzaku* (*Moe no suzaku*). Kitano Takeshi's *Fireworks* (*Hana-bi*) won the Golden Lion at the Venice International Film Festival. All at once, Japanese journalists united in using the catchphrase "Renaissance of Japanese cinema." Setting aside for the moment whether or not we can call the events of a single year a "Renaissance," such trends had been anticipated for several years. Before that year, a

Ghost in the Shell (dir. Oshii Mamoru, 1995).

flourishing new generation of independent filmmakers—including Rijū Gō, Iwai Shunji, Hayashi Kaizō, Kore'eda Hirokazu, Hashiguchi Ryōsuke, and Aoyama Shinji—had appeared one after another at international film festivals. In addition, such films as Suo Masayuki's *Shall We Dance?* (*Shall we dansu*, 1996) and Oshii Mamoru's *Ghost in the Shell* (*Kōkaku kidōtai*, 1995) experienced box office success in numerous countries, beginning with the United States. This competition as to who would be at the forefront of new Japanese film helped create the foundation for an increase in global interest in Japanese cinema.

From the late 1970s through the early 1980s, new waves appeared simultaneously in Hong Kong (Hong Kong New Wave), Taiwan (New Taiwanese Cinema), and mainland China (Fifth-Generation Films). All were instantly acclaimed internationally. By the 1990s, filmmakers in this region overcame differences in their political systems and began producing films cooperatively. A work could have a producer from Taiwan, have a director from Hong Kong, and be

filmed on the mainland in the People's Republic of China. One after another, major works that were produced in this way took prizes at international film festivals. Ironically, many of these films did their postproduction work, such as film development and editing, in Tokyo. In other words, in a reversal of the flow during the days of the Japanese Empire, now the facilities that originally had been constructed for Nikkatsu were being used in the service of East Asian cinema.

These trends in East Asia naturally stimulated young filmmakers in Japan. There had already been Chinese-Japanese coproductions beginning with 1982's *The Go Masters* (*Mikan no taikyoku*), but such films were produced as part of the policies of the Communist Party, and as movies, they were only a hackneyed celebration of friendly relations between Japan and China. In the same way, in the 1930s, there was fanfare over Nazi Germany and Japan cooperating to produce *The New Earth*. Ultimately, these films were no more than a political tool. A continental divide existed between such efforts and the developments in the 1990s. Japanese actors like Kaneshiro Takeshi and Tomita Yasuko appeared in films in Hong Kong and Taiwan, achieving mass popularity, and Ishida Eri was cast by South Korean director Kim Soo-Yong to star in *Revelation of Love* (*Ai no mokushiroku*, 1997). Japan was one step behind the New Waves in the other countries across East Asia, but Japanese cinema was finally beginning to take baby steps in learning how to position itself within a larger East Asian context.

FRAGMENTING PRODUCTION COMPANIES

Ōmori Kazuki's *Godzilla* (*Gojira*) at Tōhō and Kaneko Shūsuke's *Gamera* at Daiei were remakes that became successful series. In particular, *Gamera* brought innovation to Japan's *kaijū* monster movie for the first time in forty years by not concentrating on those battle scenes between two monsters that look uncomfortably like pro-wrestling bouts and instead never wavering from the point of view of the

terror of ordinary Japanese. Although I have mentioned both Tōhō and Daiei individually, the major studios were no longer vertically integrated monoliths with a unified style. From the 1990s on, it is no longer useful to divide the discussion studio by studio. Starting with the films of the 1990s, it is easier to gain the whole picture by grouping films by common theme.

ENCOUNTERING THE ETHNIC OTHER

The overwhelming stimulus that came from East Asian cinema, along with the presence of foreigners whose numbers had rapidly increased since the 1980s, gave Japanese film a theme that had not existed previously: the encounter with the ethnic other. That is not to say that all films were successful in dealing with this topic. In *About Love, Tokyo* (*Ai ni tsuite, Tokyo*, 1992), Yanagimachi Mitsuo hesitatingly confessed his sympathy for resident Chinese, but this never went beyond the boundaries of the patronizing feelings of a Japanese. In *Sleeping Man* (*Nemuru otoko*, 1996), Oguri Kōhei picked out first-rate actors from Indonesia and South Korea without any particular necessity and then placed them in symbolic sets that had no relationship to these performers. Such directors had no connection with the reality of East Asia, but simply adeptly folded "the other" into their existing mind-set, resulting in little more than masturbatory self-indulgence.

Directors of a younger generation, such as Yamamoto Masashi and Tsukamoto Shinya, had extremely radical views of the concept of the other, and fearlessly inscribed this stance on film. In *What's Up Connection* (*Tenamon'ya konekushon*, 1990) and *Junk Food* (*Janku fūdo*, 1998), Yamamoto Masashi set Tokyo, Yokoyama, and Hong Kong on exactly the same footing as places that could no longer belong completely to any one nation-state. He made slapstick comedies about groups of the vulnerable people who are forced to wander constantly, but who can upend the efforts of massive authorities to control them. Tsukamoto Shinya went beyond issues

of ethnicity, grotesquely depicting his humble view that the con-
temporary world is one in which humans are forced to face nonhu-
man directly. In *Tetsuo* (1989) and *Bullet Ballet* (1998), an ordinary
protagonist, bullied on account of his vulnerability, is suddenly
transformed by some event into a metal monster or a gun fanatic
and carries out a gigantic and horrifying solitary struggle against
what could be called his own monstrous identity. Tsukamoto's
inborn grotesque imagination instantly made him into an interna-
tional cult star.

Of course, the problem of encountering the other is not necessar-
ily limited to those who came to Japan from the outside. Many peo-
ple from Japan's former colonies on the Korean Peninsula and from
Cheju Island and their descendants—around six to eight hundred
thousand people—reside in Japan. To this day, they have received
no compensation or voting rights in the postwar period and must
endure all manner of discrimination and disadvantages. The makers
of postwar Japanese films, apart from a few brave exceptions like
Uchida Tomu, Imamura Shōhei, and Ōshima Nagisa, were utterly
silent about these ethnic minorities. It is true that in To'ei's *ninkyō*
and *jitsuroku* yakuza films, under the banner of entertainment films,
it was possible to introduce elements that dealt passionately with
the situation of minorities even if the ill-informed general public
remained oblivious to these elements. It was exceedingly rare, how-
ever, for any resident South or North Korean to be able to present
the conditions within which they were placed as an issue in Japanese
cinema. Sai Yōichi, who made idol films at Kadokawa in the 1980s,
took up this problem head-on in *All Under the Moon* (*Tsuki wa dotchi
ni dete iru*, 1994). It is a work both comical and radical about a female
cabaret owner who comes to Japan after she escapes the massacre
at Cheju Island as a child. The film follows her life in Japan, her rela-
tionship with her son, and a Philippine woman her son is courting
and who works as a hostess at her bar. In addition, just as his men-
tor Ōshima Nagisa never forgot the issue of Korea, Sai was dedicated
to Okinawa, one of contemporary Japan's peripheral areas. He shot
four films set in Okinawa.

MEMORY AND NOSTALGIA

In Japan during the 1980s, the philosophy of postmodernism was ini-
tially taken as the latest variant of modernism. The age of the mas-
ters like Ozu and Kurosawa was already a thing of the past. After this,
what new thing could possibly be created? Perhaps the only possibil-
ity was to quote older films or make some kind of pastiche. Among
filmmakers obsessed with this problem, a trend was born in which
elements assembled from the memory of film history and combined
like a mosaic became the basic support system for their own works.
The classical example of this is Itami Jūzō, whose works are noted in
chapter 10. The definition of film was no longer self-evident, and this
trend developed against the background of the complete dissolution
of the studio system. Now those who tried to make new films had
no choice but to grope about in the darkness for random fragments
from the past to find their concept of what a film is.

By the 1990s, the cinephilic sensibility of boastfully speak-
ing about memories of film history as privileged experiences had
already withered and died. The overwhelming spread of video
transformed these experiences into something common and ordi-
nary, and the ideal of making films that draw on the memories of
films a director once saw lost some of its glamor. The passion of
cinephilia in the classical sense that had existed in the 1960s was
already long gone and all that remained was the snobbism of young
people pretending to a nostalgia that was now impossible. Film criti-
cism became a kind of "*otaku*-ism"[1] and lost its way as serious intel-
lectual discourse.

Directors of a new generation had to free themselves from the
imprisonment of such film-historical memories that had cast a spell
over the films of the 1980s. Suo Masayuki began with *Abnormal Fam-
ily* (*Hentai kazoku: Aniki no yomesan*, 1983), a daring parody in which
he recast the characters of an Ozu film as an incestuous family. From
the late 1980s through the 1990s, he went on to take up Buddhist
temples, sumo, and social dance—themes that appear outmoded to

an average young person today—and one after another, Suo turned them into cheerful comedies. *Shall We Dance?*, in particular, depicted the quiet hopes of people living in a contemporary businessman-oriented society with a light melodramatic touch. In this way, the most ideal form of the *shōshimin* films made at Shōchiku during the 1930s was reborn sixty years later, far beyond the confines of the studios of Shōchiku.

Oshii Mamoru and Kurosawa Kiyoshi are representatives of the generation who started making movies under the influence of Godard. Oshii, an anime director, is an artist whose essence is in complete contrast with that of his predecessor in anime Miyazaki Hayao. Miyazaki is the embodiment of postwar democracy who makes films to raise the consciousness of ecology, and with his films *My Neighbor Totoro* (*Tonari no Totoro*, 1988) and *Princess Mononoke* (1997), he became a favorite of the Japanese people. By contrast, Oshii featured protagonists who constantly fight against postwar society in sci-fi anime set in the near future like the two-part series

Cure (dir. Kurosawa Kiyoshi, 1997).

Patlabor (1989) and *Patlabor II* (1993). *Ghost in the Shell* narrates a moment of crisis in an apocalyptic world in which human beings, through the development of technology, cease to be human beings. Kurosawa opted for a critical reexamination of horror and mystery films that had been made into fixed genres by Hollywood, consciously undertaking the anachronistic work of making program pictures in the 1990s when the studio system had long since collapsed. His horror films *Cure* (*Kyua*, 1997) and *Charisma* (*Karisuma*, 1999) clearly showed the extent to which the fear of mind control and mass killing from Aum Shinrikyo left a profound trauma in the psyche of the Japanese people.

Of course, a few directors also made films by purposefully using nostalgia as a methodology. Ichikawa Jun had a homesickness for the "Good Old Japanese Movies" of Ozu and Kinoshita, and in films like *Kaisha Monogatari: Memories of You* (1988) and *Tokyo Lullaby* (*Tokyo yakyoku*, 1997), Ichikawa continuously depicted the feeling of hopelessness of Tokyo's middle classes. Bandō Tamasaburō is not only an extraordinary Kabuki actor, but as a film director, he skillfully reenvisioned the *shinpa* world of Izumi Kyōka in *Operating Room* (*Gekashitsu*, 1991) and *Yearning* (*Yume no onna*, 1993). From the earliest days of film, the activity of the best *onnagata* female role specialists of different eras always has been notable, including the director Kinugasa Teinosuke, who was originally an *onnagata*; the actor Hasegawa Kazuo; and the *shinpa* star Hanayagi Shōtarō. Tamasaburō is a fitting member of this tradition. Hanayagi also occasionally has appeared as a film actor, including in films directed by Daniel Schmid and Andrzej Wajda.

THE PHENOMENON OF KITANO TAKESHI

The appearance of Kitano Takeshi was the event that most directly showed the flourishing of Japanese cinema in the 1990s. He started as a stand-up comic who stirred controversy with his barbed tongue and an antihumanism akin to that of Lenny Bruce. He appeared

Sonatine (dir. Kitano Takeshi, 1993).

in Ōshima Nagisa's *Merry Christmas Mr. Lawrence* (*Senjō no merii kurisumasu*, 1983) as an actor who had already developed a highly idiosyncratic style. Then he debuted as a director with an equally idiosyncratic style in *Violent Cop* (*Sono otoko kyōbō ni tsuki*, 1989). Kitano specialized in excising all emotion from violent scenes, coolly portraying the sudden eruption of brutality into the quiet of everyday life. *Sonatine* (1993) is the film that most forcefully captures this necrophiliac desire, combining it with a child-like sense of play. In the late 1990s, however, bit by bit, emotion began to creep into Kitano's world, which originally was remarkable for the absence of emotion. *Hana-bi* and *Kikujiro's Summer* (*Kikujirō no natsu*, 1999) give the impression of being part of a tentative process of trial and error in trying to show human solitude and salvation. Sakamoto Junji's action films, which appeared after Kitano, are profoundly imbued with a forceful sense of ethnic tensions in Osaka.

Although studio films disappeared in the 1990s, as if to fill the gap, action films produced directly for immediate release on home

video rather than for a primary movie theater market were established as a genre. This was Tō'ei's "V-Cinema" series. These were original films shot with low budgets on quick production schedules, but they ended up producing new directors in the world of action cinema, such as Mochizuki Rokurō and Miike Takashi.

In closing out this chapter, I touch briefly on those directors who debuted in the mid-1990s. Iwai Shunji started as a television director and then shifted to the film world, capturing the attention of young people with his lyrical style. *Love Letter* (1995) was a deft adaptation of Krzysztof Kieślowski's *La double vie de Veronique* (1990) with the Catholicism removed. *Swallowtail* (1996) caused a stir by focusing on an increasingly multiethnic Tokyo in which most of the main characters speak Chinese. This was little more than a superficial feature, however, and he adroitly avoided any serious examination of the concept of "Japan," unlike the sustained questioning of Yamamoto Masashi and Zeze Takahisa. Kore'eda Hirokazu tried to cast a new light on Japanese views of life and death with his films *Maboroshi* (*Maboroshi no hikari*, 1995) and *Afterlife* (*Wandafuru raifu*, 1999). It remains unclear at this point whether this will end up either as an internalized form of Orientalism or as the crystallization of metaphysical searching along the lines of South Korea's Bae Yong-Kyun.

With *Suzaku* (*Moe no suzaku*, 1996), Kawase Naomi became the youngest director to be celebrated internationally. Showing none of the interest in contesting the state or history that drove directors like Ogawa Shinsuke and Tsuchimoto Noriaki, Kawase aims instead at making movies by limiting her focus to the issue of communication with those in her immediate surroundings. What Iwai, Kore'eda, and Kawase share is an aversion to bombast, and with a minimalist philosophy they protect—if not necessarily establish—their own worlds. They were fortunate to be recognized internationally as soon as they debuted, a first in the history of Japanese cinema.

12

WITHIN A PRODUCTION BUBBLE: 2001–2011

JAPANESE CINEMA SINKS

The 2000s was an era of chaos. The malaise of Japanese society continued, with the economy unable to recover and the continuing failure to get to the heart of the problems stemming from the Aum Shinrikyo events. Just as it became clear that North Korea had been abducting Japanese citizens for many years, the prime minister decided to visit Yasukuni Shrine, considered by many to be a symbol of Japanese expansion into Asia, deepening the diplomatic isolation between Japan and other East Asian nations. The films that most directly characterize this decade are Higuchi Shinji's 2006 remake of Moritani Shirō's 1973 hit film *Japan Sinks* (*Nihon chinbotsu*) and Kawasaki Minoru's 2006 parody of it, *Everything but Japan Sinks* (*Nihon igai zenbu chinbotsu*). The prediction of Japan sinking could be said to have finally came true on March 11, 2011, with the Great Eastern Japan Earthquake. This chapter will take up the eleven years leading up to this event.

By the 2000s, it was no longer possible for a single film critic to have a total view of all the Japanese films of that time, and film

criticism no longer served as a standard for viewers to choose what films to watch. All that was left were television ads, chanted over and over into its audiences' ears. Although film studies began to be taught in Japanese universities, scholars were not involved with actual film production. Journalistic criticism based on French-style auteurism disappeared, leaving almost no trace. Writing about cinema went in two directions equally unrelated to true criticism: it became either anonymous childish personal reactions to a film or an effort to compile great masses of information about film in databases. No film research could overcome such a degraded state of affairs. It is true that anyone with an internet connection could post their thoughts on film, but now no one was paying attention.

With developments in media and technology, the ways that ordinary people can access film have changed with increasing rapidity over the past ten years. From movie theaters to video, and then DVD and Blu-ray, and further, to internet downloads, the content that once was called "a film" has gone through a dizzying series of changes in media, and the act of watching a film has thus lost its weight and the feeling of an occasion removed from ordinary daily life. Without regard for national borders, the worldwide movement of homogenization called globalization has stolen away any form of refuge from people everywhere. Despite these international developments, in Japan, out-of-date comedies like *My Darling Is a Foreigner* (*Daarin wa gaikokujin*, dir. Ue Kazuaki, 2010) become big hits as though nothing had changed. Averting its eyes from the theme of "what is a Japanese person?," Japanese cinema has sunk into one-off comedies and cynicism. As a result, it keeps losing ground. It cannot compete with Korean cinema, which is firmly based on a fierce concern for the questions of "what is a Korean person?" and "what is Korean history?" Japanese cinema only speaks Japanese and is aimed at a solely Japanese audience. It stubbornly resists all change in this insular mentality.

The universalization of digital cinema has made it inaccurate to call a work of cinema by its once-standard designation of "film."

Whether it is on videotape or it is considered to be "data" or "content," what has emerged is something utterly different from the films that had been produced over the past 110 years. YouTube and Nico-Nico Dōga have reduced movie theaters to little more than empty ruins. Now that backgrounds and composition can be achieved with computer-generated (CG) compositing, the artistic sense and passion of seasoned art directors is no longer considered necessary, making Japanese cinema visually flat and flavorless.

CHANGES IN THE MODE OF PRODUCTION

Strangely, in terms of the sheer number of films produced, this period witnessed a bubble phenomenon. Although that number had dropped to the two hundreds at the end of the twentieth century, it began to rise again in the 2000s little by little, and in 2006, 417 films were released in theaters. If we were to add to this number low-budget video works that did not pass through Eirin—Japanese cinema's self-regulating agency—the number of Japanese films would easily be at least seven hundred. When we analyze audience preferences, we see that the popularity of Western films declined, while the percentage of those watching Japanese films rose. In the year 2002, the share of Japanese films reached its historic nadir at 27 percent, and on top of this, the top-five films were all children's films. Japanese films began to gain ground gradually, however, and in 2006, their box office profits topped that of Western films for the first time in twenty-one years. But a shadow loomed over this phenomenon of a "Falling West, Rising Japan" because it accompanied the shuttering of mini-theaters for Western art-house films and a slump in Hollywood.

Toward the end of the 2000s, Tōhō was far in the lead in terms of box office returns, with more than double the revenue of Tōei and Shōchiku combined. Tōhō's hit strategy was called the "production committee" method. Production decisions were made with

an eye toward marketing the films and were made by a committee with television stations and advertising companies at their core. The publishers of the original novels were also involved. Other film production companies that had been making all the production decisions on their own came to follow Tōhō's multifaceted market strategy. As a result, the market was dominated by films that were finely calibrated to avoid all criticism and to fill all possible needs to capture as big an audience as possible. The participation of television broadcasters meant the appearance of television actors and celebrities in the movies and, in turn, the performers in the movies could appear as guests on television programs, raising the visibility of cinema as a whole. In return, however, works all started to look the same with the mass production of cheap melodramas characterized by "pure love" and what was purported to be "deep emotion."

In terms of exhibition conditions, multiplexes—the convenience stores of the film world—continued to proliferate. Movies were increasingly shot and projected digitally. In 2006, there were more than three thousand screens, and it almost looked like a return to the 1970s. Because the majority of multiplexes were set up only for digital projection, audiences had fewer opportunities to encounter older works that were available only on film.

Mini-theaters died off. Theaters specializing in classic films struggled. Film audiences aged. The magazine *Pia*, first published in 1972 and long the central source of information on films, theater, and other forms of performance, ceased publication in 2011. All of these phenomena came at the same time, demonstrating in a striking manner just how removed cinema had become from the lives of many young people. People have become accustomed to watching DVDs on tiny screens in the cramped confines of their homes, and a new generation lost the experience of going to a theater to see a movie. At the same time, however, increasing numbers of film commissions help support the regional production of films, producing some striking works centered in the outlying regions of Japan.

MELODRAMA AND HISTORICAL CONSCIOUSNESS

Nostalgia was the basis of the appeal of a few exceptional works in the 1990s and, in the 2000s, it gave birth to sequels that became commercial hits. *Always: Sunset on Third Street* (*Always: Sanchōme no yūhi*, dir. Yamazaki Takashi, 2005) and *Tokyo Tower: Mom and Me, and Sometimes Dad* (*Tokyo tower: Okan to boku to tokidoki oton*, dir. Matsuoka Jōji 2007) were both melodramas that looked nostalgically at Tokyo during the era just before the period of high economic growth, using CG compositing to recreate the look of that era. It is easy to try to aestheticize the past, and in these films, all the social contradictions and political struggles that existed during the Showa era were carefully eliminated. After the collapse of the bubble economy and with a Japanese society perpetually stuck in a deep malaise, many Japanese people welcomed this regressive trend. Yukisada Isao's film *Center of the World: Crying Out Love* (*Sekai no chūshin de, ai o sakebu*, 2004), while covering a shorter time period by comparison, joined these other works in singing the praises of the feelings of loss and mourning, which it depicted as something pure. In tandem with the establishment of multiplexes in every last corner of the country, love stories and stories about young girls aimed largely at women viewers flourished, including *Be with You* (*Ima, ai ni yukimasu*, dir. Doi Nobuhiro, 2004) and *NANA* (dir. Ōtani Kentarō, 2005). Such films avoided confronting the topic of national self-identity directly; their reliance on emotional appeal contrasted with South Korean cinema during the same period. Although the films of the South Korean New Wave present themselves as entertainment, they sharply pose questions of national identity and what it means to be South Korean.

Melodramatic films often aim to seal up and cover history, but at the same time, melodrama sometimes can aim to reconstruct the past as an actual time continuous with the present. Although few in number, some films had this goal. By focusing on youths at a Korean school who spend all their time fighting, and a young woman who can make her debut as an actress only by hiding her *zainichi* Korean

identity, the films *Break Through!* (*Pacchigi*, 2004) and *Pacchigi: Love and Peace* (2007), directed by Izutsu Kazuyuki and produced by Lee Bong Ou, attempted to foreground the existence of minorities who had been forced to live at the edges of postwar Japanese society. After that, Lee Sang-il directed and produced *Hula Girls* (*Fura gāru*, 2006), which was set in a mining town in Fukushima after the mine has closed. The narrative revolves around attempts to revitalize the town through Hawaiian hula dance.

WOMAN DIRECTORS APPEAR ON A MASS SCALE

Until recently, Japanese cinema has seen few female directors of feature films. Two examples are Sakane Tazuko, a one-time assistant to Mizoguchi Kenji who directed *A Kimono for the New Year* (*Hatsu sugata*, 1936), and Tanaka Kinuyo, who directed six films during the 1950s and 1960s following her long career as an actress. But after them, there were no successors. Depressingly, time and time again a well-known actress would direct a film, but the demand for her to show "femininity" would be so excessive that she would end up never making a film again. Japanese women filmmakers bear the burden of being women, and because they are expected to be feminine and become symbols of femininity, they give up.

The sole exception to this is in the world of Pink Films, which are forced to have low budgets and short production schedules. There, from the 1970s to the present, Hamano Sachi has directed more than three hundred films. By the 1980s, her artistic and technical skills made her into an unshakable part of the adult film world. In the films *In Search of a Woman Writer: Wandering the World of the Seventh Sense* (*Dai nana kankai hōkō: Osaki Midori o sagashite*, 1999) and *Cricket Girl* (*Kōrogi Jō*, 2006), she plunged into the imaginative world of the prewar woman novelist Osaki Midori. Women critics, however, held strong prejudices against Pink Films from the beginning, and it took an extremely long time for her cinematic passion to be recognized as legitimate.

From around the time that Kawase Naomi won the new director's prize at the Cannes Film Festival in 1997, the situation for women started to change little by little. One after another, women in their twenties and thirties who until then had not particularly been film fanatics, began to shoot films. This trend became increasingly strong from the beginning of the 2000s, with many female directors debuting in 2003 and 2004. Of course, they cannot be referred to simply as "women directors" as with Sakane and Tanaka in a previous age. This new generation of female directors feels no special responsibility or need to maintain an image just because they are women, but they also do not have any of the excessive attachment to film felt by the young male film enthusiasts of a previous generation. They give the strong impression that they simply happened to pick up the medium of film as the tool most useful for self-expression because it was nearest at hand. Their idols as female directors were neither Reifenstahl nor Varda. The director these women admired the most was Sofia Coppola.

In *Dogs and Cats* (*Inu neko*, 2004), Iguchi Nami turns her attention to the overlapping animosity and intimacy in the relationship between two women who live together and constantly fight like cats and dogs over their male friends. Tadano Miako, in *Three Years Pregnancy* (*Sannen migomoru*, 2005), depicts a pregnant woman who steadily watches as her husband cheats on her and waits for the birth of her child. Three years pass without the baby being born. Ogigami Naoko, in *Kamome Diner* (*Kamome shokudō*, 2005), tells the story of a Japanese woman who goes alone to Helsinki and opens a cafeteria that becomes a place for women to gather. Through this woman's story, she depicts the ways in which woman can care psychologically for one another. One common feature of the worlds created by these directors is that all of them are small worlds supported by a casual intimacy and are separate from larger society. This representation of a world of intimacy among women leaves little room for the male gaze as the "other" to enter. The technical staff of many of these works include women, while viewers also are mostly women.

Ninagawa Mika invented a fictional space with a sense of kitsch, portraying a brothel during the Edo period through the distorting glass of a fishbowl in her work, *Sakuran* (the title literally means "derangement," 2007). She followed this with *Helter Skelter* (2012), which pursues this sense of kitsch to the point at which it gives off the grotesque stench of rot. Furthermore, Yoshiyuki Yumi took up beauty contests with *Miss Peach: Peachy Sweetness Huge Breasts* (*Misu pi-chi kyonyū wa momo no amami*, 2005), a cheerful, erotic comedy, which began her series of films about huge breasts.

Among this multitude of women filmmakers, one particularly exceptional case stands out: Nishikawa Miwa. In *Wild Berries* (*Hebi ichigo*, 2003), she depicts an urge to kill that arises while caring for the elderly, and in *Sway* (*Yureru*, 2006), she demonstrates her writing and directing talents by taking up a challenging narrative of two brothers who fight over the same girlfriend and reconcile when the older brother returns from prison after serving a sentence for murder. In *Dear Doctor* (2009), Nishikawa tells the story of a phony doctor who settles in a village in a depopulated area with no real doctors, and the exchanges he has with the elderly villagers who adore him. Her fierce attitude, which aims to utterly affirm humanity in its entirety—with all its petty evils, vanity, and cowardice—make Nishikawa's works truly compelling.

The works left by women directors as of the current moment include a mixture of good and bad, but this will likely be sorted out over time. Here, I consider the reason for the appearance of so many women directors during the 2000s. Incidentally, exactly the same phenomenon occurred in South Korea during this period.

The first reason is rooted in the boom in mini-theaters during the 1990s, in which cinema left a strong impression on female viewers as a form of self-expression. In contrast to men who brought home DVDs, women discovered the pleasure of going to movie theaters and enjoying movies there by themselves. Second, as if to answer their desire for self-expression, film schools and organizations like the Pia Film Festival were actively seeking new talent. Third, access to photography and editing equipment became almost unbelievably

easier than it was before. Camera equipment also became much lighter, and digitalization progressed within film production. Just by combining high-definition photography and editing through personal computers, anyone could easily produce films on their own. Fourth, and most important, the male-centered system of film production that had been in place for so long gradually but unmistakably was breaking down. Thus, it was in the 2000s that an environment was built little by little in which young women could easily start directing films without having to go through the apprenticeship of first being an assistant director.

THE RISE OF J-HORROR

The strong influence of Kabuki and storytelling arts like *rakugo* on film has meant that from the prewar period, ghost stories and horror stories have existed as a distinct genre in Japanese cinema. The horror films that started in the 1990s, and reached maturity in the 2000s, created a new territory different from the traditional psychological karma and moral consciousness that shaped earlier works. These came to be known as "J-Horror."

J-Horror was initially produced under extremely low budgets as either video works aimed directly at the rental market—not slated to open in theaters—or as tales of the bizarre that would appear only on regional television stations. This movement was spearheaded by *True Horror Stories* (*Honto ni atta kowai hanashi*, 1992). Eventually, these films made their way to the world of regular movie theaters, creating their own particular genre. They were remade by South Korea and Hollywood and have come to exert a significant influence across a vast region, including Southeast Asia. Dilapidated factories. Dark waterfronts. School bathrooms and other marginal spaces. Memories buried in sealed-off places. Madness and rage that move like a disease from one person to the next without regard for kinship or social status. J-Horror repeats these tropes persistently and loves

to reveal the cracks that erupt suddenly in places that are extensions of everyday life.

This expansion of the horror genre was carried out by the producer Ichise Takashige and scenarists Konaka Chiaki and Takahashi Hiroshi. They wanted to eliminate the standard image of monstrous ghosts appearing in exaggeratedly horrific settings. As a result, they focused instead on the problem of how to make the natural human body seem inhuman and to express this visually. Without relying on gruesome make-up effects or editing tricks, they presented the sheer physical existence of human beings as an event of inescapable horror. Naturally, ghosts have no human interiority that ordinary people could understand. Their actions are limited entirely to simply existing.

I would like to discuss a few representative filmmakers and works. Nakata Hideo depicted a ghost who appears from an undeveloped canister of film discovered in a film studio in *Don't Look Up* (*Joyūrei*, 1996), and in *Ringu* (1998), he introduced a videocassette that kills anyone who watches it. Then *Dark Water* (*Honogurai mizu no soko kara*, 2001) further developed these themes. What each of these works share is the idea of ghosts emerging from inside technical image media. Nakata is a member of the last generation to learn through the studio system, so for him, *Don't Look Up* provides an elegy to the studios, while *Ringu* offers a critique of human-centric assumption that the camera always operates according to the intentions of the photographer. Thus, a ghost whose image is unexpectedly captured on film crawls out of the television tube and attacks the person viewing the screen.

Kurosawa Kiyoshi, who once declared that "all cinema is horror cinema,"[1] tried to create and maintain a subtle distinction from the suspense and sense of mystery of usual horror cinema in the films *Doppelgänger* (2003) and *Retribution* (*Sakebi*, 2006). His critical view of existing genres at times turned the works into comedies in the guise of horror films.

Shimizu Takashi, who belonged to the second generation of J-Horror, brought innovation to the genre by completely changing

the grammar that had been built up by his predecessors. In *Ju-On: The Grudge* (*Juon gekijōban*, 2003), frightening ghosts never appear, despite this being a haunted house movie. Spectators are not frightened by ghosts; rather, they feel fear when they see the fear on the faces of the human characters in the film who witness a ghost near them. Shimizu casually deploys forbidden moves—taking the perspective of ghosts, running the camera from over their shoulders. In *The Stranger from Afar* (*Marebito*, 2004), a man who always carries a camera with him wants to see the greatest fear experienced by a human being, which is the moment before committing suicide. After repeated adventures in the underground world, he asks a young girl who appears out of the depths of his own psychology to film the moment of his death. The philosophy running consistently through this film is that a person's subjective self is no more than a phenomenon that comes into being only through the mediation of multiple photographic images.

When we compare these films with those of Hollywood or Southeast Asia, the idiosyncratic position of J-Horror is evident. They are made with no specific religious ideology like Christianity or Buddhism in the background, and they downplay scenes of cruelty and explicitness as much as possible. There is nothing farther from J-Horror than a series of terrified screams. What is considered most important in editing the film is the "space" (*ma*) that is created in the gaps between sound effects and physical sounds, and this is not totally unrelated to the Japanese aesthetic sensibility of sound, from Noh drama to the music of Takemitsu Tōru. In this way, even in the genre of horror, which is generally looked down upon, Japanese cinema could come to embody the unique qualities of Japanese culture.

EXPOSING HIDDEN HISTORY

Finally, I introduce the experiments of several filmmakers who have looked sharply at the contradictions left behind in postwar Japanese society. In *Blood and Bones* (*Chi to hone*, 2004), Sai Yōichi depicts the

brutally violent love–hate relationship between a father and son within the setting of a household of Korean laborers who emigrated from Cheju Island to Osaka. Miike Takashi, in *Ley Lines* (*Nihon kuro shakai*, 1999) and *The Hazard City* (*Hyōryūgai*, 2000), depicted Chinese war orphans and foreign laborers in a picaresque manner as they eke out a living on the bottom of Japanese society. With *Rainy Dog* (*Gokudō kuro shakai*, 1997), and *The Guys from Paradise* (*Tengoku kara kita otoko tachi*, 2001), he crosses over blithely to Southeast Asia, depicting a drama of men who relentlessly mock Japan. In addition, Zeze Takahisa, in the four-and-a-half-hour *Heaven's Story* (2010), presented a narrative of Japanese people who no longer have a concept of hometown, playing out repeated cycles of animosity and vengeance within a dilapidated *danchi* apartment complex. These directors, who from the 1980s through the 1990s made innumerable idol films, Pink Films, and V-Cinema (a straight-to-video genre), all started making films depicting the underbelly of postwar history when we entered the twenty-first century. They are also all enormously productive.

Among these films, however, the most idiosyncratic of all was *Akame 48 Waterfalls* (*Akame shijūya taki shinjū misui*, 2003), directed by Arato Genjirō, who produced Suzuki Seijun's late films. This solid film, shot as if to burst the bubble of frivolous cinema, perfectly captures the intense nihilism and passion that is carried by those at the bottom of society, as if it were a destiny. It was a virtual parade of the kind of awful aspects of society from which Japanese people have averted their eyes since the late 1960s.

As far as the older generation goes, Shindō Kaneto and Kuroki Kazuo presented numerous films in their late years as if trying to use up all their remaining energy. The majority of these films were about the wartime experiences of the common people. In *Owl* (*Fukurō*, 2003) and *A Postcard* (*Ichimai no hagaki*, 2011), Shindō directed humorous dramas of fate about returnees from Manchuria and their incidents of prostitution, swindles, murder, and draft orders. The characters he depicts are all antinationalist and against state power. In contrast, through the three-part series *A Boy's Summer in 1945* (*Utsukushii natsu kirishima*, 2002), *The Face of Jizō* (*Chichi to kuraseba*, 2004), and

The Blossoming of Etsuko Kamiya (*Kamiya Etsuko no seishun*, 2006), Kuroki depicted the tidy and frugal everyday lives of the Japanese people in the desperate final days of the war and, through these films, searched for a way to calm the spirits of these people. Yoshida Yoshishige, in *Women in the Mirror* (*Kagami no onnatachi*, 2002), depicted in a tragic style a narrative of confession and denial among three generations of women who were victims of the atomic bombs in Hiroshima.

Another characteristic of Japanese cinema in the 2000s was that it showed the will to directly face and examine the political upheavals that began in 1968. Adachi Masao left the world of Japanese film in the 1970s and was involved in the making of newsreels for the liberation of Palestinian refugees. When he returned to Japan in the 2000s, Adachi marked his return to the film world with *Terrorist* (*Yūheisha*, 2006), a prison film based on the life of Okamoto Kōzō, a former member of the Japanese Red Army. One person who offered a rereading of history on a truly grand scale during this period was Adachi's friend, Wakamatsu Kōji. Within the string of works he made between *United Red Army* (*Jitsuroku rengō sekigun: Asama sansō e no michi*, 2007) and *11.25: The Day He Chose His Own Fate* (*11/25: Jiketsu no hi: Mishima Yukio to wakamonotachi*, 2011), Wakamatsu presented both the lynching murders of the Red Army in the Mt. Asama lodge incident and Mishima Yukio's suicide by *seppuku* as deaths produced within homosocial communities. These films are an indictment of society today, which suppresses discussion of the thoughts and intention of the people involved in these incidents.

Here, I take up some of the directors who are the backbone of cinema and who left astonishing work in the 2000s. Ishii Takashi accelerated more and more the fetishism around demonic women in his films *Flower and Snake* (*Hana to hebi*, 2003) and *A Night in Nude: Salvation* (*Nūdo no yoru: Ai wa oshiminaku ubau*, 2010). With *Poison Insect* (*Gaichū*, 2002) and *Canary* (*Kanaria*, 2004), Shiota Akihiko took up the issue of the kind of vulnerability that seems to invite attack, focusing on the politics that arise among children. Kore'eda Hirokazu seems to change style and genre with every film. As though filled with the ambition of answering the question of what cinema

is, he made *Nobody Knows* (*Dare mo shiranai*, 2004), which shows the ways children struggle to survive after the collapse of their family, and *Air Doll* (*Kūki ningyō*, 2009), which by contrast was a farce in which an inflatable sex-doll comes to life. Aoyama Shinji in *Eureka* (2000) and *Eli Eli Lema Sabachthani* (2005) confronted the issue of whether it was truly possible for Japanese who are in a state of perpetual wandering to have some kind of internal resurrection. Among these filmmakers, the person who staged the most boisterous scenes, presenting gleeful depictions of human relationships as they seep into petty desires, was the director Sono Sion in works, such as *Love Exposure* (*Ai no mukidashi*, 2008) and *Noriko's Dinner Table* (*Noriko no shokutaku*, 2005).

Finally, I discuss the activities of Satō Makoto and Mori Tatsuya in the sphere of documentary films, which developed a great deal in the 1990s. In *Memories of Agano* (*Aga no kioku*, 2004), the sequel to *Living on the River Agano* (*Aga ni ikiru*, 1992), Satō returned ten years later to film the residents who live along the Agano River. He then shot *Out of Place: Memories of Edward Said* (2005), following the path of this contemporary Palestinian intellectual. Mori made *A* (1998) and *A2* (2001), focusing on one of the important individuals in Aum Shinrikyo. These works drew attention for sharply interrogating the ethical principles of documentary cinema, including the use of film images as legal testimony, the myth of the neutral director, film censorship, and disruptive incidents at screenings. Mori consistently causes scandals and considers himself to be the bad boy of the documentary world. Note here that Li Ying, who had come from China, infuriated some Japanese nationalists with his film *Yasukuni* (2007).

NOTES

INTRODUCTION

1. Tsurumi Shunsuke, *Genkai geijutsu* (Tokyo: Chikuma gakugei bunko, 1999); "The Idea of Liminal Art," in *From Postwar to Postmodern: Art in Japan, 1945–1989* (New York: MOMA, 2012), 193–196.

2. Editor's note: Here the author begins comparing film and the various forms of theater in Japan. More detailed discussions appear in the following sections. Oldest is the solemn masked drama Noh and the associated kyōgen comic plays, which became a sophisticated performing art in the fifteenth century and was the theater of the samurai and continued to be the theater of the elite in the modern period. Kabuki and the *Bunraku* puppet theater (known as *ningyō jōruri*) came from the Edo period and were the theater forms for the commoner class. In the Edo period, performers of these art forms were of very low status, whereas in the modern period, the status of these performers has risen gradually such that Kabuki actors are now considered theatrical aristocrats. After the Meiji Restoration in 1868, various new forms of theater appeared. *Shinpa* (new-style theater) gained its name in distinction to *kyūha* (old-style theater), in other words, Kabuki. *Shinpa* began with the political satire of Kawakami Otojirō (1864–1911) as political demonstrations but settled into a kind of melodrama usually showing the conflict between the worlds of geisha and other traditional figures and the lawyers, businessmen, and government officials of

the new society. Although Kawakami appeared with his wife Sada Yakko (1871–1946) and toured the world, as *shinpa* became an established performance form, all female roles in *shinpa* were played by male *onnagata* female role specialists and only later did actresses begin to appear as well. *Shinpa* is crucial to the author's argument because *shinpa* not only contributed performers and stories to the film world but also becomes a label for a kind of sentimental, melodramatic mode of storytelling that is not necessarily directly related to the actual *shinpa* theater. *Kami shibai* (paper plays) were street performances in which a performer would carry a set of cards with pictures on them and would tell the story and sell candy to the crowd that gathered.

3. Editor's note: Through the first few decades of Japanese film history, films were shown with a narrator called a *benshi* who would stand next to the screen and tell the story, often dramatically declaiming speeches for the characters. As a form of vocal performance, *benshi* are related to many forms of traditional storytelling, which are often musical styles. More detailed discussions of *benshi* will follow in this chapter and the following chapter.

4. Translator's note: *Batā kusai* is a pejorative expression for Japanese works that felt overly influenced by the West.

5. Yasuzō Masumura, "Profilo Storico del Cinema Giapponese," *Bianca e Nero*, November–December 1954; Masumura Yasuzō, "Nihon eigashi," in *Eiga kantoku Masumura Yasuzō no sekai* (Tokyo: Waizu, 1999).

6. Editor's note: *Rakugo* is a form of storytelling usually performed in *yose* vaudeville halls where a solo performer sits on a cushion and acts out a story distinguishing between characters by turning to one side and another. The stories are usually comic, but the *rakugo* by San'yūtei Enchō (1839–1900) included many serious stories. One of his long ghost stories, *The Peony Lantern* (*Botan Dōrō*, 1884), became a new starting point for literature when a shorthand transcript of his vocal performance was published. *Kōdan* stories are usually more or less serious and the performer sits at a desk as though reading from some distinguished book. The stories include war tales and adventure stories and many of *kōdan*'s stories of thieves and wandering gamblers not only became a source of printed literature but also heavily influenced popular theater and *rōkyoku* ballads and then became a major source of stories for movies.

7. Editor's note: In Japan, until recently, a distinction has been made between "mass literature" (*taishū bungaku*) and "pure literature" (*jun bungaku*). Pure literature is heavily influenced by the ideals of Western fiction. Mass literature draws on the tradition of fiction from the Edo period,

and then goes through the transcripts of *rakugo* and *kōdan*, but then it grew into the novels of someone like Ozaki Kōyō (1868–1903) with his famous novel *The Golden Demon* (*Konjiki yasha*, 1897) and the novels and plays of his pupil Izumi Kyōka (1873–1939). In time, this developed into a wide variety of popular fiction, much of it serialized in newspapers and magazines.

8. Editor's note: *Jidaigeki* is one of the most important terms in Japanese film. It means "period play" and although it can technically be used for a film set in any historical period from ancient times to relatively recent times like the Meiji period, in practice, it concentrates on stories set in the Edo period with samurai and sword fights and wandering gamblers and the like. This is contrasted with *gendai geki* ("contemporary plays"), which are set in modern Japan (post-1868, when the *shogunate* was deposed and the emperor was restored to a central position of power).

9. Mizoguchi Kenji, "*Genroku chūshingura* enshutsuki, 1941" [Notes on directing Genroku Chushingura, 1941], in *Mizoguchi Kenji chosakushu* (Tokyo: Omuro, 2013).

10. Translator's note: Yomota draws attention to two additional links between cinema and theater. One is the use of the word *koya* (小屋, literally, "a hut"). In theater, it means "playhouse," but it remains in use within the film industry as another word for movie theater; another is the use of "such and such-*za*" (座) in naming, which is close to the English "company." There is no real English equivalent to these terms, but in Japan, they demonstrate the ways that, even in language, theater has contributed greatly to cinema.

11. Editor's note: The term *jidaigeki* ("period play") is used in both Kabuki and Japanese film with a slight but important difference. In both cases, censorship by the government meant that to deal with contemporary issues, especially those concerning the governing class, it was necessary to set stories in the distant past. Because Kabuki flourished during the Edo period, the plays had to be set before that period to avoid antagonizing the Shogunate. The vast majority of film *jidaigeki* are set in the Edo period. So what would have been *gendaigeki* (contemporary plays) for Kabuki are now *jidaigeki* for film.

12. Editor's note: The puppet theater known as *ningyō jōruri* (puppets and narrative music) or *Bunraku*, after the name of the last troupe in the Edo period, performs sophisticated, adult plays with large puppets with three puppeteers capable of very detailed movement. The repertory of the theater, of course, has contributed to the cinema, but what is more important for the author is the consideration that having a major form of theater in

which the visual channel and the audio channel are physically separated on stage and having a narrator who describes the scene and speaks for the characters is quite similar to the role of the *benshi* in early Japanese cinema.

13. Editor's note: Here, two more genres of theater are introduced. *Shingeki* is the modern theater movement that began after the opening of Japan. The repertory of this theater began with the Western classics: Shakespeare, Ibsen, Chekov, and the contemporary European writers that the Japanese pioneers in *shingeki* experienced when they went to Europe. *Shin Kokugeki* was a popular theater movement that specialized in plays with sword-fights. It had a much more masculine emphasis than *shinpa* and its style of fighting was influential in the film world.

14. Editor's note: As mentioned earlier, even though *shinpa* continued to emphasize *onnagata*, Sada Yakko, the wife of the beginner of *shinpa*, ran the first school for actresses in Japan and often is considered to be Japan's first modern actress.

15. Noël Burch, *To the Distant Observer* (Berkeley: University of California Press, 1979).

16. Editor's note: "Chain dramas" (*rensa geki*) were a type of performance in early cinema that alternated between scenes on film and scenes acted out live on stage.

1. MOTION PICTURES: 1896–1918

1. Tanizaki Jun'ichirō, "Yōshō jidai" [In My Youth], in *Tanizaki Jun'ichrō zenshū*, vol. 17 (Tokyo: Chūōkōronsha, 1972).

2. Editor's note: *Nihonga* are paintings in traditional styles, but they also include more contemporary paintings that largely use traditional media or subjects and are consciously "Japanese" in style in contrast to Western painting.

3. Editor's note: Ozaki Kōyō (1868-1903) was a writer whose most famous novel was *The Golden Demon* (*Konjiki yasha*, 1897). It featured two young people in love—a student named Kan'ichi and a girl named Omiya. Omiya is forced to become the mistress of a usurer, and when Kan'ichi learns this, he angrily rejects her in a fight on the beach at Atami. Izumi Kyōka (1873-1939) was Ozaki's pupil, and although his fantastic stories are most popular today, in his lifetime, he was best known for novels that became *shinpa* plays like *The Water Magician* (*Taki no Shiraito*, 1895) and *The Nihon-bashi Geisha District* (*Nihonbashi*, 1914).

4. Komatsu Hiroshi, "Shinematogurafu to Nihon ni okeru shoki eiga seisaku" [The Cinematograph and Early Film Production in Japan], in *Hikari no tanjō: Ryumie-ru!* [The Birth of Light: Lumiere!] (Tokyo: Asahi Shinbun, 1995), 38.

5. Editor's note: *Sōshi shibai* (plays of gallant citizens) were plays in the late-nineteenth century in favor of the campaign for voting rights. Eventually, this is another of the streams leading into *shinpa*.

6. Editor's note: This is a film version of a story by Izumi Kyōka that was quite famous in *shinpa*. A performer of "water magic" (making spouts of water appear from fans and many objects) named Taki no Shiraito becomes the benefactor of a young law student. She is eventually forced to steal and kill to continue her contributions. At her trial, the student she helped is her prosecutor. After convicting her, he shoots himself.

7. Editor's note: Here the author is reemphasizing that although much of early Japanese film was derived from Kabuki, it usually was not a direct borrowing, and the actual Kabuki world mostly kept its distance from the film world.

8. Lu Xun, "Tokkan Jijo," in *Lu Sun zenshū*, vol. 2 (Tokyo: Gakushū kenkyūsha, 1959), 10–11.

9. Editor's note: The puppet play *The Treasury of Loyal Retainers* (*Kanadehon chūshingura*) dramatized a true incident at the beginning of the eighteenth century when Asano Takuminokami, the lord of the small domain of Akō in what is now Hyōgō Prefecture suddenly attacked a high-ranking shogunal official named Kira Kōzukenosuke in the shogun's palace. Asano was sentenced to commit ritual suicide that day, and his clan disbanded. After nearly a year of hardship, forty-seven of Asano's former retainers avenged their lord's death by attacking and killing Kira. In the Edo period, censorship by the shogunate meant that in the puppet play, the names of the historical figures were disguised. The lord is called Enya Hangan; the man he attacked is called Kō no Moronō; and Ōishi Kuranosuke, the senior retainer who led the vendetta, is called Ōboshi Yuranosuke. The puppet play was an immediate success and was soon copied in Kabuki, but it also inspired all kinds of collateral stories, mostly totally fictional, such as the stories of members of the vendetta who do not appear in the play. The film versions rely on this rich collection of source material but use the actual historical names of the characters.

10. Makino Masahiro, *Eiga jiden* [A Life in Film], 2 vols., ed. Yamane Sadao and Yamada Kōichi. Masahiro changed the Chinese characters for his name three times: 正博, 雅裕, and 雅弘.

11. See Jacob Raz, *Yakuza no bunka jinrui gaku* [A Cultural Anthropology of Yakuza], trans. Takai Hiroko (Tokyo: Iwanami Shoten, 1996).

12. Editor's note: The author will go into more detail about this film about Emperor Meiji in chapter 7.

13. Editor's note: *Kachūsha* was an attempt to share in the success of the *shingeki* stage version of the play starring the phenomenal actress Matsui Sumako (1886–1919). Matsui has become the iconic figure of the scandalous image of early actresses, especially because she committed suicide at the grave of her lover, the head of the *shingeki* troupe, after he died from influenza. Although the play is an iconic one for actresses, in the film version, her role is taken by an *onnagata* as in *shinpa*. She recorded the theme song for the play, *The Song of Kachūsha*, and it became one of the first great hits in popular music history. She recorded another theme song, *The Song of the Gondola*, for a stage performance the following year, in which the first line is "Life is short, so love while you can, young girl." This is the song that Shimura Takashi sings at the end of Kurosawa's *Ikiru* (1952) as he sits on a swing in the park he has succeeded in building and dies in the snow.

14. Editor's note: *Rakugo* and *kōdan* are storytelling styles in which a single performer describes the scene and plays all the roles. *Kawachi ondo* is a style of singing for the group dances of the Obon season. The singer alternates narratives of old stories with songs. What the author is emphasizing is not that any one tradition led directly to the *benshi* (although that is undoubtedly true for individual performers) but that the *benshi* is related to a rich tradition of storytelling and narrative singing that made the presence of the *benshi* seem perfectly natural to audiences accustomed to this tradition.

2. THE RISE OF SILENT FILM: 1917–1930

1. Editor's note: *Shingeki* also emphasized actresses instead of *onnagata*—the men playing female roles in Kabuki, *shinpa*, and early film. In fact, using real women in female roles is one of the major characteristics of *shingeki*.

2. Editor's note: Osanai Kaoru (1881–1928) was an influential member of the second generation of *shingeki*. He traveled extensively in Europe and first started experimenting with translated plays performed by Kabuki actors; he started a pure *shingeki* troupe with the founding of the *Tsukiji Little Theater* (*Tsukiji Shōgekijō*) in 1924.

3. Découpage is often described in English as "continuity." It is the final scenario with all the information needed for filming. Images often are included of the shots to be taken. For those watching, this shows the fundamental elements of the structure of the film. In Japanese it is referred to variously as *satsuei daihon* (shooting script) or *enshutsu daihon* (production

script), or during actual shooting as just *hon* (book). In English, the word that is often used is "storyboard."

4. Translator's note: Ueda Akinari (1734–1809) was a major writer and poet during the eighteenth century. His most well-known work, a collection of supernatural tales entitled *Tales of Moonlight and Rain* (*Ugetsu monogatari*, 1776), was famously adapted by the director Mizoguchi Kenji in 1953 as *Ugetsu*.

5. Aaron Gerow, "Writing a Pure Cinema: Articulations of Early Japanese Film" (Ph.D. diss., University of Iowa, 1996), 300.

6. Editor's note: *Orochi* means "serpent." The original title of the film was *Buraikan* (Vagabond/Outlaw), but this title alarmed the censors, who forced a title change and imposed additional extensive cuts, amounting to approximately fourteen hundred feet of film.

7. Translator's note: As suggested earlier, it was these stars—including Bantsuma, Arakan, Chiezō, and Utaemon—who followed Makino's lead and started their own production companies. Most were short-lived, but they constituted one of the first waves of independent production.

8. Editor's note: Hasegawa Shin (1884–1963) was a playwright who established a new genre of popular theater that became a major source of stories for film, *matatabi-mono*, which deals with gangsters and gamblers who must constantly be on the move but who long for stable relationships. For example, *In Search of Mother* (*Mabuta no haha*, 1932) features a petty gambler who longs to find his mother, but he finds her only for her to reject him because his presence might ruin her daughter's chances for marriage. The protagonist says that he only has to close his eyes to see his ideal mother on the inside of his eyelids.

9. Sergei Eisenstein, "The Unexpected," in *Film Form: Essays in Film Theory*, ed. Jay Leyda (New York: Harcourt, Brace, and World, 1977), 18–27.

3. THE FIRST GOLDEN AGE: 1927–1940

1. Editor's note: See note 2 in chapter 2 on Osanai Kaoru.

2. Translator's note: Yamada Kōsaku (1886–1965) was a famous composer and conductor who studied in Germany and worked briefly in the United States. He wrote many orchestral works, operas, and songs. He also introduced many famous orchestral works to Japan by Debussy, Gershwin, Strauss, and others.

3. Editor's note: *Taii no musume* is part of the repertory of *shinpa*, and Mizutani Yaeko I (1905–1979) began as a *shingeki* actress and went on to become the first important actress in *shinpa*.

4. Translator's note: This is a case in which the English translation of the film's title—*The Neighbor's Wife and Mine*—does not do justice to the original. In Japanese, the distinction is between "madame" (i.e., a more sophisticated, exotic, European-sounding word for wife) and "*nyōbō*," which is a more usual, family-oriented, domesticated word. The Japanese title reflects the cultural and political tensions that run through the film.

5. Editor's note: "*Chanbara*" is the common word for *jidaigeki* that was used to emphasize sword-fighting scenes. There are many theories about the origin of the word, but it is generally taken to be an abbreviated form of *chanchan barabara*—an onomatopoeia for swords clashing (*chan*) and the movement of bodies scattered (*bara*) during chaotic fighting scenes.

6. Editor's note: "*Chindonya*" are the Klezmer-like bands that go through the streets, playing for the opening of new businesses and other occasions. The name comes from the sound, with "*chin*" representing the clang of cymbals and "*don*" the boom of a drum. Although rare, they still exist today.

7. Itami Mansaku was the father of Itami Jūzō, whose works such as *Tampopo* (1985) and *The Funeral* (*Osōshiki*, 1984) are well known in the West. For more about Itami Jūzō, see chapter 10.

8. Translator's note: In the late 1930s, *jidaigeki* were attacked by some for taking a frivolous attitude toward Japan's past. *Rekishi eiga* (history films) were presented as an alternate ideal. Closely aligned with an emergent "realist" orientation, these films aimed to capture the fine grain of historical detail rather than offer more sword-fighting spectacle.

9. Editor's note: Yamada Isuzu (1917–2012) had a *shinpa onnagata* as a father and a geisha as a mother. From the days of silent film, she worked in all genres and with nearly all the top directors, in addition to appearing on stage and television almost until her death. She is perhaps most familiar to Western viewers as the character corresponding to Lady Macbeth in Kurosawa Akira's *Throne of Blood* (1957).

4. JAPANESE CINEMA DURING WARTIME

1. Noel Burch, *To the Distant Observer: Form and Meaning in Japanese Cinema* (Berkeley: University of California Press, 1979).

2. Translator's note: The ABCD (American/British/Chinese/Dutch) line refers to a set of embargoes placed on the selling of raw materials—such as iron ore and oil—to Japan in an effort to curtail its militarism.

3. Editor's Note: "Manchukuo" is the name of the ostensibly independent puppet state set up by Japan in Northeast China and Inner Mongolia. The author intentionally uses the language of the time to give a sense for how things were described during the war years.

4. Tanaka Masasumi, *Ozu Yasujirō shūyū* (Tokyo: Bungei shunjū, 2003), 228.

5. Ruth Benedict, *The Chrysanthemum and the Sword: Patterns of Japanese Culture* (Boston: Houghton Mifflin, 2005).

6. Tsumura Hideo, "What Is to Be Destroyed?," in *Overcoming Modernity: Cultural Identity in Wartime Japan*, trans. Richard Calichman (New York: Columbia University Press, 2008), 115–127.

7. Translator's note: These include *Miyamoto Musashi: Dai-ichi-bu: Kusawake no hitobito, Dai-ni-bu: Eitatsu no mon* (1940); *Miyamoto Musashi: Dai-san-bu—Kenshin ichiro* (1940); and *Miyamoto Musashi: Ichijōji kettō* (1942).

5. FILM PRODUCTION IN THE COLONIES AND OCCUPIED LANDS

1. Editor's note: "Homeland" or "*naichi*" is the word for the main part of Japan and shows the subordinate political and cultural position of the colonies. The author uses the term in an ironic way, placing it in quotation marks to show the language of the time.

2. Editor's note: One characteristic of Chinese characters is that they can be pronounced in many different ways depending on the dialect of Chinese and also are pronounced differently in the various Asian languages that use Chinese characters. In this case, the actress Ri Kōran, a Japanese woman who was born in China, went by her Chinese name (using the same characters), Lǐ Xiānglán. The decision to conceal her Japanese origins was made so she could represent China in colonial and propaganda films. Once the war ended, she used her given Japanese name, Yamaguchi Yoshiko, and later appeared in Hollywood films as Shirley Yamaguchi. More detailed discussion of Ri Kōran will follow later in this chapter.

3. Translator's note: A traditional performing art combining singing, theater, narrative, and poetry. A performance includes a singer, who tells stories using different voices for different characters, and a drummer who, in addition to offering rhythmic accompaniment on a single drum (*buk*), also interjects words of encouragement.

4. Yi Yon Il, "Nittei shokuminchi jidai no chōsen eiga" [Colonial Korean Cinema During the Time of the Japanese Empire], in *Koza nihon eiga*, vol. 3, trans. Takasaki Sōji and ed. Satō Tadao et al. (Tokyo: Iwanami Shoten, 1986), 321.

5. Editor's note: Amakasu Masahiko (1891–1941) is a controversial figure in Japanese history. After the Great Kantō Earthquake in 1923, he supervised the extrajudicial execution of anarchists Ito Noe and Ōsugi Sakae, as well as their six-year-old daughter, and was imprisoned for a short time. Eventually, he became the head of Man'ei. He committed suicide in Manchuria when Japan's defeat was announced.

6. Translator's note: The author places the date of this film as 1943, but as the production process began in 1942 and it was released in 1944, I have changed the date to 1944.

6. JAPANESE CINEMA UNDER AMERICAN OCCUPATION: 1945–1952

1. Editor's note: Conventionally, the American Occupation government is called GHQ, which is short for "General Headquarters."

7. TOWARD A SECOND GOLDEN AGE: 1952–1960

1. Editor's note: In English, "program picture," when used at all, refers to the second feature in a program or the "B picture." The author uses this term for all major studio films, denoting primarily entertainment and genre films.

2. Editor's note: In the classical Noh theater, there is a type of story called "*mugen*" (phantasmal) Noh in which a traveling priest comes to a place famous for some person or event and hears these stories of the past from a local person. The local person turns out to be the ghost of that historical figure and then reappears in his or her true form to tell their story.

3. Editor's note: *Nihonjinron* is a genre of Japanese writing that tries to delineate the essence of the Japanese people.

4. Translator's note: The 180-degree axis (or line) refers to an imaginary line that runs between the characters (or objects) in the scene, framing their relationship to the space so that viewers can orient themselves clearly to them. Typically, the camera is supposed to stay on one side of the 180-degree line. When it crosses this line (reverse cut), it can be disorienting. Some directors break it for effect, but Ozu broke it regularly. There has been considerable scholarly debate around Ozu's willful eschewal of classical (Hollywood) film grammar.

5. Nakahira Kō, "Nihon eiga no suijun wa takai, kōgyō keitai no atsui kabe" [The Level of Japanese Cinema Is High, the Thick Walls of Box Office Form],

Eiga geijutsu [Film Art], April 1960, cited in Nakahira Mami, *Burakku shiipu: Eiga kantoku Nakahira Kō den* [Black Sheep: The Story of Filmmaker Nakahira Kō] (Tokyo: Waizu shuppan, 1999), 189.

8. UPHEAVAL AMID STEADY DECLINE: 1961–1970

1. Cinemascope is a type of widescreen format developed in the United States in the 1950s (although other, similar technologies were developed as early as the 1920s). It uses an anamorphic lens when projecting to stretch out the image horizontally. A standard size image has an aspect ratio of 1.33:1. When cinemascope was initially introduced, it had an aspect ratio of 2.66:1, about twice the width of the standard image. The lenses developed for cinemascope enabled this expansion with no distortion to the picture. Today (often shortened to "scope"), it is used somewhat more loosely, often referring to aspect ratios of 2.35:1 or wider.

2. A widescreen format of 1.66:1 or 1.85:1 was developed by Panasonic but does not use anamorphic lenses. In Japan, the 1.85:1 aspect ratio is used most often.

3. Editor's note: In both of these series, each title inserts some word in the title, for example, *Japan's Irresponsible Period* (*Nippon musekinin jidai*, 1962) and *The Sexiest Man in Japan* (*Nippon ichi no iro otoko*, 1963).

4. Mishima Yukio (in conversation with Ōshima Nagisa), "Fashisuto ka kakumeika ka" [Fascist or Revolutionary?], January 1968, in *Mishima Yukio eigaron shūsei* (Tokyo: Waizu shuppan, 1999), 639.

5. Translator's note: *Kengyō* is the highest of the official ranks for the blind in old Japan and *zatō* is the lowest rank. Ichi is the name of the character. Thus, *Zatoichi* means something like "Ichi of the lowest rank."

6. Editor's note: This series dominated postwar Shōchiku. A fuller discussion can be found in chapter 9.

7. Translator's note: *Gekiga* are comic books (*manga*) often drawn in a more realistic or rough-hewn style and dealing with more specifically adult themes. The name *gekiga* literally means "dramatic pictures" and was posed as an alternative to regular manga ("playful pictures"). The term was coined in the late 1950s by the artist Tatsumi Yoshihiro.

8. Editor's note: The aesthetic sense that Suzuki displayed in his studio pictures came to the fore in his later playful and experimental independent films, including what is sometimes known as the Taisho Trilogy—*Zigeunerweisen* (1980), *Heat Haze Theater* (*Kagerō-za*, 1981), and *Yumeji* (1991).

9. Translator's note: *My Sin*, written by Kikuchi Yūhō, was a novel serialized in the *Osaka Mainichi* newspaper in 1899. Its first cinematic adaptation

was in 1908, and since then, it has been adapted in cinema more than twenty times.

10. Translator's note: The *Ryōzanpaku* is the name of a martial arts school or *dōjō* where numerous eccentric but powerful and highly skilled fighters gathered. The name comes initially from the character Liang Shanbo in the Chinese novel *The Water Margin*.

9. DECLINE AND TORPOR: 1971–1980

1. The title here refers to the Italian term *Anni di Piombo* (years of lead)—a period from the late 1960s through the early 1980s in Italy associated with social turmoil and numerous acts of political violence from the left and the right.

2. The term "Roman Porno" is slightly misleading insofar as the films, although sex films, are not "pornographic" (they do not feature explicit, nonsimulated sex scenes). Although Nikkatsu borrowed the term "porno" from a contemporary film series at rival studio Tōei, "roman" seems to refer either to "romantic" or to the French word for novel, *roman*. In either case, the idea was to produce adult-oriented films (taking advantage of the flourishing Pink Film market; see chapter 8), while giving them a certain respectability and sophistication to set them apart. They were among the most critically acclaimed films of the 1970s and 1980s.

3. Editor's note: *Maruhi* is written with the word for "secret" in a circle and means "top-secret," giving an air of sensationalism to the movie.

4. In *Geinōshi no shinsō* [*Deeper Layers in the History of the Arts*] (Osaka: Kaihō Publishing, 1997), a collection of talks with Mikuni Rentarō, the comparative culture scholar Okiura Kazuteru, after discussing the historical significance of street entertainers, such as *yashi* and *gōmune* (operators of stalls selling things at festivals and at other marketplaces who are often related to yakuza or to groups that were once considered outcasts) and their relationship to Kuruma Zenshichi (the head of Tokyo's primary outcast organization), points out that Tora-san's name probably became Kuruma Torajirō because the director Yamada Yōji, who also penned the script, was aware of the significance of *yashi*. To all intents and purposes, film historians have ignored the history of representation of outcasts (*hisabetsu burakumin*) in Japanese film history, and the analysis and research on secret messages in cinema, including those of Toei's *ninkyō* films, will be a major task for future scholarship.

5. Editor's note: Minamata disease is considered to be one of the four big pollution diseases of Japan and is a severe neurological disease caused by

mercury poisoning. It was discovered in 1956 in Minamata City in Kumamoto Prefecture where a chemical company named Chisso had been dumping industrial wastewater into Minamata Bay and the Shiranui Sea from 1932 to 1968. Although it was discovered in 1956, it was not until 1968 that the government recognized the causes of the disease and progress could start to be made in treatment and compensation.

6. Editor's note: Originally the international airport in Tokyo was Haneda, close to central Tokyo, but noise and congestion started to become a problem in the 1960s with the use of jets. In 1965, a plan to build an airport in the villages of Sanrizuka and Shibayama in neighboring Chiba Prefecture was announced. But this involved taking the land of the farmers there and inspired anger because they had not been consulted. This resulted in 1966 in an alliance of local residents, student activists, and left-wing political parties that resisted the building of the airport with such tactics as building towers to prevent the runways from being used. This delayed the opening of the airport until 1978, and for many years after it did open, even casual visitors had to undergo strict security checks.

10. THE COLLAPSE OF THE STUDIO SYSTEM: 1981–1990

1. André Bazin, *What Is Cinema?*, trans. Timothy Barnard (Montreal: Caboose, 2009). See, in particular, "William Wyler: the Jansenist of Mise-en-scène," 45–72, as well as the translator's twenty-page note on the term "découpage."

11. THE INDIES START TO FLOURISH: 1991–2000

1. Editor's note: In the 1990s, mass media began to spotlight young people with supposedly stunted social skills who referred to other people with the old-fashioned locution of *otaku* instead of "you" and who found pleasure only in encyclopedic knowledge of trivia about some field. The term is contested, but it has loosely come to mean someone with an unhealthy or obsessive love of some aspect of culture or subculture.

12. WITHIN A PRODUCTION BUBBLE: 2001–2011

1. Kurosawa Kiyoshi, *Eiga wa osoroshii* [Cinema Is Horrific] (Tokyo: Seidosha, 2001).

INDEX